MAITAKE MAGIC

Maitake Mushroom Fractions:
Capture the Force of Nature's Amazing
Powerful Immune Boosters, Cancer Protectors
and Metabolic Activators

by
Harry Preuss, M.D.
and
Sensuke Konno, PH.D.

ABOUT THE COVER: The Japanese character *Mai* for dancing. It is said that in antiquity those who came upon and consumed maitake mushroom would dance for joy since they would now enjoy good health and longevity.

Disclaimer: This information is presented by an independent medical expert whose sources of information include studies from the world's medical and scientific literature, patient records, and other clinical and anecdotal reports. The material in this book is for informational purposes only and is not intended for the diagnosis or treatment of disease. Please visit a medical health professional for specific diagnosis of any ailments mentioned or discussed in this material.

ISBN 1-893910-19-9
Printed in the United States
Published by Freedom Press
1801 Chart Trail
Topanga, CA 90290
Bulk Orders Available: (800) 959-9797
E-mail: info@freedompressonline.com

ACKNOWLEDGMENTS

FIRST OF ALL, WE ARE GRATEFUL TO ALL THOSE who were involved and participated in this project. We would like to acknowledge the effort of Dr. Preuss' research associates, Bobby Echard, M.T. and Nadeem Talpur, M.D. who performed much of our laboratory research. Dr. Preuss would also like to express his gratitude to Rich Scheckenbach and Dr. Dallas Clouatre, two formulators who are a rich source of knowledge on dietary supplements. We would like to thank the staff of Dr. Konno's department at New York Medical College, including Drs. Choudhury, Eshghi, and Tazaki. Particularly, their support on clinical studies is greatly appreciated. Also, we must thank the urology residents at New York Medical College who tirelessly spent their time on clinical and basic science research. We also wish to acknowledge the support of our respective families for supporting our quest to learn about, teach and research natural products.

To Mr. David Steinman, who served as the skillful editor and who played a significant role in the completion of this book. He deserves all credit and we thank him.

We also wish to thank Ms. Naoko Noaki who worked so many hours behind the scenes. We know you were there and thank you.

Finally, our special gratitude to our friend and a (successful) businessman, Mr. Mike Shirota, who initiated this project and continued to encourage us until the work was completed. His generous gifts of Grifron D-fraction and maitake caplets with concomitant funding from Maitake Products, Inc. have made our studies possible. Thanks, Mike!

Now "we" have done it! Once again, we thank you all.

CONTENTS

THE HEALING POWER OF MAITAKE MUSHROOM

PAUL STAMETS USED TO GET SICK A FEW TIMES A YEAR OR MORE—just like the rest of us. Colds. Flu. Bronchitis. You name it, and he would catch it. But not anymore. Since Stamets has been ingesting nature's rich source of a remarkably potent, yet ancient form of complex sugar, called a beta-glucan on a daily basis, he hasn't been sick in five years. "I am around other people with the flu and colds and I stay fine. It's amazing. I just seem immune to the infections that get everyone else."

Was Stamets born this way? No, he used to get sick all the time. What was he doing differently? Stamets recalls clearly that his resistance to infectious diseases such as cold and flu improved markedly when he began consuming maitake mushroom daily. Not surprisingly, maitake is one of nature's richest sources of beta-glucans, complex natural sugars (also called polysaccharides) that are among, or even may be, the most potent, natural immune forces ever discovered.

Carolyn McKenzie, thirty-seven, was suffering uterine fibroids. Her first doctor discussed the possibility of surgery including a partial hysterectomy. That was when she visited Abram Ber, M.D., of Phoenix, Arizona. A specialist in nutritional healing, Dr. Ber prescribed Carolyn eight grams of maitake extract tablets to be taken daily on a regular basis. Within six months, using ultrasound results, Dr. Ber discovered a "substantial reduction of the fibroids." She no longer needed surgery. Dr. Ber used this same regimen with five other female patients whose uterine fibroids healed and no longer required surgery.

Meanwhile, a 75-year old woman with Type II diabetes was on medication for her condition but unable to adequately lower her blood sugar lev-

els. When she began taking maitake mushroom tablets regularly, she was not only able to normalize her blood sugar levels but also reduced her drug dosage by half. In fact, so important has research into maitake mushroom's ability to aid diabetics become, the prestigious medical journal *Diabetes, Obesity and Metabolism* has reported on its benefits.[1]

A 45-year-old female (name withheld to protect patient confidentiality) with estrogen-responsive breast cancer underwent surgery in April 1992 to remove her tumor. Following this, she received mild chemotherapy until February 1994. Nevertheless, the cancer recurred in April 1994. She refused surgery this time and instead started to take 100 milligrams of Maitake D-fraction (a type of beta-glucan isolated from a specific fraction obtained from the maitake mushroom) and five grams of crude maitake mushroom powder every day for six months. After six months, she reduced her dosage of D-fraction to 50 mg a day. By May 1995, clinical and laboratory examination confirmed her tumor had disappeared.

These and other true-life healing reports represent only a few of the amazing results obtained from an exciting new, yet paradoxically ancient, natural medicine, maitake mushroom, which is one of nature's richest sources of complex beta-glucans.

As health professionals, we have found that maitake mushroom is an important natural "medicine" that can help patients and persons involved in self-managed care to defend against some of the most deadly diseases of aging and potentially add years of health to their life span. We believe that maitake mushroom and its rich source of various beta-glucans—whether compared to prescriptions drugs or natural remedies—will someday be recognized to be one of the most important immune-supporting nutrients available to health-conscious consumers.

Maitake may prevent cancer as well aid persons already undergoing cancer therapy; in some cases, maitake's powerful healing powers could even make the difference between remission and spread. In fact, one of us (Dr. Konno) has participated in government-sanctioned clinical studies and reported on other clinical studies, in which maitake extracts have been provided to cancer patients with highly gratifying results, including complete remissions in many cases of breast, prostate and other malignant conditions.

But there's a lot more to the beta-glucan-maitake mushroom story. Maitake can also play a key role in palliating frank diabetes and associated conditions, often referred to as Syndrome X. Most recently, our own published scientific research has demonstrated the vital health role that beta-

glucans found in maitake mushroom can play by enhancing the body's healing response among diabetics and prediabetics. It is worth repeating that these same beta-glucans can also help persons suffering from Syndrome X, an increasingly prevalent condition involving high blood sugar and insulin resistance, and a condition that may predispose many of us to the most deadly diseases of aging, including diabetes, circulatory disorders, and possibly cancer.

These days, with the very real threat of biological terrorism, and the emergence of ever-more virulent strains of bacteria and viruses with drug resistance, we all realize how important it is to support our own immune health. Maitake's impact on human immune function is profound and can contribute to reduced incidence of colds, flu, and enhanced resistance to other bacterial and viral diseases.

We all want to enjoy great health and long life span. Well, maitake mushroom with its powerful contingent of beta-glucans—when used as a dietary supplement—can play a key role in extending the best and healthiest years of your life.

With this natural remedy, it is possible to dramatically improve one's immune health, cut sick days, reduce risk for cancer, and even enjoy lowered cholesterol and blood pressure, improved weight loss, and normal blood sugar levels.

Both of us have been privileged to be intimately involved in much of the most recent, groundbreaking experimental and clinical research on this important natural medicine.

We predict that maitake, although a relative newcomer to the world of natural medicine, will become one of the most thoroughly studied nutritional supplements, offering exciting new hope in the quest to stay healthy.

DISCOVERING THE HEALING POWER OF MAITAKE'S BETA-GLUCANS

MAITAKE:
THE KING OF MUSHROOMS,
SOURCE OF BETA-GLUCANS

IT MAY BE LEGEND AND ONLY HALF-TRUTH, but it has been said among the Japanese that wild monkeys rarely experience cancer, high blood pressure or diabetes. Perhaps, as the legend suggests, it is due, to some extent, their consumption of wild mushrooms. In Japan, this legend helped to spur research into the maitake mushroom.

Whether the legend is true or not, we are fortunate that corroborating research has been conducted. We now know that maitake mushroom has extremely beneficial effects on the body's metabolism of sugar and response to insulin, the hormone secreted by the pancreas and that is responsible for sugar metabolism. But this is only part of the maitake story. We also know that maitake can beneficially influence certain cancers—even those that do not respond to standard chemotherapy, radiation or surgery. And we've seen patient upon patient experience fewer sick days—less colds or flu— when they incorporate maitake mushroom's beta-glucans into their daily diet and nutritional supplement program.

It is interesting to note that elsewhere in the world, especially Japan, maitake (pronounced "my-tah-key") and other mushroom extracts are considered to be frontline medical "drugs." In the United States and some other western nations, however, these important natural agents may be purchased freely as nutritional supplements at health food stores, natural health centers, and even from a growing number of pharmacies and other health professionals.

Despite this, like most people—including even many health professionals with an interest in complementary medicine—you may have never heard of maitake mushroom. We're not surprised. Sometimes people make

so many shopping choices out of a sense of comfortable familiarity, they lose out on experiencing new foods and, subsequently, new avenues for enhancing their health. Take mushrooms. Who would have ever thought that the lowly mushroom could hold so many healthy benefits for an aging population? Most people who buy these fungi invariably pick "button" mushrooms (*Agaricus brunnescens*) whose health benefits are nowhere near as profound as those to be derived from other mushroom species, such as shiitake, enokidake, and, of course, maitake.

Why do so many people in the modern world have so much fear of, and hold so many ambivalent feelings towards, mushrooms? The deadly *Amanitas* was used to kill Claudius II and Pope Clement VII. The death of Buddha—at least in legend—resulted from his ingestion of a poisonous "underground" mushroom given him by a peasant who thought it to be a delicacy.

"True to their beguiling nature, fungi have always elicited deep emotional responses: from adulation by those who understand them to outright fear by those who do not," writes fungi expert Stamets, author of *Growing Gourmet & Medicinal Mushrooms* (Ten Speed Press 1993).

Yet, elsewhere in the world, the healing powers of mushrooms have been known for more than 5,000 years. In the winter of 1991 hikers in the Italian Alps discovered the frozen remains of a man who had died some 5300 years earlier. Found among the artifacts with which he was traveling, quite apart from his knapsack and flint ax, was a string of dried mushrooms called birch polypores (*Piptoporus betulinus*) and another as yet unidentified mushroom.

"The polypores can be used as tinder for starting fires and as medicine for treating wounds," writes Stamets. "Further, a rich tea with immuno-enhancing properties can be prepared by boiling these mushrooms."

Mushrooms, the plant of immortality? That's what ancient Egyptians believed according to the Hieroglyphics of 4600 years ago. The delicious flavor of mushrooms intrigued the pharaohs of Egypt so much that they decreed that mushrooms were food for royalty and that no commoner could ever touch them. This assured themselves the entire supply of mushrooms. In various other civilizations throughout the world including Russia, China, Greece, Mexico and Latin America, mushroom rituals were practiced. Many believed that mushrooms had properties that could produce super-human strength, help in finding lost objects, and lead the soul to the realm of the gods.

Many centuries later, France became the leader in the formal cultivation of mushrooms. Some accounts say that Louis XIV was the first mushroom

grower. Around this time mushrooms were grown in special caves near Paris set aside for this unique form of agriculture.

Building on information from France, the gardeners of England found mushrooms a very easy crop to grow which required little labor, investment, and space. Mushroom cultivation began gaining popularity in England with more experimentation with spawn* and publicity in journals and magazines.

In the late 19th century, mushroom production made its way across the Atlantic to the United States where curious home gardeners in the East tried their luck at growing this new and unknown crop. However growers had to depend on spawn imported from England, which, by the time it reached the United States, was of poor quality.

In 1891, the first book on mushroom growing was published and it shed new light on the theory of cultivation. William Falconer, a mushroom grower and experimenter from Dosoris, Long Island, agreed with the recommendations of agricultural journalists and compiled their theories in *Mushrooms: How to Grow Them; A Practical Treatise on Mushroom Culture for Profit and Pleasure*.

Today mushrooms are commercially produced in virtually every state. From the caves of Paris to the dinner tables of millions of Americans, fresh mushrooms have come out of the dark and into the spotlight.

In the urban concrete "wilderness" of America, in supermarkets and health food stores, the popularity of gourmet medicinal mushrooms, although small, is growing. In the early 1990s, the United States Department of Agriculture reported exotic mushroom sales almost doubled from an excess of 4.4 million pounds to more than 8.4 million pounds annually. (Today—based on cultivation tonnage—the worldwide volume of sales of maitake mushroom alone are probably greater than the total U.S. sales volume of all exotic mushrooms reported only seven or eight years ago.)

Although gourmets exhort people to simply enjoy mushrooms' pleasurable tastes, low caloric content and the fact that they contain neither fat nor cholesterol, medical experts note that several species of these delicious edibles have been shown to have a wide range of beneficial effects on human health. Indeed, an enormous amount of research is currently being performed on several well-known medicinal mushrooms at major universities.

* *Used to grow mushrooms, spawn is essentially a mushroom "starter" culture used to inoculate the final mushroom-producing cultures.*

In the Orient, certain specific mushrooms are highly regarded as longevity herbs that preserve youth and maintain health. There are many tales of folklore and anecdotes on such mushrooms. Traditional healers in China, Japan and other parts of Asia have prized and recognized the health enhancing potential of particular mushrooms so much so they are even considered, as we mentioned, mythic foods of immortality.

Yet, the scientific study of mushrooms has only begun during the last twenty years. Researchers have found that some mushrooms are rich in minerals (such as potassium, calcium and magnesium), various vitamins (D_2, B_2, niacin and C), fibers, and amino acids. Another important ingredient especially found in the family of polyporaceae (so-called "Monkey's Bench") are polysaccharide compounds—known as beta-glucans—which exhibit strong immune support activity. In many healing traditions, maitake is the most prized member of the Monkey's Bench family.

An especially rich source of beta-glucans, maitake mushroom is indigenous to the northeastern part of Japan. For hundreds of years, indeed for some thirty centuries—some 3000 years—this rare and tasty mushroom has been prized in traditional Chinese and Japanese herbology. It has been noted by Y. Harada that maitake was sought in the forests of the Akita Prefecture in Japan "when the early Fall winds start blowing across the valleys and mountains."[2] And writer Kenneth Jones adds, "Maitake hunters jealously guarded their picking area. Generally, these pickers went out alone and hid in the solitude of their secret troves. More than 10 kg of the mushroom was considered to be a veritable 'island of treasure' and its location would be kept from everyone, including the picker's immediate family. A maitake hunter was content to take the secret of a gathering location to the grave or to whisper the secret to a son just before dying."[3] Indeed, maitake was exclusively wild harvested as recently as the mid-1980s.

Professor Takashi Mizuno, one of Japan's leading experts on medicinal mushrooms, notes that some of the earliest mentions of maitake date to the Chinese materia medica, the *Shen Nong Ben Cao Jing*, of the Han dynasty (206 BC-220 AD). In a 1995 article, Professor Mizuno said that maitake was used to improve the function of the spleen, relieve stomach ailments, treat hemorrhoids, and to provide a sense of calm.[4]

Maitake mushroom has a rippling form with no caps and grows in clusters at the foot of Japanese oak trees, giving it an image of butterflies dancing to the eyes. Based on this visual image, it may have been thus named maitake—literally "dancing mushroom."

Others say that maitake is so named because people who found it in the deep mountains knew its delicious taste and health benefits and thus began dancing with joy. In the feudal era of Japan it was exchanged with the same weight of silver by local lords who in turn offered it to the shoguns.

The botanical name of maitake is *Grifola frondosa* referring to a mythical beast that is half-lion and half-eagle. Maitake, the only edible mushroom among all the Monkey's Bench family, sometimes grows to weigh over 50 pounds. That is certainly why this giant mushroom is called the "king of mushrooms."

But it was not until the late 1980s that a significant number of scientists recognized its important medical and health benefits, and that it was much more potent than any of the mushrooms previously studied.

In recent years, maitake has quickly become perhaps the most extensively researched of all herbs and medicinal mushrooms with many research papers published by scientists and doctors at various institutes and universities, including Georgetown University Medical School (where research is being conducted by Dr. Preuss) and New York Medical College (where Dr. Konno has conducted his research). Further laboratory studies and extensive clinical studies are under way in collaboration with leading research institutes both in the United States and in Japan. Yet, long before modern medicine's discovery of the maitake mushroom, the healing power of beta-glucans was being documented.

Though mushrooms in general are not particularly known for being nutrient-dense, much more importantly, many mushrooms are being recognized for their important health benefits, and maitake is increasingly being recognized as a potent source of beta-glucan polysaccharide compounds and their dramatic health-promoting properties. That mushrooms should possess significant healing powers, of course, is nothing new to Asian healing traditions. In the Orient, several types of mushrooms have been used for centuries to maintain health, preserve youth, and increase longevity. [5]

In a 1996 article in *Nutrition Reviews*, R. Chang, of the Department of Medicine, Memorial Sloan-Kettering Cancer Center, New York, noted:

"Edible mushrooms...may have important salutary effects on health or even in treating disease. A mushroom characteristically contains many different bioactive compounds with diverse biological activity, and the content and bioactivity of these compounds depend on how the mushroom is prepared and consumed. It is estimated that approximately 50% of the annual 5 million metric tons of cultivated edible mushrooms contain functional 'nutraceutical' or medicinal properties. In order of

decreasing cultivated tonnage, Lentinus (shiitake), Pleurotus (oyster), Auricularia (mu-er), Flammulina (enokitake), Tremella (yin-er), Hericium, and Grifola (maitake) mushrooms have various degrees of immunomodulatory, lipid lowering, antitumor, and other beneficial or therapeutic health effects without any significant toxicity. Although the data for this functional food class are not as strong as those for other functional foods such as cruciferous vegetables, because of their potential usefulness in preventing or treating serious health conditions such as cancer, acquired immune deficiency syndrome (AIDS), and hypercholesterolemia, functional mushrooms deserve further serious investigation. Additionally, there is a need for epidemiological evidence of the role of this functional food class."[6]

Mark Mayell, the former editor of *Natural Health* magazine and author or co-author of five books on alternative medicine, most recently *Depression Free for Life* with Gabriel Cousens, M.D., has also taken note of the importance of maitake:

"Maitake (*Grifola frondosa*) is the Japanese name for an edible fungus with a large fruiting body characterized by overlapping caps. It is a premier culinary as well as medicinal mushroom. Maitake is increasingly being recognized as a potent source of polysaccharide compounds with dramatic health-promoting potential...[that] have shown particular promise as immunomodulating agents, and as an adjunct to cancer and HIV therapy. They may also provide some benefit in the treatment of hyperlipidemia, hypertension, and hepatitis."[7]

Maitake cultivation, in particular, is a recent development. Only within the past two decades have producers been able to switch from a reliance on foraged maitake to offering cultivated maitake. Japanese commercial cultivation, mainly for food, started in 1981 with 325 tons. It grew to 1,500 tons in 1985, 8,000 tons in 1991, and almost 10,000 tons in 1993. Commercial maitake production worldwide may now be in excess of 40,000 tons.

Within the past two decades, maitake has also begun to be cultivated for packaging as a dietary supplement that can benefit overall health. It may be the most versatile and promising medicinal mushroom supplement, though currently less well known than shiitake (*Lentinus edodes*) and reishi (*Ganoderma lucidum*). Best-selling holistic medicine author Andrew Weil, M.D., says that maitake appears to be the most effective immune-boosting mushroom of all, noting that it belongs to the polypore family of medicinal

mushrooms that, in the Far East, includes many mushrooms that "are highly esteemed as medicinal herbs, especially in the class of superior drugs, the tonics and panaceas that increase resistance and promote longevity." Such adaptogens are often taken on a daily basis to help balance bodily functions and prevent disease.

Most recently, maitake extracts have joined the elite club of mushroom-based anti-cancer drugs. In particular, Maitake D-fraction has been developed and commercialized by Maitake Products, Inc., of Ridgefield Park, New Jersey, since 1995. Maitake D-fraction, a registered trademark for the standardized extract from maitake mushroom, contains, as its active ingredient, a unique protein-bound ß-glucan (i.e., beta-glucan) complex. Importantly, this unique active compound makes it very potent in enhancing immune system function by oral administration, in contrast to many other natural immune modulators.

The professional version of Maitake D-fraction (Grifron®-Pro D-Fraction®) has been used at the Cancer Treatment Centers of America (CTCA) since 1993. At that time, Dr. Robert Atkins, known as the "pantheon" of alternative medicine in this country, began using it at the Atkins Center in New York City for the treatment of various cancer patients. When Maitake D-fraction received strong support by Dr. Weil, this product became well known among doctors in alternative medicine. Now, it is time for all health professionals—from many different areas of specialization—to learn about the important healing potential inherent in the maitake mushroom.

Certainly, our own government has recognized its healing potential. Recently, Grifron®-Pro D-Fraction® received Investigational New Drug Application approval from the Food and Drug Administration to conduct a Phase II study on its use for advanced breast and prostate cancer patients in 1998. The usually required Phase I study for toxicity was exempted due to the established safety record of maitake mushroom, as determined by studies conducted in both Japan and the United States.

Meanwhile, researchers (including co-author Konno) from the Department of Urology at New York Medical College, Valhalla, New York, have announced the discovery of apoptotic activity (programmed cell death-inducing) by Grifron®-Pro D-Fraction® on human prostatic cancer cells. This discovery, announced in late 1999 and subsequently published in the journal *Molecular Urology*, made maitake the center of keen attention by prostate cancer researchers and clinicians.[8]

Yet another research team (this one headed by co-author Preuss) has reported that another beta-glucan derived from a different fraction of maitake than the beta-glucan in D-fraction has powerful healing properties for diabetics and sufferers of Syndrome X. This powerful beta-glucan constitutes the most recent product development, the SX-Fraction, a proprietary maitake extract that has shown particular promise as an insulin/glucose-modulating agent. In the future, more beta-glucans with healthful benefits may be derived from this naturally occurring medicinal powerhouse.

CHAPTER TWO

THE MOST AMAZING
DEFENSE ARSENAL
ON EARTH

THE HUMAN IMMUNE SYSTEM IS THE MOST AMAZING defensive arsenal on earth. The immune system has four recognized essential duties: first, it must recognize alien substances such as bacteria, viruses, parasites and chemical toxins as distinguished from self (native cells); second, it must react in a specific manner to each invading pathogen or toxin; third, once the immune system has encountered a specific invader, it must remember the alien substance to quickly counter future invasions; finally, once an immune invader has been subdued, the immune system must become relatively quiescent as it awaits new threats.

The multifaceted immune system is comprised of more than a trillion cells with a collective weight of about one kilogram (2.2 pounds). Within the immune system there are two separate general responses to abnormal or foreign substances:

- The first response involves the production of *immunoglobulins*, protein-based substances in our blood that are often referred to as "antibodies." Activation of immunoglobulins is termed *a humoral immune reaction*. Such a response is targeted against foreign organisms such as bacteria or viruses.
- The second response is the *cellular immune response*, or *cell-mediated immunity*. As its name implies, this response depends on interactions between various types of immune system cells called lymphocytes. This cell-mediated immune response is directed mainly against body cells that become cancerous or are infected with a pathogen—be it a virus, bacteria, fungus or parasite.

Our body's immune cells respond to what are called *antigens*—substances such as enzymes or proteins that are foreign to healthy tissue and that stimu-

late the immune system to go into action. It is estimated that the human body can react to over 100 million different antigens. However, many infectious agents mutate readily, thereby presenting a different appearance to the immune system. This is the reason that we are repeatedly susceptible to viral infections such as colds and flu. Some parasites, such as the one that causes malaria, also rapidly mutate (change) in order to evade the body's immune defenses. This is the reason for the cyclical flare-ups experienced by malaria victims. Bacteria such as staphylococcus and mycobacterium mutate in such a manner that they become antibiotic resistant. Health experts recognize this is an emerging health problem throughout the world. Each mutation that alters the appearance of the virus, bacterium or parasite must be dealt with by a separate immune response. Yet, amazingly, most of the time, our immune system is able to quickly adapt and subdue life-threatening pathogens.

A balanced and healthy immune system is central to the body's ability to defend against all types of infections and even chemical toxins; anything we can do to strengthen our immune system will help to assure our well being and longevity.

Richard Bennet, Ph.D., an infectious disease immunologist, has said:

"It's in our ability to create a really healthy immune system that I think represents the greatest potential in gains in human health in the world. If we can do something to make us all just a little bit more healthy, there's going to be less disease and less suffering."

Today, however, many factors contribute to the general weakening of the body's defenses. It is worth emphasizing that current research suggests that antibiotics—commonly viewed as the most important advance in the history of medicine—have begun to fail as the resistance of many infectious strains multiplies. In fact, we now recognize that our antibiotics are being squandered from overuse among humans and because altogether too often ranchers dose their livestock with subtherapeutic amounts of antibiotics to

Did You Know?
MOST ANTIBIOTICS NOW USED FOR LIVESTOCK

The Union of Concerned Scientists reports that some 70 percent of all antibiotics made in the United States are used to fatten up livestock. Such uses may contribute to super bugs—strains of antibiotic-resistant bacteria.

hasten growth. This has resulted in creation of super-resistant bugs such as salmonella and *E. coli* that are resistant to the very antibiotics that once so quickly subdued them when people got sick.

Disease now spreads more easily than ever before due to the failure of government control of health codes, deterioration of water quality, and frequent international travel.

A time bomb lurks. Because of international travel, diseases once confined to other territories can be easily transmitted to persons in industrialized nations.

For some time during the heyday of the sixties and seventies we might have thought that we had somehow gained the upper hand against the scourge of age-old infectious diseases. We haven't. Ancient diseases caused by bacterial and viral toxins as well as parasites continue to account for half of all deaths worldwide.

Indeed, a forecast by researchers at UC San Francisco predicts that by 2070, the world will have exhausted all antimicrobial drug options, as the viruses, bacteria, parasites and fungi evolve complete resistance to the human pharmaceutic arsenal. It is a vision that remarkably is shared by many of the world's top microbiologist and infectious diseases experts.[9] We may be able to come up with new drugs, but we are all vulnerable. Fortunately, recent research has uncovered natural immune-boosting agents that can potentially save lives and increase the quality of life for many people. Unfortunately, the race between new drug development and emerging resistant strains of pathogens may be won by the latter. As most competitors would say, "I want the edge in the battle." Maitake mushroom provides you with that "edge."

Determine Your Immune Function

1 Do you catch colds easily?
2 Do you get more than two colds a year?
3 Are you suffering from a chronic infection or abnormal immune cell counts?
4 Do you get frequent cold sores or have genital herpes?
5 Are your lymph glands sore and swollen at times?
6 Do you have now or have you ever had cancer?

If you answered yes to any of these questions, your immune system may benefit from maitake mushroom.

THE MIGHTY MACROPHAGE

Our white blood cells are our body's major defense against both infection and cancer. The white blood cells play key roles in both humoral and cell-mediated immunity. The immune system is comprised of many types of white blood cells, each with relatively specific immune functions (see also our Glossary). Neutrophils are a commonly type of white blood cell that engulf and kill bacteria and errant cancerous cells. Lymphocytes include T-cells, B-cells and natural killer cells. The B-cells produce antibodies that rush to destroy foreign invaders such as viruses, bacteria, and cancer cells. The T-cells produce interferon and interleukin, essential immune chemicals that ward off infections and cancer. The T-cells also help to down-regulate our immune system once the threat has been subdued. Natural killer cells destroy tumor cells and pathogen-infected cells. But one immune cell in particular—the macrophage—is the key to overall immune vitality.

The body's mighty macrophages, which are immune system cells found virtually everywhere in the body including even in brain tissue, are its first line of defense. As mentioned, you'll find these fundamental defenders in all body tissues—and particularly in your lungs, lymph system, even in the liver (where they are called Kupffer cells) and skin (where they are known as Langerhans' cells). Macrophages develop from bone marrow precursors known as monocytes that mature and enter the bloodstream and are then recruited into different tissues where they differentiate into resident macrophages. They perform many important functions, specific to their host tissues.

Macrophages engulf foreign cells and particles and pathogenic bacteria, release intracellular hormones called cytokines (messenger proteins) that aid cell-cell communications between B- and T-cells, and they transport a wide range of pathogens and diseased tissues to the lymph system to help to purify bodily tissues.

As sentinels of disease, macrophages can even present processed foreign antigens to already primed T-cells, allowing the enhancement or inhibition of a specific immune response. This then initiates, or brings to an end, an entire immune cascade whose one mission is (or was) to neutralize the looming threat. Once successfully neutralized, macrophages help to transport the remaining debris to the lymph system for elimination.

The mighty macrophage is your body's first-line of defense against illness. Macrophages are part of our nonspecific immunity. That means they are effective against many different types of health threats, including bacte-

ria, viruses, mold, and fungi, and even malignant cells.

From the evolutionary viewpoint, this ancient white blood cell is perhaps the oldest component of immunity, being common to not only higher animal life but also even much more simple and ancient organisms, such as the hydra (a small tubular freshwater microorganism, known as a polyp, having at one end a mouth surrounded by tentacles).

The word *macrophage* itself is derived from the Greek and literally means "big eater."

Although minute to us, the macrophage is a living giant in the microscopic cellular world. Even its name ought to intimidate the bad guys—pathogenic bacteria, virus, parasites, and fungi. Macro, of course, tells us this is one big bruising cell—and *phage* means it eats; it devours bad guys—seeks and destroys them.

Macrophages are hunters. They're the predators of our bodily seas. "Think of a giant octopus when you try to visualize the activated macrophage," notes one health expert. "Be it an errant cancerous cell or an invasive microbe, you can be sure that the macrophage will devour it. They'll even signal for additional bone marrow production of more immune cells and for other immune cells to start an attack or to quiet the attack once the invader has been vanquished."

The macrophage is known to secrete some 100 different substances, such as cytokines (signaling molecules to orchestrate the immune response); a wide range of inflammatory mediators that play a central role in acute and chronic inflammation; as well as proteases (protein breakdown agents); and growth factors (to direct and stimulate tissue renewal and repair), which are important in tissue remodeling and wound repair after injury.

Did You Know?
IMMUNITY & THE BRAIN

Only recently, researchers have discovered that the macrophage is quite a communicator. In fact, the same receptor sites on macrophages are also found in the human brain. Researchers believe this indicates that the brain and immune system are by no means distinct entities, operating separately, but, rather, that brain function and immunity are closely intertwined and both organ systems engage in what we might term "cross-talk."

In particular, cytokines are small proteins that allow cells of the immune system to communicate with one another via cytokine receptors expressed at the cell surface. Many cytokines are initially given descriptive names but, as their basic structure is identified, they are renamed as interleukins—messengers between various leukocytes or immune cells.

Among the cytokines macrophages secrete under different pathophysiological immune conditions and when stimulated or "primed" by the maitake mushroom are the following:

- *Tumor necrosis factor.* Tumor necrosis factor is made by many other cells besides macrophages, which are major sources. Certainly, maitake primes its release in the presence of certain ubiquitous endotoxins or lipopolysaccharides (a molecule composed of a lipid [an oil] with a polysaccharide [a complex sugar] usually produced by gram-negative bacteria), as shown by researchers from the Tokyo College of Pharmacy, Japan.[10] Tumor necrosis factor is an anti-angiogenic agent that prevents tumors from developing blood vessels for nourishing its growth. TNFα (TNF-alpha) specifically initiates a cascade of cytokines that mediate the body's inflammatory response. It also regulates the expression of many genes in many cell types important for the host response to infection. Tumor necrosis factor also inhibits propagation and population growth of parasites and viruses.

- *Interleukin-1β (IL-1β).* A pro-inflammatory cytokine, IL-1β is secreted by macrophages activated by a number of stimuli including TNFα and bacterial endotoxins.

- *Interferon alpha/beta.* Macrophages, and many other cells produce interferons, which help to "interfere" with growth of diseased cells. Interferons were among the first cytokines to be discovered. Produced by T cells and macrophages (as well as by cells outside the immune system), interferons are a family of proteins with antiviral properties. Interferon from immune cells, known as immune interferon or gamma interferon, activates macrophages.

- *Interleukin-6 (IL-6).* A pro-inflammatory cytokine, interleukin-6 is produced in response to infection and tissue injury. It stimulates liver secretion of acute phase proteins; stimulates B-cells to produce antibodies; and causes T-cell activation

- *Interleukin-10 (IL-10).* An immunoregulatory cytokine, IL-10 can exert a wide range of different effects on different cell types, down-regulating inflammatory processes.

- **Interleukin-12 (IL-12).** Not only does IL-12 stimulate the response of activated natural killer (NK) cells, types of T- cells that attack cancerous or diseased cells, it also suppresses production of some interleukins.

Unfortunately for our health, despite its many capabilities, even immune superheroes like our macrophages can be caught "sleeping." As an example, take the common flu viruses. These deceptive pathogens, so small and lacking cell walls, often slip past sleeping macrophages that are supposed to be guarding your health. The macrophage isn't literally sleeping. Rather, it is *non-activated*. Some viruses may even infect the macrophages themselves, reducing their ability to defend. When enough viruses have replicated themselves, the body is overwhelmed. The result may be a cold or flu or much more serious illness such as pneumonia. Even many parasitical infections result when our macrophages are non-activated.

Unfortunately, many common illnesses cause depressed immune function and less-than-optimal macrophage responses. These include cancer, diabetes, HIV/AIDS, and Epstein-Barr. Exposures to toxic environmental chemicals, poor diet, sedentary lifestyle, and obesity can also bring about difference in immune response and add to the disease-produced insensitivities.

Enter maitake mushroom's beta-glucans.

THE MAITAKE GLUCAN FACTOR

Did you know that certain yeasts and fungi produce substances that can boost your immune system? Beta-glucan (also known as β-1,3/1,6-D-glucan or beta-1,3/1,6-glucan) is a non-digestible polysaccharide (long chain carbohydrate) found in the cell walls of these organisms. As with any glucan (or polyglucose), β-1,3/1,6-D-glucan consists of glucose units linked together. Unlike table sugar, however, beta-glucans are far more complex structures, consisting essentially of repeating structural units.

One author has noted that healing sugars may sound like a contradiction in terms, but we are describing specific sugar substances—the "good guys." The discovery of beta-glucans, which are a type of healing, immune-activating sugar, must be considered one of the most important immune-health breakthroughs in recent medical science history.

We've all been bombarded with warnings about the evils of consuming too much sugar. These warnings should not spill over to beta-glucans. In fact, for our bodies to function properly, we need small amounts of beta-glu-

can intake, because these are no longer abundantly in the average, variety-limited and overly processed diet.

When beta-glucan is consumed in just the right amount, the immune health benefits can be breathtaking. As researchers and health professionals, our own patients who use maitake mushroom have shown us that most individuals regain their potential to fight disease, reactivate their immune systems, and are able to ward off infection.

Based on cutting-edge research in the rapidly evolving science of glucans, we now recognize that their ingestion involves an exciting new approach to health and disease prevention.

As medical doctors and scientific researchers, we must explain that these essential sugars are not the same as common confectioner's sugar found in baked goods and candies. These essential sugars are known as polysaccharides, or complex sugars, and they are the basis of multicellular immune intelligence—the ability of immune cells to communicate, cohere, and work together to keep us healthy and balanced.

Even tiny amounts of these sugars—or lack of them—have profound effects. In test after test conducted at leading institutes around the world, beta-glucans have been shown to dock onto receptors on the outer cell walls of macrophages to activate them and affect cytokine production, so that they can aid us in our fight against cancer and infectious disease.

Bacterial infections can respond remarkably to polysaccharides, as do many viral infections—from the common cold and flu to herpes and HIV. Beta-glucans even often mitigate the toxic effects of radiation and chemotherapy—while augmenting their cancer-killing effects, resulting in the possibility for prolonged survival and improved quality of life for cancer patients.

Dietary supplementation with beta-glucans offers a revolutionary new health approach that is on the cutting edge of health care.

Whether your goal is to prevent disease, live longer and better, or treat a serious illness that has eluded conventional medicine, beta-glucans are essential to health.

As simple as they are structurally, many beta-glucans are powerful immune support agents. Perhaps the primitive simplicity is part of their functional beauty. Macrophages contain specific protein-based receptor complexes on their cell walls to which the β-1,3/1,6-D-glucan molecule readily binds. The binding of β-1,3/1,6-D-glucan activates macrophages and enhances their ability to detect and scavenge health threats. It may be truly stated that the body's macrophages and beta-glucan were meant for

FYI:
New Receptor Discovered for Beta-glucans

We now know that beta-glucans exert potent effects on the immune system—stimulating antitumor and antimicrobial activity—by binding to receptors on macrophages and other white blood cells and activating them. In the past, it was thought that beta-glucans docked onto a group of receptors known as complement receptor 3. Most recently, however, scientists have discovered that another beta-glucan receptor is present on macrophages.[11] This receptor is known as dectin-1, a finding that provides new insights into the innate immune recognition of beta-glucans.

each other. Once, beta glucan docks there, it activates these powerful defenders. It wakes them up.

When the body's macrophages are functioning optimally, they are able to initiate powerful immune forces that can help to destroy tumor cells and ward off other opportunistic organisms that pose risk of secondary infections during cancer therapeutics.

These naturally occurring complex sugars (polysaccharides) have been called a "potent stimulator of macrophage functions" with a "protective effect against a range of infections in rodent models," note researchers from the Institute of Immunology and Rheumatology, The National Hospital, Oslo, Norway. More recent research, conducted by co-author Konno, shows us that maitake's beta-glucans directly destroy certainly cancer cells by interacting with their genetic materials and inducing cellular death in a process known to science as apoptosis (see Chapter Six).

The fact that such a small number of glucose units can activate these receptors is "very remarkable," notes clinician Donald J. Carrow, M.D. What is more remarkable still is that there should be such specific receptors on the surface of the most ancient cell in the immune cascade. "There is now evidence to show that β-1,3-glucan is, from an evolutionary point of view, the most widely and most commonly observed macrophage activator in nature," says Dr. Carrow.

By taking beta-glucan orally, consumers receive a wide range of immune and other related health benefits. These broad-spectrum effects make beta-glucan incredibly important to health and well-being. From their actions, it

is postulated that they may be especially indicated for prevention of cancer, as well as diseases emanating from biological pathogens. More recently, our own research has shown that variations of the basic beta-glucan molecule are incredibly important in enhancing the healing response among persons suffering diabetes and Syndrome X-related complications.

Thus, this is one supplement that should be in virtually all health programs. As health reporter Donald Bodenbach notes, beta-glucans represent "a significant breakthrough in nutritional supplementation." He adds that although they safe, non-toxic compounds, without side effects, "there are no natural compounds or pharmacological drugs that can match [their] remarkable properties."

But why do we recommend beta-glucan and, more to the point, beta-glucans derived from maitake mushroom so highly? To be sure, many biological response modifiers stimulate nonspecific immunity. Among these are

FYI:
Beta-glucan History—A Brief Chronology

As early as the 1940s, Dr. Louis Pillemer and colleagues noted that a crude yeast cell wall preparation (Zymosan) was able to stimulate nonspecific immune function. In the 1960s, Dr. Nicholas Di Luzio of Tulane University isolated β-1,3/1,6-D-glucan, which he reported as the agent responsible for this immune activation.[12]

In 1985, Dr. Joyce Czop at Harvard University discovered specific β-1,3/1,6-D-glucan receptors on the surface of macrophages that, when activated, stimulated a cascade of events that turned the immune system into what she termed "an arsenal of defense."[13]

In a 1989 report, researchers observed. "The beta-glucan receptors provide a mechanism by which a heightened state of host responsiveness is initiated."[14]

Meanwhile, also in 1989, research conducted at Baylor College of Medicine demonstrated that orally administered beta-1,3-D-glucan is highly effective.[15]

By the early 1990s, various type of beta-glucan supplements reached the marketplace as nutritional supplements. One such supplement is maitake mushroom.

various synthetic and biological agents, each with completely different chemical structures. Herbs such as astragalus, echinacea and others have been documented to have a nonspecific immunomodulatory effect.

While we will engage in a more in-depth discussion of this issue in Chapter Eleven, one of the reasons we recommend maitake's beta-glucans as an extraordinary immune support supplement is that maitake mushroom's powers are well supported by scientific studies, especially when it comes to protection against both chemical toxins and biological pathogens, as well as radiation, and many of the most deadly diseases of aging. Plus, maitake mushroom is safe to take on a daily basis. It is simply a whole food concentrate and thus augments our nutritional requirements with the type of complex sugars that have been missing from our diet due to the overly processed fare most of us con-

What Leading Scientists Have to Say about Beta-Glucans...

"Beta-1,3/1,6-glucan is a potent macrophage stimulant and is beneficial in the therapy of experimental bacterial, viral, and fungal diseases."
—*William Browder, M.D., Department of Surgery and Physiology, Tulane University School of Medicine*

"A cascade of interactions and reactions initiated by macrophage regulatory factors can be envisioned to occur and to eventuate in conversion of the glucan treated host to an arsenal of defense."
—*Joyce K. Czop, Ph.D., Department of Rheumatology and Immunology, Harvard Medical School*

"Glucan (beta-1,3) has been shown to enhance macrophage function dramatically, and to increase nonspecific host resistance to a variety of bacterial, viral, fungal, and parasitic infections."
—*M.L. Patchen, Ph.D., Department of Experimental Hematology and Radiation Sciences, Armed Forces Radiobiology Research Institute*

"Because it significantly reduced the size of mammary tumors in mice, Maitake D-fraction is now being used in clinical trials of women with breast cancer. The first studies, which had promising results, were not from randomized controlled trials. One such study reported significant improvement of symptoms and/or tumor in 11 out of 15 breast cancer patients who had standard chemotherapy and Maitake D-fraction."
—*Susan Love, M.D.*

continued on next page

sume on a daily basis.

Most of the medicinal mushrooms such as reishi, shiitake, cordyceps and maitake show a common property of enhancing immune function by stimulating cell-mediated immunity. Quite simply, mushrooms seem to turn on cells in the immune system, including macrophages and T-cells, which appear to have significant cancer- and infection-fighting properties. Yet, while many fungi can be used as a source of beta-glucans, maitake is substantially differentiated from the others in that maitake's beta-glucans appear to be most effective and to retain their efficacy when taken orally, and, of course, they are completely safe. Lentinan, for example, which is derived from shiitake, must be administered intravenously to be most effective.

Dr. Weil, a strong believer in the usefulness of mushrooms to our every

What Leading Scientists Have to Say about Beta-Glucans...*continued*

"In a prospective, randomized double-blind study... the perioperative administration of [beta-glucan]... increases the microbial killing activity of leukocytes, can decrease infectious complications in patients undergoing major surgical procedures... the preliminary results are positive and should be interpreted as good news."
—*J.A. Norton, professor of surgery, chief of Endocrine and Oncologic Surgery, Washington University School of Medicine*

"When water-soluble aminated beta 1,-D-glucan (AG) was injected intravenously or intraperitoneally on day 7 of tumor growth, the tumors underwent complete regression."
—*Seljelid, R. "A water-soluble aminated beta 1-3-D-glucan derivative causes regression of solid tumors in mice." Biosci Rep, 1986; 6(9):845-851*

"In certain controlled clinical trials, the increased survival of patients receiving these immunostimulatory beta-glucans has been reported."
—*Todd, R.F. "The continuing saga of complement receptor type 3 (CR3)." J Clin Invest, 1996;98:1-2*

"Soluble glucan, a beta-1,3-linked glucopyranose biological response modifier, is effective in the therapy of experimental neoplasia, infectious diseases and immune suppression."
—*Williams, D.L., et al. "Pre-clinical safety evaluation of soluble glucan." Int J Immunopharm, 1988;10(4):405-414*

continued on next page

health, observes, "Research on the therapeutic properties of maitake is bet-ter and more extensive than that on other [mushroom] species." In *Eight Weeks to Optimum Health,* he expands on his initial observations and offers his own personal preference: "My tonic of choice at the moment is an extract called Maitake D-fraction, which concentrates the immune-boosting con-stituents...and since I've been [using it] I almost never get colds."

What we know about beta-glucan from maitake mushroom is that it is one of the most effective, can be taken orally, and is completely safe. Plus, the crude maitake powder caplets offer many additional health benefits to consumers, including blood sugar control, lowering cholesterol and high blood pressure, even aiding weight loss. This is due to the crude powder's

What Leading Scientists Have to Say about Beta-Glucans...*continued*

"Thus glucan is capable of increasing survival, inhibiting hepatic necrosis, and maintaining an activated state of phagocytic activity in mice challenged with [mouse hepatitis virus strain] MHV-A59."
—*Williams, D.L. & Di Luzio, N.R. "Glucan-induced modification of murine viral hepatitis."* Science, *1980;208:67-69*

"Beta-glucans are pharmacologic agents that rapidly enhance the host resistance to a variety of biologic insults through mechanisms involving macrophage activation."
—*Abel, G. & Czop, J.K. "Activation of human monocyte GM-CSF and TNF-alpha. Production by particulate yeast glucan." International Congress for Infectious Diseases, Montreal, Canada (abstract), 1990*

"Animal studies indicate that beta-glucans with 1,3-and/or 1,6-linkages are active pharmacologic agents that rapidly confer protection to a normal host against a variety of biological insults. The beta-glucan receptors provide a mechanism by which a heightened state of host responsiveness is initiated."
—*Czop, J.K., et al. "Phagocytosis of particulate activators of the human alternative complement pathway through monocyte beta-glucan receptors." Prog Clin Biol Res, 1989;297:287-296*

"The broad spectrum of immunopharmacological activities of glucan includes not only the modification of certain bacterial, fungal, viral and parasitic infections, but also inhibition of tumor growth."
—*Di Luzio, N.R. "Immunopharmacology of glucan: a broad spectrum enhancer of host defense mechanisms." Trends in Pharmacol, 1983; 4:344-347*

complex mixture of beta-glucans, many of which have yet to be character-ized or completely identified. In this case, the fact that we have the crude powder extract available is a good thing. If this were highly purified almost to the point of being a synthetic chemical, much like a medical drug, its ben-efits would be limited.

Today, thousands of studies have been conducted on various beta-glu-cans. Beta-glucans are classified by scientists as semi-essential non-vitamin factors and are believed to protect against certain diseases. Beta-glucans are found in other superfoods, including oats, nutritional yeast and other med-

"Because it significantly reduced the size of mammary tumors in mice, Maitake D-fraction is now being used in clinical trials of women with breast cancer...One such study reported significant improvement of symp-toms and/or tumor in 11 out of 15 breast cancer patients who had standard chemotherapy and Maitake D-fraction."
—Susan Love, M.D.

icinal mushrooms. But the chemical structures of maitake's beta-glucans, known more commonly as the D- and SX-fractions, are unique. This is due to their greater degree of molecular branching, which promotes even greater immune cell activation. Research on the beta-glucans in maitake have demonstrated its effects on not only macrophages but also natural killer cells and various T cells and demonstrates one of the highest cancer inhibi-tion rates with oral administration of any source of beta-glucan.

Thousands of cancer and infectious-disease patients have benefited from the use of beta-glucans. However, the beta-glucans found in maitake mush-room have far more health benefits than simply fighting cancer. More recent research demonstrates that beta-glucans also enhance the body's ability to reduce cholesterol, balance blood sugar levels and increase insulin sensitiv-ity. Their ability to support overall immune function ranks as an important contribution to health and well being.

CHAPTER THREE

MAITAKE &
SUPER IMMUNITY

IMMUNITY IS ONE OF THE HOTTEST TOPICS on health-conscious people's minds today. No wonder. We've all heard the reports. Hanta virus in the American southwest can be transmitted from rat feces. The plague is alive and well in India. The images of persons afflicted with Ebola and leaking blood from every orifice are horrifying to us—even as we sit in the comfort of our living rooms. The cocoon of protection we once felt from living in the most advanced industrialized nations on earth is no longer, thanks to relatively unrestricted air travel, international trade, and bioterrorism.

Supergerms. Many of us—including our own primary care physicians—have been so obsessed with heart disease and cancer that we have neglected doing the necessary things to support healthy immunity. Yet, the fact is that infectious diseases are the third leading cause of death in the United States. Even diseases we don't think of as infectious in origin actually often are the result of viruses or bacteria. Cirrhosis, hardening of the liver, is more often caused by infections than alcohol consumption. Heart disease is now linked with infectious agents. Moreover, low-grade infections such as colds and flu also weaken the body's resistance against heart disease and cancer. Lester Packer, Ph.D., and Bruce Ames, Ph.D., of the University of California at Berkeley, now believe that about a third of all cancers are actually caused by infections leading to chronic inflammation.

Many informed health professionals refer to maitake as "the king of immune-enhancing mushrooms" and maitake has enjoyed positive results in hundreds of published and non-published studies and clinical case reports on its effects on cancer, diabetes, Syndrome X, HIV, and general

immune strength. It can help us to fortify our bodily defenses against disease-causing pathogens and even chemical toxins.

Beta-glucans, like those found in maitake, have been studied more than thirty years as a supplement to improve immune function. We should not be surprised by the health benefits to be derived from maitake mushroom. During the past 50 years, many major advancements in medicine came from lower organisms such as molds, yeast, and fungi. Penicillin, derived from a mold (*Penicillum notatum*), was hailed as a wonder drug for communicable diseases. We have also seen a rapid pace of advancement in organ transplant due to cyclosporin, a billion-dollar drug derived from a fungus that uses insects as its host. In contrast to maitake, cylcosporin suppresses the immune system of transplant patients, lowering tissue rejection rates. Many transplant operations that were not possible due to tissue rejection have become commonplace today. The isolated compounds from three mushrooms alone—*Coriolus versicolor*, *Lentinula edodes*, and *Schizophyllum commune*—are used as adjuncts to chemotherapy drugs in Japan with an annual aggregate sales of over one-billion U.S. dollars. Like maitake, these compounds are capable of elevating the immune systems of patients undergoing chemotherapy.

HOW MAITAKE SUPPORTS IMMUNE HEALTH

"The most fascinating aspect of the medicinal mushrooms is immunomodulation—enhancing the function and activity of the body's immune system," says Dr. Weil.

When the immune system is functioning optimally, people are less vulnerable to a wide range of infectious and environmentally caused maladies—including all too common occurrences of colds, influenza, and cancer.

Just how mushrooms help stimulate the body's immune system is a matter of controversy. Most experts agree that a key to their immune stimulating properties is their content of polysaccharides—beta-glucans—that in experimental and clinical studies have shown potential for boosting immunity and preventing cancer.

"Although clinical research shows that they are orally active, one of the controversies in any kind of mushroom therapy is that we ultimately break them down into simple monosaccharides (simple sugars) in the digestive process," says herbal expert Rob McCaleb, founder and president of the Herb Research Foundation (HRF) in Boulder, Colorado, an internationally

recognized research and education organization. "There is no accepted explanation why they remain active orally."

Although some scientists have discounted the ability of such complex and large compounds to enhance immune function, research reported at the Fifth International Mycological Congress on August 16, 1994, in Vancouver, British Columbia, shows that low molecular weight polysaccharides (fractions of these larger polysaccharides and polymers broken down during digestion) can be introduced directly into immune cells, specifically lymphocytes, and that they, indeed, have demonstrated enhanced immune response.[16]

Remarkable Ability of Mushrooms to Prosper and Protect

Many of the compounds found in medicinal mushrooms are classified as host defense potentiators (HDP). These compounds include polysaccharides, polysaccharide-peptides, nucleosides, triterpeniods, complex starches, and other related substances.

By looking at the life cycle of mushrooms, the logic of HDP effects is revealed, observes an expert who notes that mushrooms sit close to the lowest rung in the ecosystem, thriving on decaying materials in a very hostile environment. "During this vegetative, or the mycelial, stage in the mushroom lifecycle, digestive enzymes are excreted to digest food outside the cells. Since the mushroom needs to absorb the digested food, it must first deactivate any natural pathogens. It does by utilizing its unique polysaccharides. Mushrooms are also very proficient at expelling undesirable chemicals and contaminants that are absorbed during ingestion. Therefore, in order for a mushroom to endure and thrive, its very existence depends on its biologically unique, aggressive and proactive immune system." When we ingest certain mushrooms, these beneficial immune properties are conferred upon our own body.

If we can minimize the frequency and severity of illnesses, and recover quickly, we are more likely to enjoy a better quality of life.

CAN YOU BENEFIT FROM MAITAKE MUSHROOM?

Have you ever suffered from any of the conditions listed below?
Do you participate in activities known to suppress immune function?
If so, maitake mushroom may be an important health aid.

Conditions Associated with Poor Immune Health

Advanced age and aging	Herpes simplex
Alcoholism	HIV/AIDS
Allergies	Insomnia
Cancer	Nutritional deficiencies
Candidiasis	Occupational exposures to toxic
Chronic fatigue syndrome	chemicals
Chronic Infection	Pesticide exposures
Colds and Flu	Pneumonia
Cytomegalovirus	Radiation exposures
Dental disease	Sports activities
Diabetes	Stress
Drug Addiction	Surgery
Epstein-Barr virus	Trauma

CHAPTER FOUR

Maitake & Optimal Immune Function

NO MATTER WHETHER AN INFECTION IS BACTERIAL, viral, fungal, or parasitical—maitake's beta-glucans powerfully activate the immune system and enhance the body's healing response. Beta-glucans impact a type of non-specific or generalized immune enhancement by supporting the most fundamental aspect of immune function—the primitive, yet all-powerful, macrophage. Indeed, beta-glucans appear to be essential to optimal immune function for virtually all life forms. They are especially helpful against viral infections.

MAITAKE AND VIRUSES

In 1898, Friedrich Loeffler and Paul Frosch found evidence that the cause of foot-and-mouth disease in livestock was an infectious particle smaller than any bacteria. This was the first clue to the nature of viruses, genetic entities that lie somewhere in the gray area between living and non-living states.

Viruses depend on the host cells that they infect to reproduce. When found outside of host cells, viruses exist as a protein coat or capsid, sometimes enclosed within a membrane. The capsid encloses either DNA or RNA, which code for the virus elements. While in this form outside the cell, the virus is metabolically inert.

When it comes into contact with a host cell, a virus can insert its genetic material into its host, literally taking over the host's functions. An infected cell produces more viral protein and genetic material instead of its usual products. Some viruses may remain dormant inside host cells for long peri-

ods, causing no obvious change in their host cells (a stage known as the lysogenic phase). But when a dormant virus is stimulated, it enters the lytic phase: new viruses are formed, self-assemble, and burst out of the host cell, killing the cell and going on to infect other cells.

Viruses cause a number of diseases. In humans, smallpox, the common cold, chickenpox, influenza, shingles, herpes, polio, rabies, Ebola, hanta fever, and AIDS are examples of viral diseases. Even some types of cancer—although definitely not all—have been linked to viruses.

Viruses themselves have no fossil record, but it is quite possible that they have left traces in the history of life. It has been hypothesized that viruses may be responsible for some of the extinctions seen in the fossil record. It was once thought by some that outbreaks of viral disease might have been responsible for mass extinctions, such as the extinction of the dinosaurs and other life forms. This theory is hard to test but seems unlikely, since a given virus can typically cause disease only in one species or in a group of related species. Even a hypothetical virus that could infect and kill all dinosaurs, 65 million years ago, could not have infected the ammonites or foraminifera that also went extinct at the same time.

On the other hand, because viruses can transfer genetic material between different host species, they are extensively used in genetic engineering. Viruses also carry out natural genetic engineering: a virus may incorporate some genetic material from its host as it is replicating, and transfer this genetic information to a new host, even to a host unrelated to the previous host. This is known as transduction, and in some cases it may serve as a means of evolutionary change.

Let's look at how maitake can help to enhance the body's resistance to, and recovery from, virally induced illnesses.

HIV/AIDS

Worldwide, at the end of 2001, an estimated 40 million people—37.2 million adults and 2.7 million children younger than 15 years—were living with HIV/AIDS, notes the National Institutes of Health. More than 70 percent of these people (28.1 million) live in Sub-Saharan Africa; another 15 percent (6.1 million) live in South and Southeast Asia.

Worldwide, approximately one in every 100 adults aged 15 to 49 is HIV-infected. In Sub-Saharan Africa, about 8.4 percent of all adults in this age group are HIV-infected. In 16 African countries, the prevalence of HIV infection among adults aged 15 to 49 exceeds 10 percent.

Approximately 48 percent of adults living with HIV/AIDS worldwide are women.

An estimated five-million new HIV infections occurred worldwide during 2001; that is, about 14,000 infections each day. More than 95 percent of these new infections occurred in developing countries.

In 2001, approximately 6,000 young people aged 15 to 24 became infected with HIV every day—that is, one person about five every minutes.

In 2001 alone, HIV/AIDS-associated illnesses caused the deaths of approximately three-million people worldwide, including an estimated 580,000 children younger than 15 years.

Worldwide, more than 80 percent of all adult HIV infections have resulted from heterosexual intercourse.

In the United States, the Centers for Disease Control and Prevention (CDC) estimates that 800,000 to 900,000 U.S. residents are living with HIV infection, one-third of whom are unaware of their infection. Approximately 40,000 new HIV infections occur each year in the United States, about 70 percent among men and 30 percent among women. Of these newly infected people, half are younger than 25 years of age.

Of new infections among men in the United States, CDC estimates that approximately 60 percent of men were infected through homosexual sex, 25 percent through injection drug use, and 15 percent through heterosexual sex. Of newly infected men, approximately 50 percent are black, 30 percent are white, 20 percent are Hispanic, and a small percentage are members of other racial/ethnic groups. Of new infections among women in the United States, CDC estimates that approximately 75 percent of women were infected through heterosexual sex and 25 percent through injection drug use. Of newly infected women, approximately 64 percent are black, 18 percent are white, 18 percent are Hispanic, and a small percentage are members of other racial/ethnic groups. In the United States, 774,467 cases of AIDS had been reported to the CDC through December 31, 2000. The estimated number of new adult/adolescent AIDS cases diagnosed in the United States was 49,691 in 1997, 42,955 in 1998, and 41,680 in 1999. In 2000, 41,960 new cases of AIDS in adults/adolescents were reported in the United States.

Maitake should be recognized as a potential therapeutic adjunct for persons with HIV/AIDS. In a January 17, 1992 report on an *in vitro* study conducted for possible anti-HIV drugs, the National Cancer Institute noted that Maitake D-fraction was effective against HIV.[17] The NCI results demonstrat-

ed that D-fraction can prevent HIV-infected helper T-cells from being destroyed by as much as 97 percent *in vitro*. This is very important because measuring a patient's helper T-cell count is considered as a benchmark in monitoring the progression of HIV to full-blown AIDS. Japan's National Institute of Health had announced similar conclusions one year earlier.

According to authors Lieberman and Babal:

"The researchers at NCI admitted that the maitake extract is as powerful as AZT (a commonly prescribed drug for AIDS, and the only FDA-approved drug at the time) but without the toxic side effects associated with AZT. These prestigious research institutes confirmed in test-tube experiments that D-fraction enhances the activity of other immune cells as well as T lymphocytes. Since then, a number of practitioners involved in AIDS/HIV treatment have reported favorable responses in patients, including increases in helper T-cells and reversal of HIV-positive status to HIV-negative. This feedback supports what the studies show. Some physicians are also applying D-fraction extract topically as a treatment for Kaposi's sarcoma, a skin cancer which often develops in AIDS patients."[18]

Two doctors, whose work with maitake has been most often cited, are well known for their successes with HIV/AIDS patients: physician and health freedom activist Dr. Joan Priestley (Omni Medical Center, Anchorage, Alaska) and Dr. David Hughes (Hyperbaric Oxygen Institute, San Bernardino, California).

Dr. Priestley has found considerable improvement in her HIV/AIDS patients who are taking maitake. She has found that her patients' T-lymphocyte cell counts have stabilized or increased over the course of treatment. She has also found D-fraction to be a more effective treatment than maitake tablets alone. "I have used maitake products on my patients for some time now and have been very impressed with the results," says Dr. Priestley. "Topical application produced good regression of Kaposi's sarcoma lesions in one AIDS patient, which I consider a major accomplishment." Kaposi's sarcoma is an often fatal skin condition found among some 40 percent of HIV/AIDS patients

In 1993, Dr. Priestley told health writer Anthony Cichoke:

- Kaposi's sarcoma is clearly improved by taking maitake for some of her patients.
- Maitake extract (D-fraction) seems to be working better with her patients than maitake tablets.

- Those patients with Kaposi's sarcoma, who had received radiation treatment before taking maitake, showed dramatic improvement.
- Many symptoms of AIDS were generally improved after taking maitake.

Dr. Priestley adds this caveat: More comprehensive and controlled studies are needed to investigate maitake's activity against Kaposi's sarcoma because it is known that natural remission sometimes occurs in such cases.

Meanwhile, Dr. David Hughes, of San Bernardino, has applied Maitake D-fraction mixed with dimethyl sulfoxide (DMSO) to treat Kaposi's sarcoma in AIDS patients, reporting the lesions are phased out within several days. Dr. Hughes reports that one of his patients, who had been HIV positive, became HIV negative by taking Maitake D-fraction orally for a month.

According to Dr. Hughes, Maitake D-fraction may be applied directly to the Kaposi's sarcoma lesions and recommends the following treatment:

Take two-thirds Maitake D-fraction liquid extract, plus one-third DMSO. Apply this mixture with a Q-tip to the Kaposi's sarcoma lesions. The lesions reduce in a few days.

Dr. Hughes adds two cautions: 1) The mix gets quite hot—so it seems that maitake will react chemically with DMSO; and 2) some patients who kept using it continuously got quite "high." He cautions patients not to use more than four times per day.

One of Dr. Hughes's patients claimed his HIV-positive status was turned to negative by his use of maitake. On July 14, 1994, he tested positive for HIV, but a follow-up test result dated August 23 showed that he was HIV-negative. His diary shows the progress of his improvement:

- 07/20/94: ...bad eye infection caused by getting motor oil in eyes....Dr Hughes suggested use of ampicillin and he looked at my blood and again noticed my blood counts were low.... he suggested maitake.
- 07/21/94: Took maitake as prescribed, one teaspoon in morning and evening.
- 07/22/94: Continued regime.
- 07/23/94: Continued regime.
- 07/24/94: I cut myself and noticed blood was bright pink (oxygenation).
- 07/25/94: Felt higher energy levels and between ampicillin and maitake. Eye infection cleared up.
- 07/26/94: Continued higher energy level.
- 07/28/94:Certain facial lines appeared minimal compared to prior treatment.

- 07/29/94: Continued higher energy level.
- 07/30/94: Cut myself again and blood still bright pink.
- 07/31/ 94: Last day of taking maitake. Dr. Hughes wanted to have blood stabilized and then have blood panel done.... CD4/CD8 ratio went from 0.8 to 1.0 and HIV went from positive to negative.

While we can neither be sure about the initial diagnosis nor ascertain that the condition was thus reversed, it seems evident that Maitake D-fraction played some kind of positive role in this patient's improvement, probably enhancing his overall immune health.

But, fortunately, we have additional evidence that beta-glucan is an important aspect of HIV/AIDS treatment—and this evidence offers further support for use of maitake by such patients:

- One study comes to us from the prestigious M.D. Anderson Cancer Center. In 1986, researchers administered an intravenous solution containing beta-glucan to end-stage AIDS patients who experienced notable improvements in several immune "markers," including interleukin-1 and interleukin-2. Both of these are integral to healthy immune function.
- In another study, 20 male patients from 18 to 60 years of age with AIDS or Aids Related Complex (ARC) were enrolled in an evaluation of intravenously administered beta-glucan. Baseline and serial determinations of immune function were obtained. The treatment group exhibited elevations in their plasma interleukin-1, 2, and 3 levels, as well as improvement in helper-suppressor T-cell ratios with IV infusion of beta-1,3-glucan. Elevation of interleukin-1, 2 , and 3 is indicative of immune enhancement and activation. Interleukin-2 enhancement in patients infected with HIV is of notable value, as the virus is known to infect helper T-cells responsible for the production of this important immune system messenger. The production of interleukin-2 alerts the dormant immune system of infectious assault, resulting in the multiplication of immune B-cells and interferon production.
- A particularly compelling study concerning HIV was conducted with a form of beta-glucan synthesized from glucose. It was established that beta-1,3-glucan inhibits the attachment of the HIV virus to T-cells. Even more compelling was the fact that after the virus and cells were exposed to beta-1,3-glucan for two weeks, complete inhibition of the replication of the HIV virus ensued. These results prompted a clinical trial in which the beta-1,3-glucan was administered intravenously to three HIV patients. A significant rise in immune system marker CD4 was accomplished.

In light of these improved immune system markers, treatment of immune-compromised patients with Maitake D-fraction or intravenous beta-glucan should be seriously considered.

Hepatitis

Hepatitis (meaning an inflammation of the liver) is caused by several different viruses. Hepatitis A is spread through contaminated water and food and is excreted in the stools. Hepatitis B is acquired from transfusions or other blood products. It can be transmitted through minute cuts or abrasions or by such simple acts as kissing, tooth brushing, ear piercing, tattooing, having dental work or during sexual contact. It can be transmitted from a pregnant woman to her baby. Hepatitis C, formerly called non-A, non-B hepatitis, is primarily spread through infected blood. It causes cirrhosis in 50 percent of cases.

Thus, taking care to insure a strong immune system, reducing high risk behavior, getting regular check-ups, and using a clinically validated daily liver care supplement are all important facets of a total liver health program.

In hepatitis, the liver often becomes tender and enlarged, and the patient usually exhibits symptoms including fever, weakness, nausea, vomiting, jaundice, and aversion to food, which can result in marked weight loss. The virus may be present in the bloodstream, intestines, feces, saliva, and in other bodily secretions.

Hepatitis is common in the United States but even more so in developing nations, and some forms of it can be extremely infectious. Most people recover from viral forms of the disease without treatment, but some die and others may develop a chronic, disabling illness.

Drs. Williams and Di Luzio initially undertook studies on the anti-viral potential of beta-1,3-glucan when they investigated viral hepatitis.[19] The doctors observed that when beta-1,3-glucan was administered prior to, as well as after viral infection, maximum survival was achieved.

In contrast to the profound liver damage found in the control mice, beta-1,3-glucan-treated mice exhibited very little liver pathology. Normalization of liver enzyme and cell markers was observed in the treatment group indicating a return to healthful liver function.

Of greater significance was the observation that mice infected with viral hepatitis showed major impairment of macrophage function, but pretreatment with beta-1,3-glucan resulted in active macrophage function. These studies suggest that maintenance of activated macrophages results in a

heightened immune state, increased survival and inhibited liver damage. "Thus, glucan is capable of increasing survival, inhibiting hepatic necrosis, and maintaining an activated state of phagocytic activity in mice challenged with MHV-A59. Macrophage stimulants may have a significant role in the modification of virally induced hepatic lesions."

In light of this research, maitake mushroom, like other similar beta-glucans, should be considered a potent adjunctive therapy in the treatment of infectious liver disorders.

This was emphasized in a presentation by researchers at the International Symposium on Production and Products of Lentinus Mushroom, Qingyuan, Zhejiang, China, November 1-3, 1994.[20] In their pilot study on hepatitis B patients, researchers from Zhejiang Medical University and the Edible Fungi Research Institute of Qingyuan, Zhejiang Province, China, teamed with doctors at the People's Hospital of Qingyuan. They compared maitake with routine treatment. Thirty-two patients with longstanding hepatitis B were given either routine treatment or capsules containing maitake. Kenneth Jones summarized their findings:

"The researchers reported several promising outcomes: a comparatively higher recovery rate in alanine transferase levels in the maitake-polysaccharide group (72.7 percent) than in the control group (56.6 percent); a significantly higher rate of HbeAg seroconversion from positive to negative compared to the control group; and no side effects in the polysaccharide group."[21]

Viral Inhibition of Wound Healing

Mice acutely and chronically infected with Sendai virus suffered impaired wound healing. This inhibition in the healing process could be overcome by instilling beta-glucan into their incised wounds.[22] These results are reminiscent of those achieved by Dr. Hughes in treating Kaposi's sarcoma patients.

Common Cold and Flu

One of us (Dr. Konno) has been generously giving maitake powder caplets and maitake tea to four residents in his medical college's department of urology. Every time they begin to get sick and their throats became scratchy, they start ingesting the caplets and tea. These seem to stop their symptoms. Even when they already have severe symptoms, their recovery is shortened.

MAITAKE AND BACTERIAL PATHOGENS

Ever since their discovery several decades ago, many studies have been conducted on beta-glucans to determine their protective benefits against bacterial pathogens. The studies below clearly demonstrate the power of beta-glucans to support healthy immune function and their protective effect against a wide range of such pathogens. Because these studies were done on a wide range of beta-glucans, it is reasonable to conclude that maitake's beta-glucans hold similar benefits:

Staph

Staph is the short name for *Staphylococcus aureus* (pronounced: sta-fuh-low-**kah**-kus are-ee-us) bacteria. Staph bacteria are the number one cause of hospital infections. They are blamed for about 13 percent of the nation's two-million hospital infections each year, according to the CDC. Overall, the two-million infections kill 60,000 to 80,000 people. That number is climbing due to the fact that some staph infections are now impossible to treat even with our most powerful antibiotics.

The evolution of resistance to antibiotics is inevitable, as bacteria grow and reproduce. The cell wall has become much thicker, notes Dr. William Jarvis, a medical epidemiologist with the CDC. "As a result, it is much more difficult for the antibiotic to go across that cell wall and get inside the cell" to kill the organism.

Not all staph infections are deadly. Many teens and adults alike experience occasional outbreaks of staph-related boils on their face and sometimes back and shoulders, too. Such a boil may start out fairly small and itchy but can become big and red and sore. Usually these bacteria can live harmlessly on many skin surfaces, especially around the nose, mouth, genitals, and anus. But when the skin is punctured or broken for any reason, staph bacteria can enter the wound and cause an infection.

Staph bacteria can cause several different types of infections, including folliculitis, boils, scalded skin syndrome (which mostly affects infants and younger kids), impetigo, toxic shock syndrome, cellulitis, and other types of infections such as a bone infection called osteomyelitis.

Research shows that activating our macrophages is a key to prevention and treatment. In an experimental study, administration of beta-glucan prior to intravenous administration of the deadly bacterium *Staphylococcus aureus* resulted in "significantly increased survival."[23] Beta-glucan also "significant-

ly inhibited renal necrosis associated with systemic staphylococcal diseases."

In a 1979 study, these results were confirmed, in which it was found that intravenous injection of beta-glucan prior to intravenous challenge with staph "resulted in a significantly increased survival as compared to control mice."[24]

In a 1998 study of mice with severe bacterial infection (sepsis), beta-glucan boosted immunity sufficiently to decrease mortality by 300 percent, compared with untreated control animals.[25]

Perhaps most important in our modern world where bacterial strains are increasingly resistant to antibiotics, beta-glucan also protected rodents infected by multiple antibiotic-resistant *Staphylococcus aureus* by increasing phagocytic cells.[26]

These results with lower life forms are likely to be duplicated in human clinical trials. For example, in one small study, it was found that staph patients in whom phagocytosis or bacteria-engulfing capabilities of their white blood cells was improved have been seen to do much better.[27]

Tuberculosis

Various fungal beta-glucans were examined for immunopotentiating effects among post-chemotherapy mice in whom experimental tuberculosis was induced.[28] After being treated with a combination of chemotherapeutic drugs, the mice of each treated group were divided into three subgroups to receive or not to receive beta-glucan. The fungal beta-glucans helped to inhibit multiplication of tubercle bacilli in the lungs and spleen.

Sepsis

Also known as gram-negative or gram-positive bacteremia, sepsis is a serious infection caused by bacteria that have entered a wound or body tissue that leads to the formation of pus, or to the spread of the bacteria in the blood.

Sepsis is a result of a bacterial infection that can originate anywhere in the body. Common sites are the genitourinary tract, the liver or biliary (liver secretion) tract, the gastrointestinal tract, and the lungs. Less common sites are intravenous lines, surgical wounds, surgical drains, and sites of skin breakdown known as decubitus ulcers or bedsores. The infection can lead to shock (also known as septic shock). There has recently been an increase in the occurrence of sepsis caused by organisms that are resistant to most standard antibiotics.

Sepsis can be a life-threatening situation, especially in people with a weakened immune systems.

Hospitalization is necessary to achieve treatment goals. The death rate can be as high as 60 percent for people with severely low white blood cell counts or suppressed immune systems. In people with no underlying disease, the death rate is about five percent.

In an experimental study, intraabdominal sepsis was experimentally induced in rodents.[29] Those receiving beta-glucan did much better, especially when combined with antibiotics. "It is concluded that glucan has a clear effect on the survival rate of rats with induced peritonitis, probably by enhancing the activities of reticuloendothelial system—an important part of the total host resistance."

FYI:
The Reticuloendothelial System

The reticuloendothelial system is a diffuse system of phagocytic immune cells originated from bone marrow stem cells, which themselves are associated with the connective tissue framework of the liver, spleen, lymph nodes and other serous cavities.

These strongly phagocytic cells are found throughout the body, but primarily found in lymph nodes and in blood and lymph sinuses in the liver, spleen, and bone marrow.

Lung Infections & Pneumonia

Pneumonia is a serious infection or inflammation of the lungs. The air sacs in the lungs fill with pus and other liquids. Oxygen has trouble reaching your blood. If there is too little oxygen in your blood, your body cells can't work properly. Because of this, combined with spread of infection through the body, pneumonia can cause death.

Until 1936, pneumonia was the number one cause of death in the United States, although, since then, use of antibiotics brought it under control. Nevertheless, in 1997, pneumonia and influenza combined ranked as the sixth leading causes of death.

Pneumonia affects your lungs in two ways. Lobar pneumonia affects a section (lobe) of a lung. Bronchial pneumonia (or bronchopneumonia) affects patches throughout both lungs.

Pneumonia is not a single disease. It can have over 30 different causes. There are five main causes of pneumonia:

- Bacteria.
- Viruses.

- Mycoplasmas.
- Other infectious agents, such as fungi, including pneumocystis.
- Various chemicals.

Bacterial pneumonia remains one of the leading causes of death and disability in the elderly. Bacterial pneumonia can attack anyone from infants through the very old. Alcoholics, the debilitated, post-operative patients, people with respiratory diseases or viral infections and people who have weakened immune systems are at greater risk.

Pneumonia bacteria are present in some healthy throats. When body defenses are weakened in some way, by illness, old age, malnutrition, general debility or impaired immunity, the bacteria can multiply and cause serious damage. Usually, when a person's resistance is lowered, bacteria work their way into the lungs and inflame the air sacs. The infection quickly spreads through the bloodstream and the whole body is invaded.

Research performed with various types of beta-glucans has established that it is effective in combating lung infections in animal models—against both Gram-positive and Gram-negative bacterial strains.

In a 1983 laboratory study, beta-glucan was studied in rats and mice to determine its protective capacity in respiratory infections.[30] Beta-glucan was administered intravenously to the rodents prior to infection with aerosolized bacterial strains, including *Staphylococcus aureus* and *Klebsiella pneumoniae*.

Gram-negative bacilli such as *Klebsiella pneumoniae* account for less than two percent of community-acquired pneumonias, but they do account for most hospital-acquired (nosocomial) pneumonias, including fatal ones. Beta-glucan was shown to be effective against both bacilli. "Glucan-treated rats had significantly increased rates of phagocytosis and killing of *Staphylococcus aureus* immediately after infection..." note the researchers. "In contrast, pulmonary killing of *Klebsiella pneumoniae* in rats was markedly enhanced by glucan at [four hours].... Histological studies demonstrated greatly increased numbers of macrophages in the lungs of glucan-treated rats; the lungs of glucan-treated mice appeared normal. That results show that glucan can enhance intrapulmonary bacterial killing. In rats, this is due to the ability of glucan to increase the number of lung macrophages resulting in increased bacterial ingestion."

E. Coli Infection

Escherichia coli is an emerging cause of food borne illness. An estimated 73,000 cases of infection and 61 deaths occur in the United States each year.

Infection often leads to bloody diarrhea, and occasionally to kidney failure. Most illness has been associated with eating undercooked, contaminated ground beef. Person-to-person contact in families and childcare centers is also an important mode of transmission. Infection can also occur after drinking raw milk and after swimming in or drinking sewage-contaminated water.

E. coli O157:H7* is one of hundreds of strains of the bacterium *Escherichia coli*. Although most strains are harmless and live in the intestines of healthy humans and animals, this strain produces a powerful toxin and can cause severe illness. *E. coli* O157:H7 was first recognized as a cause of illness in 1982 during an outbreak of severe bloody diarrhea; the outbreak was traced to contaminated hamburgers. Since then, most infections have come from eating undercooked ground beef.

In an experimental study, rats were subjected to either splenectomy (removal of the spleen) or sham laparotomy (simply surgical section of the abdominal wall) and then challenged with the introduction of *E. coli* into their bodies.[31] Beta-glucan protected against *E. coli*-induced sepsis even in rats subjected to splenectomy.

Furthermore, beta-glucan has been shown to synergize antibiotics used against *E. coli*-induced sepsis.[32]

We also know that glucan therapy increases bone marrow proliferation and enhanced phagocytosis of *E. coli*, based on *in vitro* studies.[33]

Listeria Infection

Listeria monocytogenes is a kind of bacteria often found in soil and water, which can cause serious illness. Illness from eating foods (e.g., soft cheeses and processed meats) with *Listeria monocytogenes* is called listeriosis.

Most people do not get listeriosis. However, pregnant women and newborns, older adults, and people with weakened immune systems caused by cancer treatments, AIDS, diabetes, and kidney disease are at risk for becoming seriously ill from eating foods that contain *Listeria monocytogenes*.

According to the Centers for Disease Control and Prevention, less than 2,000 people in the United States report serious illness from listeriosis each year. Of those reporting, approximately 25 percent die as a result of the illness.

In 1990, Japanese researchers demonstrated in an experimental murine study that orally administered beta-glucan could protect against *Listeria*

* The combination of letters and numbers in the name of the bacterium refers to the specific markers found on its surface and distinguishes it from other types of E. coli.

monocytogenes.[34] "An enhanced elimination *in vivo* of *L. monocytogenes* was observed at the relatively late phase of listerial infection."

Leprosy

Leprosy is a chronic infectious disease that usually affects the skin and peripheral nerves but has a wide range of possible clinical manifestations. It is caused by *Mycobacterium leprae*, which multiplies very slowly and mainly affects the skin, nerves, and mucous membranes. The organism has never been grown in bacteriologic media or cell culture, but has been grown in mouse footpads.

In 1999, the world incidence was estimated to be 640,000; and in 2000, 738,284 cases were identified. In 1999, 108 cases occurred in the United States. In 2000, WHO listed 91 countries as endemic, with India, Myanmar, and Nepal having 70 percent of cases.

Worldwide, one- to two-million persons are permanently disabled as a result of this disease. However, persons receiving antibiotic treatment or having completed treatment are considered free of active infection.

Although the mode of transmission remains uncertain, most investigators think that *M. leprae* is usually spread from person to person in respiratory droplets.

In 1983, the effect of beta-glucan was studied on experimental murine leprosy[34]. Of all the agents studied, beta-glucan was found to most highly activate the reticulo enodothelial system and to be "the most active inhibitor of the multiplication of Hansen's bacilli," say researchers.

PARASITES

Leishmania Donovani

Based on an experimental study, beta-glucan can help to protect against parasites. Intravenous administration of beta-glucan at the same time of infection by the protozoan parasite *Leishmania donovani* demonstrated that glucan-activated macrophages "significantly reduced multiplication of the intracellular parasite." Not only does this show that otherwise healthy persons can better protect themselves against parasites with beta-glucan—this critical information is useful for persons with HIV/AIDS, especially as infection with *Leishmania donovani* among such persons may accelerate HIV

replication, note researchers from the Armauer Hansen Research Institute, Addis Ababa, Ethiopia.[36]

Malaria

Malaria is by far the world's most important tropical parasitic disease, and kills more people than any other communicable disease except tuberculosis. In many developing countries, and in Africa especially, malaria exacts an enormous toll in lives, in medical costs, and in days of labor lost. The causative agents in humans are four species of plasmodium protozoa (single-celled parasites): *P. falciparum*, *P. vivax*, *P. ovale* and *P. malariae*. Of these, *P. falciparum* accounts for the majority of infections and is the most lethal. Malaria is a curable disease if promptly diagnosed and adequately treated.

Thanks to a grant from the Howard Hughes Medical Institute and the U.S. Army Medical Command, researchers Alenka Lovy and Barbara Knowles, of the Institute of Biological Chemistry, Washington State University, Pullman, and Ronald Labbe and researchers at the University of Massachusetts, Amherst, tested 10 edible mushroom species for their antimalarial activity.[37] Of all mushrooms, maitake was rated as having the greatest antimalarial activity. These findings may be especially relevant today, as malaria appears to be spreading into the United States.[38]

Antimalarial Activity of Mushroom Extracts In Vitro Against *Plasmodium falciparum* (Pyrimethamine-Resistant)—Infected Red Blood Cells

Mushroom/extract	Inhibition	
	Extract	Protein fraction
Maitake (*Grifola frondosa*)/water	98%	0.68%
Shiitake (*Lentinula edodes*)/water	95	0.62
Chuling (*Grifola umbellata*)/water	68	100
Reishi (*Ganoderma lucidum*)/water	40	3.50
Reishi fruit body/DMSO[a]	35	0.62
Reishi mycelium/water	29	1.71
Reishi fruit body/ethanol	6	0.78

Table adapted from Jones, K. "Maitake: A Potent medicinal food." *Alternative & Complementary Therapies*, December 1998:420-429.

FUNGAL INFECTION

Candida

Beta-glucan is also experimentally effective against Candida albicans, another troubling infectious agent. In an experimental study, infection with candida resulted in a paltry 20 percent survival rate following surgery.[39] However, with administration of beta-glucan, the survival rate rose to 73 percent. "Glucan significantly enhanced macrophage phagocytic function..." note the researchers.

PROTECTION IN THE HOSPITAL

Are you going to the hospital or do you know someone who is? Then, you will want to make sure that beta-glucan is part of a protective regimen.

In a 1994 report, the benefits of beta-glucan were examined in a double blind, placebo-controlled multi-center study.[40] Patients scheduled for surgery were given beta-glucan before and immediately following thoracic (high-risk) surgery. Those who received the immune agent experienced decreased postoperative infections.

The bacterium *Klebsiella pneumoniae* accounts for a significant proportion of hospital-acquired urinary tract infections, pneumonia, septicemias (i.e., presence of pathogenic bacterial in the bloodstream), and soft tissue infections. Because of its ability to spread rapidly in the hospital environment, this bacterium can be particularly troubling. In a 1983 experimental study, bacterial infection of the lung was induced with *Klebsiella pneumoniae*.[41] Treatment with beta-glucan resulted in "markedly enhanced" activity of macrophages against the bacterium and led to greater bacterial ingestion (phagocytosis). "These observations suggest that biologic response modifiers such as glucan may be effectively employed in patients who are at risk for post-operative infections."

USED WITH ANTIBIOTICS

Beta-glucan is particularly useful as an additive treatment when persons are prescribed antibiotics and other anti-infective agents.

Scientists have found lower dosages of antibiotics or antivirals are required when β-1,3/1,6-D-glucan is added to the medication regimen in animals challenged with different bacterial, fungal and viral pathogens, including *Staphylococcus auras*, *Klebsiella pneumoniae*, and *Escherichia coli*, as well as the herpes zoster virus.[42, 43]

Notes Phil Wyde, Ph.D., of the Baylor College of Medicine, Houston, Texas, "This demonstration of bactericidal enhancement via oral dosing suggests an application for beta-1,3-glucan as a component in a combined modality with conventional anti-infective agents. Beta-glucan, through the stimulation of host defense systems, creates a more supportive environment within the body to assist the primary killing action of the conventional agent."[44]

THE DOCTORS' PRESCRIPTION

The fact that maitake mushroom is effective against viral, bacterial, fungal, parasitic and cancerous invasion is because of its ability to universally activate macrophages. As simple as it is, maitake's beta-glucan offers powerful immune support agent. There is even a beta-glucan receptor site on the macrophage. It may be truly stated that the body's macrophages and beta-glucan were meant for each other.

Maitake mushroom therefore is an altogether important whole food concentrate to utilize for stimulating generalized immune function and one that we would recommend for year-round use.

Recommended Maitake Dosages for Immune Support & Therapeutics

The following dosages of Maitake D-fraction and maitake caplets for adults are recommended (but not established):

- One to four grams per day of maitake tablets for prevention and four to seven grams for therapeutic self-help (e.g., for patients with chronic immune dysfunction).

- Five to six drops of Maitake D-fraction (Grifron®-Pro D-Fraction®; Maitake Products) three times per day, for health maintenance and 15 to 20 drops, three times per day for therapeutic purposes.

- Optionally, 250 to 1,000 mg of vitamin C can be taken with Maitake D-fraction or tablets as described above.

PART TWO

CANCER PREVENTION & THERAPEUTICS

MAITAKE D-FRACTION & CANCER THERAPY

CANCER IS SO PREVALENT IN OUR MODERN WORLD. It is a health issue most persons will have to deal with either directly or indirectly. It is important for persons with cancer or who know someone with it to know about the specific measures that can be taken to complement their doctor's prescribed treatments such as chemotherapy, radiation therapy or surgery—or to use with true hope when these fail to provide adequate results. It is also important to have good information on how cancer occurrence might be prevented or delayed. In either case, one thing we tell all cancer patients and persons interested in reducing risk of cancer is that use of maitake is probably one of the most important nutritional measures by which persons can help themselves to prevent, delay, treat or survive this often deadly disease.

Much attention is being paid today to cancer chemoprevention. Maitake appears to be an important protective and therapeutic substance. In both experimental studies and clinical settings, Maitake D-fraction has been shown to significantly inhibit many types of cancer.

Meanwhile, studies on various types of beta-glucans, all with similar configurations and derived from a variety of sources, demonstrate an even broader array of therapeutic benefits. These include prevention and treatment of many types of cancers, as well as protection against surgical-, chemotherapeutic- and radiation-induced side effects.

In the 1980s when lentinan, derived from shiitake mushroom, was approved as an anticancer drug by the Japanese Pharmaceutical Council and became a hot topic, the late Dr. Kanichi Mori, then head of the Japanese Mushroom Institute, gave a speech in which he also recommended scientific trials focus on the powers of the maitake mushroom. It was at this time that researchers first began to investigate whether the body could be stimulated to

produce various beneficial cytokines (including interferons and interleukins) by ingesting maitake extract. Until then, it was impossible to cultivate maitake artificially, so researchers could not get regular access to it for research purposes. Thus, the primary research focus up until that time had been on shiitake. It is important to note that shiitake, already approved in Japan as an anti-carcinogenic drug, was effective by intravenous injection but not by oral administration. However, at around that time, a cultivation method of maitake was established on bio-farms, leading to stable quality, which, in turn, led to the beginning of maitake research. Today, the growing of maitake mushroom with high quality control standards has become an important industry in various regions of the world. Not only could maitake now be commercially harvested; but, more importantly, researchers found oral administration of maitake was as potent as injection by needles. With that discovery and improved cultivation yields, much research switched from shiitake to maitake.

People have either known or at least suspected for a very long time that the Monkey's Bench family, of which maitake is a member, possesses significant anti-cancer potential. Thus, they have used the ingredients obtained by boiling these substances down as a sort of medicinal hot water treatment for certain cancers. It is now known conclusively that the ingredients which exhibit the greatest antitumor effects are the result of the activity of various beta-glucans found in the mycelium (which is the mass of interwoven filaments that form the vegetative portion of the maitake mushroom and are submerged in soil or organic matter). Thus, materials for research studies were obtained by heating maitake and extracting its polysaccharides. Researchers obtained various fractions by continually refining down the elements in the fruiting body of maitake. The results of this research were first

FYI:
What is Adjuvant Cancer Therapy?

When we speak of natural medicines that may be used as adjuvants in cancer therapy, we generally mean the utilization of those specific agents that can give aid to the accepted standard therapies to make them more effective.

A review of the literature published on maitake confirms this natural medicine is often an important adjuvant in cancer therapeutics, both for mitigating the damaging side effects of chemotherapy and radiation, as well as for improving the body's innate immune defenses and improving the main outcome—living cancer-free.

published in 1985.[45] Interestingly, it was the D-fraction of maitake extract, which was obtained last, that was found to possess the most potent antitumor activity, leading to the highest reduction rate in cancer proliferation.[46,47]

Not only does daily use of maitake extract among otherwise healthy persons help to support normal immune function and reduce cancer risk through its protective effects against chemical carcinogens and metastasis, its use in cancer therapeutics effects a significant benefit often when conventional treatment fails. Maitake enables the body to withstand, to some extent, the rigors of chemotherapy, radiation, and surgery that patients may undergo—in addition to enabling the immune system to function more fully, thereby also helping the patient to survive cancer.

HOW MAITAKE WORKS

Inhibits Environmental Carcinogens

Maitake inhibits chemical carcinogenesis, that is chemicals to which we are exposed in our food, water and air or occupationally that can initiate cancerous processes. In one study, 20 five-week-old mice were injected in the back only once with a carcinogenic substance (3-MCA, methylcholanthrene). Beginning on the fifteenth day after the injection, ten of the mice were fed 0.2 mg of Maitake D-fraction for 15 consecutive days. The other ten in the control group received saline solution. At the end of the thirty days, the number of mice with cancer was 30.7 percent in the maitake group and 93.2 percent in the control group.[48]

In another study, researchers exposed mice to a known urinary bladder carcinogen N-butyl-N'-butanolnitrosoamine (BBN) every day for eight weeks and then fed them medicinal mushrooms, including maitake, shiitake, and oyster mushrooms.[49] All of the mice treated with BBN developed bladder cancer. While each of the mushrooms reduced the number of bladder cancers, maitake was clearly most effective (carcinomas were observed in 46.7 percent of the maitake-treated mice compared to 52.9 percent and 65 percent for shitake and oyster, respectively). The researchers also noted that the mushrooms helped prevent a significant depression in lymphocyte and NK cell activity.

Induces Release of Cytokines

Another way that maitake's beta-glucans may help is by stimulation of tumor inhibitors. In these and other experimental models, systemic macrophage activation and certain cytokine releases seem to be critical for freeing tissues of tumor cells and inhibiting metastasis.[50]

In 1995, Dr. Mitsuhiro Okazaki and co-researchers demonstrated that maitake mushroom stimulates release, or, rather, "primes" the body to release tumor necrosis factor-alpha.[51] Additional studies have shown that maitake is a powerful, broad-spectrum cytokine inducer (see table *below*). In other words, Maitake D-fraction exhibits an antitumor effect on tumor-bearing mice not only through enhanced cytotoxic (i.e., diseased-cell killing) activity and stimulating the macrophages but also by potentiating them—helping the macrophages to live up to their fullest potential. This enhanced cytotoxic activity of macrophages has resulted in elevated production of interleukin-1 and thereby to the activation of cytotoxic T lymphocytes, as well as activation of many additional cytokines.[52, 53]

But, admittedly, this report sheds light on just how much we don't know about the pharmacology of maitake mushroom. For example, in 1986, researchers from the Chemotherapy Division of the National Cancer Center Research Institute, Tokyo, Japan, discovered that a substance with marked tumor inhibitory activity could be induced by injecting mice with beta-glucan.[54] They specifically noted that the agent was different than tumor necrosis factor but at that time did not clearly identify it.

That same year researchers from Tulane University noted that the lytic activity of specific types of macrophages could be highly enhanced with administration of beta-glucan.[55] This means that beta-glucan supercharges white blood cells so that they can more ably break down or decompose tumor cells—perhaps by stimulating an intensified release of specific antitumor compounds. These results were amplified and expanded in the journal *Cancer Research* in 1987 when Japanese researchers from the Department of Pathology

Activation of Immune-Competent Cells and Interleukins by Maitake D-Fraction in Tumor-Bearing Mice

Immune cells/interleukins	Activation by D-fraction injection (Relative to control[a] value of 1.00)
Natural-killer cells	1.52
Lymphokine-activated killer cells	1.64
Cytotoxic T-lymphocytes	2.22
Interleukin-1	1.98
Interleukin-2	1.73

[a]Saline injection.

Adapted from Konno, S. "Maitake D-fraction: Apoptosis inducer and immune enhancer." *Alternative & Complementary Therapies*, April 2001:102-107.

Yamagata University School of Medicine showed that when the beta-glucan molecule docks on the receptors of macrophages it activates cellular genetic materials, leading to the release of powerful antitumor compounds.[56]

Inhibits Metastasis

Another focus of research is whether D-fraction could inhibit metastasis of cancer cells—which was confirmed by experimental studies that indicate cancer metastases could be reduced to less than one-tenth with use of Maitake D-fraction.

In a well-designed laboratory study, MM-164 liver cancer was injected into the left rear footpad of three groups of mice.[57] The first group was given normal feed. The second group received 20 percent maitake powder in their feed. The third group received one milligram per kilogram Maitake D-fraction with their feed. All three groups were then followed for another 30 days. The number of tumors metastasized to the liver was counted using a microscope. It was observed that metastasis to the liver was prevented by 91.3 percent with Maitake D-fraction and by 81.3 percent with maitake crude powder. Among the control group, all (100 percent) experienced distant metastasis to the liver. The researchers noted that tumor cells present in blood and/or lymph were necrotized by the activated cellular immune-competent cells. The result of this animal test indicates that cancer metastases could be reduced to less than 10 percent of the controls by the use of Maitake D-fraction daily.

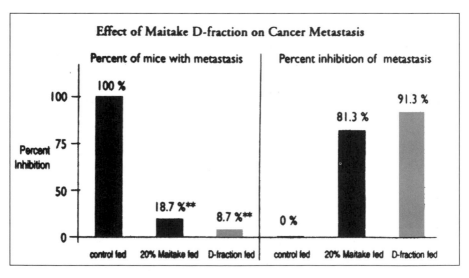

FYI:
Metastasis Requires Angiogenesis

Cancer researchers studying the conditions necessary for cancer metastasis have discovered that one of the critical events required is the growth of a new network of blood vessels. This process of forming new blood vessels is called *angiogenesis*.

Tumor angiogenesis is the proliferation of a network of blood vessels that penetrates into cancerous growths, supplying nutrients and oxygen and removing waste products. Tumor angiogenesis actually starts with cancerous tumor cells releasing molecules that send signals to surrounding normal host tissue. This signaling activates certain genes in the host tissue that, in turn, make proteins to encourage growth of new blood vessels.

Fortunately, maitake's beta-glucans can prevent this process by stimulating tumor necrosis factor. Maitake D-Fraction was observed to affect angiogenesis *in vivo* and to enhance the proliferation capability and migration capability of human vascular endothelial cell *in vitro*.[58] The D-Fraction also increased plasma vascular endothelial growth factor (VEGF) concentration significantly. Also VEGF and TNF-alpha production by the activated peritoneal macrophages were enhanced. "These results suggest that the antitumor activity of the D-Fraction is not only associated with the activation of the immuno-competent cells but also possibly related to the carcinoma angiogenesis induction."

Inhibits Angiogenesis

Most recently in the October 30, 2001 issue of *Cancer Letters*, we discovered new information about Maitake D-fraction that was previously unknown to us. Besides improving immune activity, inhibiting metastasis and inducing apoptosis, we now suspect that Maitake D-fraction inhibits angiogenesis.

WHAT RESEARCHERS HAVE TO SAY ABOUT MAITAKE

Here's what researchers say about maitake's anticancer effects:
- A polysaccharide (3-branched *f*À-1,6-glucan MT-2) extracted from the fruit body of *Grifola frondosa* (maitake) showed an antitumor effect against mouse syngeneic tumors (MM-46 carcinoma and IMC-carcinoma).[59] It not only directly activates various effector cells (macrophages, natural killer

FYI:
What Is Metastasis?

When patients are diagnosed with cancer, they want to know whether their disease is local or has spread to other locations. Cancer spreads by *metastasis*, the ability of cancer cells to penetrate into lymphatic and blood vessels, circulate through the bloodstream, and then invade and grow in normal tissues elsewhere. In large measure, it is this ability to spread to other tissues and organs that makes cancer a potentially life-threatening disease, so there is great interest in understanding what makes metastasis possible for a cancerous tumor.

cells, killer T cells, etc) to attack tumor cells, but also potentiates the activities of various mediators including lymphokines and interleukin-1. Thus, it acts to potentiate cellular functions and at the same time to prevent a decrease of immune functions of the tumor-bearing host.

■ The author of one such reports notes he has been studying medicinal mushrooms for the last 15 years and has reported that of all mushrooms studied, maitake mushroom (*Grifola frondosa*) has the strongest activity in tumor growth inhibition, both when administered orally and intraperitoneally.[60] Maitake D-fraction was investigated to determine its effectiveness not only on the inhibition against tumors already growing, but also on the inhibition of formation of the secondary focus due to metastasis of tumor cells in lymph and /or blood. In the tests of cancer inhibition rates on mice bearing MM-46 breast cancer cells, they were bred for one month with foods containing 20 percent edible mushroom powder. The result was that maitake outperformed all other mushrooms. Through the 31-day oral administration, total remission of the tumor was visibly confirmed on four out of ten maitake-fed mice. The remaining six rodents also indicated almost 90 percent suppression rate compared to untreated (control) mice. Most other mushroom extracts have been reported to be ineffective or less so when given orally (see table *below*).

31 DAYS AFTER TUMOR IMPLANTATION	
Control	0% *
Grifola frondosa (maitake)	86.3% (4/10 complete)
Lentinus edodes (shiitake)	77.9%
Pleurotus ostreatus (hiratake)	62.7%
Flammulina velutipes (enokidake)	61.7%
* Inhibition ratio (from Mushroom Science XII. 1989. P653)	

- Based on the outstanding results of oral administration, researchers went on to study the effects of maitake by intraperitoneal injection (i.e., administering the substance through the smooth transparent serous membrane that lines the cavity of the abdomen of a mammal). According to a 1987 report in the Japanese *Chemistry Pharmacy Bulletin*, maitake extract was injected into mice bearing Sarcoma 180 tumors. Inhibition rates of 80 to 86 percent were "clearly observed through the 10 day consecutive administration of 1 mg/kg/injection (about 0.025 mg/mouse as its average weight is 25 [grams])....the antitumor effect of maitake extract is outstanding. On the other hand, PSK (extract of *Coriolus versicolor*), known as an approved tumor drug in Japan, has shown no effect even though 300 mg/kg/day was administered. Also, lentinan (*Lentinus edodes*, an extract from shiitake mushroom approved an anti-stomach cancer drug) has shown relatively weak inhibition effect in this test."

- Researchers investigated whether Maitake D-fraction was effective against chemically induced cancer and against metastasis of MM-46 breast cancer.[62] BALB/C mice were prepared and cancer-inducing 3-MCA was injected. On the 15th day, 0.2mg of D-fraction was orally administered for 15 days. After 30 days, the number of mice with cancer was 30.7 percent in the experimental group and 93.2 percent in the control group, showing the anti-carcinogenic activity of Maitake D-fraction. MM-46 breast cancer was intraperitoneally implanted in C3H mice and the formed tumor was surgically removed. Then 0.2mg of D-fraction was injected for 10 days. After 20 days, the tumor metastasis was inhibited by 92.1 percent in mice given D-fraction compared to the control group and tumor recrudescence was also inhibited by 91.9%. Also, the synergistic effect of mitomycin C (a widely used anti-cancer drug) and Maitake D-fraction was confirmed on cancer metastasis inhibition.

- Another interesting study was reported on the augmented antitumor activity with a combination of D-fraction and mitomycin C used in chemotherapy.[63] Mitomycin C is probably the most popular antibiotic used among Japanese doctors (also being widely used in the United States) for various cancer treatments. In the study using tumor-bearing mice, D-fraction alone exhibited superior tumor growth inhibition compared to mitomycin C alone (approximately 80 percent versus 30 percent, respectively). When D-fraction and mitomycin C were given to the mice together (cutting each dose by half), tumor inhibition was increased further to nearly 98 percent. Such an enhanced antitumor effect of D-fraction and mitomycin C could be

explained by the stimulated immune response caused by D-fraction and the direct attack of mitomycin C on tumor cells.

- In 1998, *in vitro* tests found that maitake was highly inhibitory against a line of human cervical cancer and T4 leukemic cells.[64] These researchers noted the potency of the maitake extract warranted further study.

- At Gunma University School of Health Sciences, Gunma, Japan, researchers compared maitake with shiitake and oyster mushroom (*Pleurotus ostreatus*).[65] Mice given maitake in their feed showed much lower rates of urinary-bladder cancer when compared to the control group, as well as those mice receiving the other mushrooms. Even more important, these cancers were induced with a highly potent nitrosamine-based substance (N-butyl-n-butanolnitrosamine). Nitrosamines are a well-known cause of various human cancers, including cancers of the brain and leukemia. That maitake was able to significantly inhibit nitrosamine-induced cancer processes demonstrates its utility in reduction of risk and occurrence of potentially a wide range of environmentally caused cancers.

STANDARD PRACTICE IN EUROPE AND ASIA

Our recommendation for use of maitake mushroom is based on solid science and principles of cancer therapeutics. In fact, standard medical practice elsewhere in the world often includes beta-glucans.

For example, beta-glucan is used as a biological response modifier with radiation therapy for cancer treatment in Japan, note researchers at the Laboratory for Immunopharmacology of Microbial Products, School of Pharmacy, Tokyo University of Pharmacy and Life Science, Hachioji, Japan.[66]

In the Czech Republic, researchers have tested combination therapy with beta-glucan injected together with the chemotherapeutic agents. The combination has proven even better than use of either agent alone. "We have observed a significant protective effect…" "Moreover, the data revealed that combination therapy considerably enhances antitumor efficacy of the targeted anticancer drug."[67]

This kind of scientific evidence is only the tip of the proverbial iceberg. It is time that beta-glucan be widely recognized for its potential therapeutic benefits: additive effect in cancer treatment; ameliorating some of the side effects of chemotherapy and radiation; and protective effect in cancer prevention.

While we believe compelling evidence can be found to include Maitake D-fraction™ as part and parcel of a daily cancer prevention program—

Maitake D-fraction may be even more important to persons undergoing cancer treatment.

Not only has maitake mushroom been shown to produce excellent clinical results in cancer treatment, for some patients, whose cancers did not respond to conventional treatment, maitake mushroom has meant the difference between life and death.

COMPELLING SCIENTIFIC EVIDENCE

Let's look more closely at the benefits of beta-glucans in cancer prevention and treatment in general before examining the clinical studies on maitake in particular.

Melanoma

In 1978, Peter W. Mansell, M.D., and co-authors wrote about the use of beta-glucan for immune modulation and control of cancer as an adjuvant therapy. One of the most lethal cancers today is melanoma. In two separate reports authored by Dr. Mansell and published in 1975 and 1978, it was shown that injection of beta-1,3-D-glucan into melanoma lesions led to successful regression.[68,69] Examination of the site indicated extreme macrophage activity during the time that they engulfed and destroyed tumor cells. Use of injections also appeared to reduce the risk of the spread of the cancer. Reporting in 1975 in the *Journal of the National Cancer Institute*, it was shown the size of the cancer lesions was "strikingly reduced in as short a period as five days" and in small lesions "resolution was complete," reported Dr. Mansell and co-investigators.

A 1980 experimental study from the Department of Physiology at Tulane University School of Medicine, New Orleans, Louisiana, also demonstrates that beta-glucan may be able to help inhibit the growth of these cancers.[70] Beta-glucan injections decreased tumor weight by about 70 percent in mice with melanoma and inhibited spread of the cancer to the lungs. Beta-glucan administration, the researchers stated, "was effective in prolonging survival of mice with ME [melanoma]."

Leukemia

In a 1978 experimental study, it was shown that a combination of beta-glucan and radiation therapy or beta-glucan and chemotherapy led to improved cancer-free survival rates, compared to when either agent was used alone.[71] For example, in the treatment of leukemia, chemotherapy with

the agent carmustine (BCNU) and beta-glucan "yielded a high level of cures compared to no survival for either agent alone." These results were confirmed in 1980 in an experimental study from the Department of Physiology at Tulane University School of Medicine, New Orleans, Louisiana.[72] Beta-glucan, the researchers stated, "also prolonged the survival" of mice with lymphocytic leukemia.

Lung Cancer

Researchers report intravenous injections of beta-glucan "caused a significant increase in the rate and extent of clearance" of cancer cells from the lungs of a specific breed of mice.[73]

Breast Cancer

For patients with breast cancer, the already-detailed 1980 experimental study from the Department of Physiology at Tulane University School of Medicine, New Orleans, Louisiana, shows that beta-glucan may be able to help inhibit the growth of this cancers.[74] The researchers note that beta-glucan "was most efficacious" in maintaining survival of mice with breast cancer; "mortality decreased from 100% to 20%" when beta-glucan was administered intravenously. And accompanying these excellent results, it was found that the macrophages derived from the mice receiving beta-glucan "possessed significantly greater antitumor activity...than normal macrophages."

Liver Cancer

More recently, researchers from the Department of Experimental Pathology, Institute of Medical Biology, University of Tromsø, Norway, investigated the combined antitumor effect of beta-glucan and interferon-gamma (IFN-gamma) in an experimental liver metastasis model.[75] In this study, liver metastases were established by inoculation of specialized colon carcinoma cells into mice. Treatment started 24 hours after inoculation of tumor cells by daily intravenous injections of either beta-glucan, IFN-gamma or a combination of both for a duration of six days. The resultant liver metastases were then quantified after an additional period of 11 days. The combination of IFN-gamma and beta-glucan inhibited the growth of liver metastases almost entirely and produced a more marked effect than either agent used alone. These results were probably the result of enhanced activation and recruitment of liver macrophages.

Adjunct to Chemotherapy

In the case of transplantable leukemia cell lines, when beta-1,3-D-glucan was combined with BCNU, a chemotherapeutic agent, the combination resulted in a 56 percent cure rate, whereas there were no survivors when either agent was used alone.[76]

Leukocytopenia, characterized by decreases in the number of leukocytes, is associated with the use of chemotherapeutic agents. Because of leukocytopenia, lower dosages often must be used, compromising the curative effects of chemotherapy. However, with beta-1,3-D-glucan, leukocyte depletion can be countered, as was shown in a 1992 study with 5-fluorouracil when beta-1,3-D-glucan enhanced recovery of macrophage populations.[77]

Most recently, the combination of beta-1,3-D-glucan and interferon-gamma "inhibited the growth of liver metastases almost entirely."[78]

A way that this combination appears to work is by induction of nitric oxide which stimulates apoptosis or programmed cell death (characterized by cellular blebbing and DNA fragmentation of the cancer cells).[79] When stimulated with interferon-gamma and soluble beta-1,3-D-glucan, macrophages exerted cytotoxicity towards tumor cells. This cytotoxicity was associated with a high level of nitric oxide production. (Both cell death and nitric oxide production were significantly inhibited by the addition of aminoguanidine, a specific inhibitor of inducible nitric oxide synthase, to the culture medium.) Maitake mushroom has shown dramatic apoptotic effects, which we will discuss in Chapter Six.

Adjunct to Radiation Therapy

For persons undergoing radiation treatment, the use of beta-glucan is also important. Myra Patchen, Ph.D., undertook a number of studies on administered beta-1,3-D-glucan on behalf of the U.S. Armed Forces Radiobiology Institute.

In a 1984 experimental study, it was shown that mice subjected to high radiation doses and administered beta-glucan "consistently exhibited a more rapid recovery" of immune function.[80] Best results in experimental studies have come when beta-glucan was administered *prior* to and quickly following radiation exposure. In 1989, Dr. Patchen reported that beta-glucan "has been demonstrated to be effective in protecting mice from doses of radiation which are lethal or close to lethal level."[81] This report also noted that beta-glucan was highly effective when administered orally. Dr. Mansell notes that when rodents were exposed to very high, lethal doses of radia-

tion, the administration of beta-1,3-D-glucan enabled 70 percent to survive without apparent radiation-related damage.[82] In subsequent research, Dr. Patchen found that beta-1,3-D-glucan is a highly potent free radical scavenger that protects blood macrophages from free radical attack after radiation exposure, thus enabling the immune system to continue to function.[83]

Thus, we see that beta-1,3-D-glucan may be quite useful to persons who are undergoing radiation therapy, both by reducing radiation side effects and allowing a higher dosage to be used and by maintaining a relatively healthy and functioning immune system that can continue to subdue cancer cells.

Sometime after these earlier findings, Donald J. Carrow, M.D., of Tampa, Florida, began the use of beta-1,3-glucan with cancer patients. In his own clinical practice, Dr. Carrow has tested beta-1,3-glucan on a variety of conditions, including cancer and ulcers, and for general health maintenance. In one informal trial, five breast cancer patients undergoing radiation took 7.5 mg daily of beta-1,3-glucan and were free of radiation injuries to the skin. By applying beta-1,3-glucan topically to ulcers on two patients, Dr. Carrow was able to help them to heal completely within two months.

As an Adjunct to Both Radiation & Immunotherapy

Japanese researchers from Central Research Laboratories, Kaken Pharmaceutical Co., Kyoto, Japan, studied the efficacy of Sizofiran (SPG), a highly purified form of beta-1,3-D-glucan used in combination with local irradiation for treatment of squamous-cell carcinoma.[85] When SPG was administered after irradiation, remarkable inhibition of tumor growth was observed in comparison with the radiation alone group. Furthermore, the combination effect of radiation and active immunotherapy using mitomycin C-treated NR-S1 cells as a vaccine was examined. When radiotherapy and active immunotherapy were combined with SPG, suppression of tumor growth was observed from an early stage in comparison with the group which was not administered SPG. The highly purified form of beta-1,3-D-glucan also inhibited lung metastasis.

MAITAKE D-FRACTION CLINICAL RESULTS

What about research specifically on Maitake D-fraction? The research on Maitake D-fraction is steadily advancing the science that supports its use for cancer prevention and therapeutics.[86]

In published studies, Maitake D-fraction has been shown to markedly benefit persons suffering cancers of the pancreas, brain, prostate, liver, lung,

and breast, either by decreasing or stabilizing tumor size, reducing tumor markers, or by prolonging patients' expected life span by more than four-fold. For example, Chinese researchers from Zhejiang Medical University and Zhejiang Cancer Hospital, Hangzhou, Zhejiang Province, China, used maitake extract among 63 cancer patients as adjuvant therapy with their chemotherapy and radiation treatments.[87] The patients took the maitake extract before meals, four times per day. The results were highly gratifying with a 95.83 percent success rate against solid tumors and 90.91 percent among the leukemia patients. The total effectiveness rate for overall immune enhancement was rated by the researchers at 86.67 percent.

Case reports from Japan involving 165 cancer patients with liver, lung or other cancers are particularly encouraging. In these studies, patients had been using chemotherapy with only minimal benefit but adding the Maitake D-fraction to their regimen markedly enhanced results. In several cases with both liver and lung cancer patients, they went from dangerous stage III status to more manageable stage I. Especially promising results were seen for breast and lung cancers. Some 73.3 percent of breast cancer patients experienced symptomatic improvement or tumor regression; 46.6 percent of cases with liver cancer; and 66.6 percent of lung cancer cases.[88]

The use of the Maitake D-fraction also ameliorated various side effects due to chemotherapy such as lost appetite, vomiting, nausea, hair loss and white blood cell deficiency in 90 percent of patients; pain was reduced in 83 percent.

Most recently, based on these successful clinical reports, Maitake D-fraction was given investigational new drug status from the Food and Drug Administration to conduct a Phase II pilot study in the United States on its benefits in treatment of advanced breast and prostate cancer patients. Because of the established safety of the Maitake D-fraction, the FDA waived the need for additional Phase I toxicity studies.

Perhaps what most impressed FDA officials when they accorded Maitake D-fraction investigational new drug status were recent clinical results obtained from cancer treatment studies conducted in Japan where results suggest that breast, lung and liver cancers were improved by use of Maitake D-fraction and crude maitake powder.

Indeed, the data shown below indicate that further clinical trials are in order for this remarkable natural agent. In the non-randomized clinical study involving 165 patients diagnosed with various stages III-IV cancers and aged 25 to 65, they were given Maitake D-fraction with crude maitake powder tablets only or with chemotherapy. Tumor regression or significant

improvements were observed among 11 out of 15 breast cancer patients, 12 out of 18 lung cancer patients, and 7 out of 15 liver cancer patients. If taken with chemotherapy, these response rates improved by 12 to 28 percent.

Liver Cancer

A 51-year-old male with liver cancer had received adriamycin (ADM) since 1993 (for about three years). But the treatment yielded poor results with severe side effects and he no longer wanted to undergo chemothera- peutic treatments. He began taking 35 mg of Maitake D-fraction and four grams of crude maitake powder per day. After eight months, his levels of bilirubin (a reddish yellow water-insoluble pigment occurring especially in bile and blood and causing jaundice if accumulated in excess) and albumin (water-soluble proteins that occur in blood plasma or serum and serve to maintain osmotic pressure) were both improved. His bilirubin values decreased from 4.7 milligrams per deciliter (mg/dL) to 1.8 mg/dL and albu- min values from 3.7 grams per deciliter (g/dL) to 2.1 g/dL .

His prothrombin activation increased from 36 percent to 92 percent. This was excellent. When the liver is diseased, it is unable to manufacture ade- quate amounts of clotting or thrombosis factors, so improved prothrombin activation indicates better liver function.

His T-factor improved from 3-4 to 1-2. This is also an important finding, as T-factors indicate tumor diameter, and a T-factor 3 indicates a tumor more than two centimeters with potential spread into blood vessels.

His N-factor changed 0-1 to 0. This was also good, since N-factor 1 indi- cates the tumor has metastasized to the lymph nodes. In other words, his metastasis had been halted.

In a second clinical case, a 56-year-old female was diagnosed with stage III liver cancer with a serum bilirubin reading of 3.5 mg/dL, albumin of 2.8 g/dL, and prothrombin activation of only 48 percent. Her T-factor was 3 and N-factor was 1. Her M-factor, indicating remote metastasis, was 0. She received transcatheter arterial embolization in January 1994 and 10 mil- ligrams of lipodol, 15 mg of adriamycin and 100 mg of cisplatin administered by injection. Next, 200 mg of 5-fluorouracil (5-FU) was orally administered for 60 consecutive days but no improvements were seen. In December 1994, she started taking 55 mg of Maitake D-fraction liquid and six grams of maitake crude powder tablets everyday. As of July 1995, her bilirubin value had gone down to 3.5 mg/dL, her albumin down to 3.1 g/dL, and prothrombin activa- tion level had improved to 63 percent. She was diagnosed as stage I.

Lung Cancer

A 53-year-old female was diagnosed in November 1993 with lung cancer diagnosed as stage III-A. She was given chemotherapy (cisplatin and ADM), but treatment was halted by March 1994 due to severe side effects. After fourteen months of daily use of 50 mg of the D-fraction and four grams of crude maitake powder tablets, together with other treatments, she improved to stage I.

In another clinical case, a 71-year-old male was diagnosed with stage IV lung cancer. He was told by his doctor he had three months to live but refused chemotherapy. Typically, we want patients to work with their doctor. But in this case, the patient did not. He began taking 70 mg of Maitake D-fraction and six grams of crude maitake powder tablets daily. The patient outlived his doctor's prediction, surviving another 20 months. He showed much improvement and was diagnosed as stage III-A before he passed away.[90]

Breast Cancer

A 45-year-old female with estrogen-responsive breast cancer underwent surgery in April 1992 to remove the tumor, which measured 1.8 centimeters. She received mild chemotherapy with 5-FU and ADM until February 1994. But the cancer recurred in April 1994, the tumor size measuring 0.9 cm. She refused surgery and instead started to take 100 mg of Maitake D-fraction and five grams of maitake powder every day for six months. After six months, she reduced her dosage of D-fraction to 50 mg a day. By May 1995, it was confirmed that the recurred tumor had disappeared.

In a current case, which is part of an FDA Phase II clinical trial, a 36-year-old female was diagnosed with cancer in her left breast in 1998. Metastasis occurred by January 2000. Her chronic embryonic antigen (CEA) marker was 188 and her CA15-3 measurement (another prognostic indicator) was 678 with her lymphocytes at 39 percent. She began on Maitake D-fraction; her condition stabilized within six months.

Thus far, results from the FDA-sanctioned breast cancer study have demonstrated positive benefits including: stabilization of bone metastases; improved quality of life with less pain and discomfort; decreasing tumor markers (CEA, BCA, NCC and CA-15-3); and, maintenance of high levels of natural killer cell and lymphocyte activity.

Leukemia

Dr. Peter D'Adamo, N.D., of Greenwich, Connecticut, author of the best-selling *Eat Right for Your Type*, notes the case of a leukemia patient who had

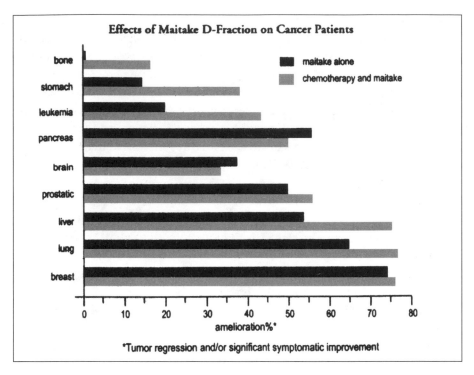

Effects of Maitake D-Fraction on Cancer Patients

■ maitake alone
▨ chemotherapy and maitake

amelioration%*

*Tumor regression and/or significant symptomatic improvement

received chemotherapy; yet, her tumor had spread to her spleen. "The tumor grew fast and her spleen was swollen when she came to me," he says. "I gave her D-fraction and instructed her to take a half teaspoon twice a day. After a while the tumor completely disappeared."

Brain Cancer

Finally, we report on a 44-year-old male with a brain tumor. The patient had undergone four cycles of chemotherapy earlier that he could not tolerate and had been without any treatment whatsoever for about four months when he began a new regimen that include 100 mg of Maitake D-fraction and six grams of maitake crude powder tablets every day for four months without any other chemotherapy or radiation treatments. The patient showed "dramatic improvement" and experienced complete regression of an egg-sized tumor.

TREATMENT MODALITIES

Now let's look at how Maitake D-fraction might work to augment typical cancer treatments.

Chemotherapy

Most clinicians prefer use of Maitake D-fraction together with conventional therapy. This is especially true for chemotherapy where we see strong potential of Maitake D-fraction to synergize chemotherapy (see also our next chapter on prostate cancer).

Interestingly, in one study Maitake D-fraction demonstrated tumor growth inhibition that was superior to the chemotherapeutic agent, mitomycin C, but when both the natural agent and MMC were combined at half the dose of each, the inhibitory effect was even further enhanced. This is important, because when we can achieve a chemotherapeutic effect with our patients at a lower dosage of the medical drug, this markedly reduces side effects, a limiting factor in almost all chemotherapeutic regimens.

In this study, Maitake D-fraction demonstrated superior tumor growth inhibition to that of MMC, the difference being 80 percent to 45 percent for each agent, respectively. But when MMC and D-fraction were given together, each dose reduced by half, tumor inhibition was highly enhanced to almost 98 percent. "The result indicates some synergistic effect between MMC and Maitake, i.e., tumor cells are directly attacked by MMC while the immune system is activated by D-fraction," notes the researcher who conducted this study. He goes on to note, "Chemotherapy is sometimes very harmful as it significantly lowers the immune system of the patients. We have seen many advanced cancer patients recover from severe side-effects caused by chemotherapy by taking Maitake D-fraction (orally) as an adjuvant."[91]

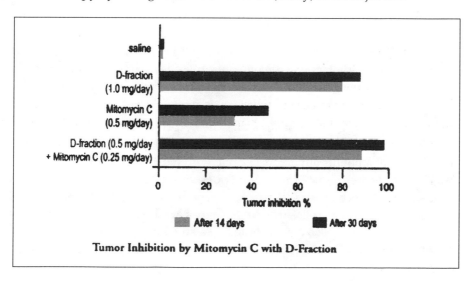

Tumor Inhibition by Mitomycin C with D-Fraction

Ameliorates Side Effects

There are also strong indications that while Maitake D-fraction contributes to tumor reduction without a high loss of white blood cells, it also reduces pain, hair loss, nausea and other side effects usually associated with chemotherapy as a cancer treatment. In other words, maitake improves quality of life.

USE OF MAITAKE D-FRACTION AS PART OF INTEGRATING ALLOPATHIC AND ALTERNATIVE MEDICAL THERAPIES

A case report from Eric A. Scheinbart, M.D., published in the May/June 2001 issue of *Alternative Therapies*, shows us how Maitake D-Fraction may be used as a key part of a comprehensive complementary cancer therapy program.[94] Dr. Scheinbart, a board-certified general practitioner and diplomate of the American Academy of Anti-Aging Medicine, also specializes in Ayurvedic medicine. This report, condensed from the original article, is illustrative of how important complementary cancer therapies are becoming to the integrative treatment of patients.

In this case, the cancer was multiple myeloma, a neoplastic disease characterized by infiltration of bone and bone marrow by myeloma cells forming

FYI:
Vitamin C Synergizes Maitake D-fraction

Very recent discoveries have been made on combined use of beta-1,3-D-glucan and vitamin C derivatives. We now know that the vitamin C content in macrophages reaches 40 times the level of the nutrient in plasma. However, macrophages activated with beta-1,3-D-glucan exhibit a significant drop in their vitamin C content. This might lead to the exhaustion of free-radical scavenging capacity of these cells, as well as to impaired motility and certain enzyme production by macrophages.

Fukumi Morishige, M.D., Ph.D., a renowned Japanese surgeon and a member of the Linus Pauling Institute, Corvallis, Oregon, explains that taking small amounts of vitamin C along with mushroom supplements will facilitate absorption of polysaccharides and enhance their effectiveness further.[92] Such increased absorption renders polysaccharides more accessible to immune cells, including macrophages and NK cells. Synergy with vitamin C was also demonstrated by a study on Maitake D-fraction-induced apoptosis in prostatic cancer PC-3 cells (see Chapter Six).

multiple tumor masses that lead to pathological fractures. The condition is usually progressive and fatal. Symptoms include anemia, renal damage, and high globular levels in blood and increased susceptibility to bacterial infections. The life expectancy of responding patients is only two to three years.

Dr. Scheinbart's patient was a 56-year-old white male who had been a supervisor at a nuclear energy plant. "He initially presented to the office on September 20, 1998, complaining of tiredness, weakness, general malaise, abdominal discomfort, productive cough, and was concerned about attending his daughter's wedding.

The patient was referred to an oncologist in Augusta, Georgia. That February he underwent the first of several unsuccessful bone marrow transplants. His red blood cell and platelet counts continued to decline. Renal function continued to deteriorate over the next several months. The patient visited the hospital laboratory for evaluation, on November 5, 1999, after the last bone marrow transplant. His red blood cell and platelet counts remained low. He continued to lose weight and reached a low of 140 pounds from an original weight at diagnosis of 175 pounds.

In late December, he presented at the emergency department and was transferred to Doctor's Hospital in Augusta, Georgia, with a low-grade fever, pneumonia and possible sepsis.

Additional symptoms were shortness of breath, cough, diarrhea, nausea, vomiting and anorexia. Sputum and blood cultures performed on admission to the referral facility were positive for vancomycin-resistant *Staphylococcus aureus*.

He remained in the hospital for seven days, after which, he was instructed to return home to "get his affairs in order," with a diagnosis of multiple myeloma unresponsive to three bone marrow transfusions and vancomycin-resistant *Staphylococcus aureus* pneumonia.

The patient, bedridden and housebound, requested that the family leave him alone to die. On presentation of the patient's wife and daughter and because of previous discussions of the application of alternative medicine in this case and the desire of the patient and family to try anything—a program of alternative therapy was prescribed.

Among the supplements that Dr. Scheinbart prescribed:

- Beta-1,3-D-glucan 500 mg (three times a day)
- Maitake D-fraction mushroom extract, two droppers (three times a day)
- Maharishi Amrit Kalash (herbal concentrate) MAK-4, one teaspoon (three times a day)

- Maharishi Amrit Kalash (herbal tablet) MAK-5, one tablet (three times a day)
- Pro-Boost Thymic formula, one packet sublingually (three times a day)
- Gerovital GH-3, one tablet (three times a day)

In order to insure that he met minimum nutrient targets his diet included daily portions of fresh fruits, vegetables, and supplementation with a liquid protein supplement as tolerated. Along with these oral medications, counseling was also included in the protocol that would reinforce the need for a positive mental attitude and guided imagery. To his credit, the patient was extremely compliant and followed the alternative clinical protocol religiously.

Within a period of one week, ulceration of the mouth had resolved and the patient was somewhat better in appearance and was ambulatory. Laboratory results indicated that BUN and creatinine levels were slightly lower and his electrolyte status was improved, although he continued to be acidic.

All laboratory results during this period were copied and sent to his physicians in Augusta and Arkansas. He also maintained a positive mental attitude.

During January and early February 2000, the patient continued exclusive treatment with the alternative therapies and traveled to the clinic in Arkansas for follow-up. It was during this visit that it was determined that the patient was "miraculously in remission and without pneumonia."

Upon his return home, the patient insisted on continuation of the alternative therapy. His platelet count began to rise in the second half of February, and, during the last week of February, the oncologist began therapy with thalidomide. Subsequent platelet counts began to drop and the thalidomide therapy was discontinued. Platelet counts again began to once again rise.

He began to improve significantly and resumed many of his former activities. During this period of well-being, he decided, without notifying either his physicians or family, to decrease his medications and within a period of two weeks his laboratory results began to reflect a slide in his condition. He was counseled as to the necessity to maintain the clinical protocol as instructed and again, after a short period of optimum compliance, his health and laboratory results began to improve.

Currently, his electrolyte status, complete blood cell and differential counts, immunoglobulin levels, results of electrophoresis and bone marrow aspiration are all within the normal range.

Dr. Scheinbart notes in his article that a greater number of Americans are turning to alternative therapies for the treatment of a wide variety of health

conditions, either as a way to enhance their traditional medical care or as a substitute for conventional methods of treatment. Dr. Scheinbart says that, ideally, a complementary therapy should not interfere with any traditional therapy the patient may already be receiving; provide protection from the toxic effects of the traditional therapy the patient is receiving; and be capable of supporting the patient as a stand-alone therapy.

His rationale for the use of Maitake D-fraction and purified beta-glucan is that the macrophage "plays an essential role" in initiation and maintenance of the immune response. The macrophage must be activated, a process involving a number of morphological changes, in order to function defensively. He adds that, although macrophage stimulation or activation can be initiated by a variety of different stimuli such as endotoxin, bacteria, viruses or chemicals, these activators can be too toxic or pathogenic to be medicinally useful.

He combined two potent forms of beta-glucan because both are very powerful stimulators of the immune response. While purified beta-glucan is a source primarily of beta-1, 3-D-glucan, Maitake D-fraction is a broad-spectrum source of beta-glucans. "The D-fraction component appears to possess considerable antitumor activity."

He further notes:

"Unlike other medicinal mushrooms, the β-glucan obtained from maitake mushrooms has a unique and complex chemical structure: a 1,6 main chain having a greater degree of 1,3 branches. It is generally theorized that the greater the degree of branches, the more chance to reach each immune cell for activation, and thus the greater the potency. The Maitake D-fraction activates macrophages, natural killer cells, and other T cells to attack the tumor cells. It also potentiates the activity of various mediators, mainly lymphokines and interleukin-1 and interleukin-2, all of which activate the cell-mediated response.

"Research has shown that Maitake D-fraction not only inhibits tumor growth, but can be used to prevent new formation of tumors and to slow metastasis of existing cancer cells. When taken in conjunction with chemotherapeutic agents, Maitake D-fraction increases the benefits the agents provide by inhibiting cancer cell growth and ameliorating many adverse effects of the toxic agents. Therefore, thanks to the immunomodulating properties of β-1,3-glucan and Maitake D-fraction extract, we hoped that the combination would optimize the patient's immune function."

Furthermore, the combination of the two beta-glucan sources would help to protect against opportunistic infections that plague cancer patients whose immune system function is compromised.

The Ayurvedic formulas played a key antioxidant role. Maharishi Amrit Kalash-4 (MAK-4) and Maharishi Amrit Kalash-5 (MAK-5) are complex herbal mixtures rich in vitamin C, vitamin E, beta-carotene, polyphenols, bioflavonoids, and riboflavin. Research shows they may be as much as one-thousand times more effective at scavenging free radicals than the well-known antioxidant vitamins C and E. The thymus extract helped to restore thymic hormone function. The Gerovital GH-3 was added to improve the patient's mood and spirit.

For physicians and consumers desiring detailed information, we recommend that the entire report be obtained.* However, the take-home message is that complementary cancer therapies work, and Maitake D-fraction frequently is playing a key role. It has been more than two years since the initial diagnosis of multiple myeloma in this patient. "The alternative therapy protocol of immunostimulants, antioxidants, thymic protein, and nutritional supplements, along with a positive mental attitude, guided imagery, and strong family support has shown (1) remission of the multiple myeloma, (2) resolution of the vancomycin-resistant *S. aureus*, (3) absence of toxic effects of the alternative treatments, (4) improvement in the patient's longevity and quality of life, and (5) comparatively less cost in the treatment," says Dr. Scheinbart.

Jeanne M. Wallace, Ph.D., C.N.C., reports that in her work with brain tumor patients she utilizes a comprehensive nutritional and botanical protocol as a complement to conventional therapies (cautiously and selectively chosen). "My approach is to utilize integrative support to impact the cancer process from many angles: inflammatory cascade, immune function, angiogenesis, invasion, cell-cell communication, differentiation and apoptosis," she says. An article summarizing her work appeared in the March 1999 issue of the *International Journal of Integrative Medicine* (formerly the *American Journal of Natural Medicine*). Here is a summary of her current brain tumor clients who are taking Maitake D-fraction as part of their protocol:

* *Reprint requests: Eric A. Scheinbart, M.D., 401 E. Liberty St., Savannah, GA 31401; phone, (912) 236-4825; fax, (912) 238-5813; e-mail, e.scheinbart@lycos.com.*

Client	DX	Date of Dx	Status* Treatments*
A.R.	GBM IV	3/95	excellent S, RT, GK, CH
D.K.	GBM IV	3/97	excellent S(2), RT, CH
C.C.	GBM IV	10/97	excellent S, RT, GK,
D.Cl.	GBM IV	9/98	excellent S, RT
B.R.	GBM IV	3/98	stable S, RT, CH, Cantron
R.P.	GBM IV	7/98	excellent S, RT
D.Cr.	GBM IV	8/98	stable? (inoperable), RT
R.L.	AA II/III	6/91	stable S(2), RT
E.T.	AA III	5/98	stable S, RT, BDY, CH

* Status, as of 12/1/98, is reported as Excellent when history includes regression of the tumor as demonstrated by MRI; reported as Stable when MRIs to date show no progression of the tumor
* Treatment Key: S= surgery, RT=radiation therapy, CH=chemo, BDY=bradytherapy, GK=gamma knife

Besides 10 to 20 drops of Maitake D-fraction, taken three times a day, some of the additional supplements utilized by her clients (protocol is tailored for each patient) include: a multiple vitamin/mineral (without iron); high-dose bromelain, inositol hexaphosphate with inositol per day (10 to 16 capsules of PhytoPharmica Cellular Forté with IP_6 and Inositol); astragalus, Siberian ginseng, alkylglycerols, an omega-3 fatty acid supplement.

THE DOCTORS' PRESCRIPTION

The use of Maitake D-fraction and maitake crude powder should be characterized as immunotherapy and as a complement to chemotherapy, radiotherapy or surgery. Its use is completely safe—and as we hope we have demonstrated very important for persons undergoing cancer therapy.

Our recommendation was recently confirmed when the specific Maitake D-fraction material on which we reported was given investigational new drug status from the FDA to allow cancer researchers to conduct a Phase II pilot study in the United States on its benefits in treatment of advanced breast and prostate cancer patients.

In fact, FDA authorized skipping usual first-phase toxicity studies, allowing researchers to proceed directly to clinical trials. This is because earlier studies have shown Maitake D-fraction and maitake crude powder to be without toxicity or significant side-effects.

continued on next page

The Doctors' Prescription (continued)

From these clinical results, we can say very clearly that Maitake D-fraction appears to hold real promise as adjuvant therapy for cancer patients, particularly for breast, lung, liver, pancreatic and prostate cancers but was less effective against bone and stomach cancers or leukemia.

It is important to use the materials that are being clinically studied: **Grifron®-Pro D-Fraction®**, from Maitake Products, Inc.

The usual dosage is 30 drops daily; however, other health professionals have recommended a dosage as high as 68 drops daily. We recommend that D-fraction use be combined with whole maitake mushroom products.

ADDITIONAL DOSAGE INFORMATION

For general use as a dietary supplement, five to six drops of **Grifron®-Pro D-Fraction®**, three times daily between meals, is recommended. (One drop of **Grifron®-Pro D-Fraction®** contains approximately 1.1 mg of pure Maitake D-fraction.)

The therapeutic amount of Maitake D-fraction is from 0.5 mg to 1.0 mg per kilogram (kg) of bodyweight per day. To find your weight in kilograms, multiply your weight in pounds times 0.45. Example: 150 pounds = 68 kilograms (150 x .45). The therapeutic daily amount would range from 34 mg to 68 mg of pure D-fraction, which is approximately equivalent to 34 to 68 drops of **Grifron®-Pro D-Fraction®**. One one-fluid ounce bottle contains approximately 820 drops.

Sample D-fraction Dosages

Weight in pounds	Weight in Kg	Total Daily Amounts Grifron®-Pro D-Fraction®
100 lbs.	45 kg	22-45 drops
120 lbs.	54 kg	27-54 drops
150 lbs.	68 kg	34-68 drops
200 lbs.	90 kg	45-90 drops

CHAPTER SIX

Maitake D-fraction: Not Just Another Immune Enhancer but an Apoptosis Inducer

MANY PROSTATE CANCER PATIENTS HAVE WONDERED whether natural medicines can reliably be recommended as part of their treatment program. Newly published research findings show us Maitake D-fraction can, and probably should, be part of many prostate cancer treatment programs.

For many men with prostate cancer, therapeutic use of Maitake D-fraction can be as important and critical a part of their cancer treatment program as radiation, surgery, or chemotherapy.

The use of Maitake D-fraction may be especially valuable for hormone-refractory prostate cancer cases. These are types of prostate cancers that are resistant to hormonal intervention; thus, typically used prostate cancer drugs have little to no lasting effect.

Prostate cancer is the most common malignancy in elderly men and the second-leading cause of male cancer death in the United States with approximately 140,000 new cases and over 39,000 deaths expected to occur annually.[95]

One of the reasons for such high mortality is due primarily to the progression of the disease to a hormone-refractory or androgen-independent cancer state. And, thus far, current conventional therapies for hormone-refractory prostate cancers are relatively ineffective.

While initial responses to hormonal drug therapy for prostate cancer are often quite positive, for about 80 percent of patients the cancer eventually becomes unresponsive to further therapy. Tragically, most of these men's cancers will progress to other tissues and organs, leading to a fatal relapse within a few years.

The work of co-author Konno, in collaboration with Dr. Hiroshi Tazaki, M.D., Ph.D., also of New York Medical College, is important because, as associate editor and editor, respectively, of the international medical journal, *Molecular Urology*, both men have much "gate-keeper" influence on cutting edge therapies that are destined to become accepted as part of mainstream urological oncology. Thanks to their work, scientists worldwide have begun to view Maitake D-fraction as an emerging individual or complementary therapy in prostate cancer treatment.

Dr Tazaki recently presented findings from the FDA-sanctioned clinical study with prostate and breast cancer patients at the 9th International Congress on Anti-Aging & Biomedical Technologies. In his presentation in December 2001 at the Las Vegas conference, Dr. Tazaki noted that for prostate cancer patients use of Maitake D-fraction:

- Helps lower PSA.
- Improves quality of life in bone metastasis patients.
- Maintains optimum levels of natural killer cell and lymphocyte activity.
- Probably induces apoptosis (cell death) in tumors.

He also presented findings from laboratory work that shows us how Maitake D-fraction actually induces suicide among prostate cancer cells—and why its use may be so important to patients whose cancers are unresponsive to typical therapeutic drugs.

BEAUTY OF CELLULAR DEATH

Hey, guys, don't you just love apoptosis? What, you've never of good old apoptosis? Well, you should.

If you are concerned about prostate health, cellular apoptosis could be important, and, if you want to induce apoptosis in your own body, Maitake D-fraction could be one of the better friends you'll make in the nutritional supplement world.

When Death is Good

Most scientists, like most people, abhor the thought of death. It usually means that something in our biological make-up has worn out or gone bad, notes Christine Gorman, a writer for *Time* magazine.[96]

Yet, sometime in the 1970s, researchers began pioneering the notion that for living organisms to remain in a state of health, death must ensue. We are speaking of cellular death. Large numbers of our cells must die for

us to go on living. The immortal cell foreshadows death of the organism. The immortal cell is, after all, the basis of the cancerous cell. Thus, cell death must be part of our genetic make-up. The process of genetically programmed cell death is called *apoptosis* (from the Greek *apoptOsis* for falling off).

Although until around 1991 there was little awareness or study of apoptosis and only around 300 total papers could be found on medical data bases, that had changed markedly by early 1995, at which time the number of papers had soared to more than 3,000.[97]

Part of our knowledge of apoptosis stems from the work of H. Robert Horvitz, of the Massachusetts Institute of Technology, reports Gorman. Dr. Horvitz researched a tiny worm, *C. elegans*, consisting of fewer than 1,000 cells. It just so happened that during his postdoctoral fellowship work in Britain, Dr. Horvitz was able to trace the appearance and fate of every single of these of these cells from fertilized egg to adult. Many more cells were produced than managed to survive. Later, Dr. Horvitz proved that this cell death was not random but genetically programmed, not an aberration, but at the very heart of the worm's orderly development, notes Gorman.

Alas, what is true for worms is true for humans. We all have these same basic genes that lead to programmed cell death. We need programmed cell death to maintain orderly growth and development.

But what happens when something with our genes goes awry? What happens when our cells forget to die? Many cancers today, we now believe, result because our cells have forgotten how to bow out gracefully and have instead opted for immortality at our expense.

Apoptosis vs. Chemotherapy

Cell death in general follows two distinct pathways: passive necrosis or active apoptosis. However, if men can naturally induce orderly cell death among prostate cells, they can treat and prevent this most common male cancer more effectively than ever before.

When caused by chemotherapy, passive necrosis—the alternative to apoptosis as a means of cell death—might be considered "random cell murder." It is a disorganized, chaotic process of death that releases cytotoxic materials through sudden cell rupture, with randomly adverse effects on healthy cells. The resulting secondary inflammation of adjacent and distant cells is a major problem with such necrotic cell death, and is responsible for the side effects of chemotherapy.

In contrast, apoptosis is a highly organized biochemical process. In this form of meticulously orchestrated death, only those cells programmed to die (or to commit suicide) will do so, and without rupture or release of cytotoxic substances, thereby leaving all neighboring cells intact.

This is the primary advantage of apoptosis and the reason why, if they become available, treatment regimens specifically triggering the targeted apoptosis of cancer cells may represent a great advance over standard chemotherapeutic regimens in terms of reducing side effects.

Not Just an Immune Enhancer but an Apoptosis Inducer

This is why Maitake D-fraction (in this case, Grifron®-Pro D-Fraction®) deserves immediate attention from both oncology patients and doctors. It has been shown to bring our cells back to normalcy and induce orderly apoptosis of prostate cancer cells. It has also been shown to have some of the highest cytotoxic effects on prostate cancer cells of all natural agents (see table *below*).

Once we thought that Maitake D-fraction worked not by killing cancer cells directly but rather via enhanced immune cell function and potentiated the body's natural kill cell and macrophage activity against cancer cells. Now we know Maitake D-fraction can bring our cells back to normalcy and induce orderly apoptosis of cancer cells.

Cytotoxic Activity of Various Natural Extracts on Prostate Cancer Cells

Extracts	Cytotoxic activity[a]
Maitake (*Grifola frondosa*)	>95%
Hime-matsutake (*Agaricus blazei*)	
Extract A	<5%
Extract B	<5%
Reishi (*Ganoderma lucida*)	>50%
Okinawa Mozuku	
Extracts A–E (50–500 kDa)	<5%

[a]The percentage (%) of cell death in prostatic cancer PC-3 cells in vitro.

Table adapted from Konno, S. "Maitake D-fraction: Apoptosis inducer and immune enhancer." *Alternative & Complementary Therapies*, April 2001:102-107.

And now we have suggestive, peer-reviewed scientific evidence that the extract from the maitake mushroom—known as Grifron®-Pro D-Fraction®—induces such programmed cancer cell death.

Based on this most recent evidence, an earlier recommendation—that Grifron®-Pro D-Fraction® be incorporated into prostate cancer therapeutics and prevention program—is now even more urgent.

Some 39,000 men will die this year from prostate cancer.[98] One reason for the high mortality among prostate cancer patients is that prostate cancers—although initially fueled by androgens (i.e., male hormones)—eventually become androgen-independent and take on a life of their own. Thus, anti-androgen therapy is effective for only a few years before its efficacy declines, thus leading to disease progress and death.[99,100] Unfortunately, chemotherapy has not been able to achieve desired efficacy, either.

One of us (Dr. Konno) has explored the potential antitumor effect of D-fraction on androgen-independent human prostatic cancer PC-3 cells *in vitro* (in the test tube). These findings were published in a recent issue of *Molecular Urology*.[101]

Among the findings of this study was a clear-cut dose-response relationship between survival of the cancer cells and various concentrations of D-fraction. The higher the dosage, the greater the percentage of cells that died. At the highest dosage, "almost complete cell death was attained."

"The affected cells were all floating, resulting from a loss of their adherence to the flask, and morphologically, they exhibited 'blebbing' (vesicle formation), indicating oxidative stress," according to co-author Konno and researchers.

Clearly, the death was the result of tinkering with the cancer cells' genetic codes. This could be discerned since little cell fragmentation or disintegration was apparent. Thus, the death of the cancer cells probably did not result from necrosis but rather from turning on the genes within the cancer cells that lead to programmed death.

Taking this research further, Dr. Konno and co-researchers tested the chemotherapeutic agents carmustine (BCNU), 5-fluorouracil and methotrexate (MT), at maximum physiological concentrations for a duration of 72 hours, using the same cells that the Maitake D-fraction so ably decimated. Yet, none of these agents could induce more than a 50-percent reduction in cell viability.

Chemotherapy, as we mentioned, often fails patients because of the hormone-refractory nature of prostate cancer cells. In addition, multiple drug

combinations that cancer doctors prescribe may pose severe side effects.

Improving the efficacy of chemotherapy is urgently required. With the addition of Maitake D-fraction, the efficacy of BCNU for the androgen-resistant prostate cancer cells went from a 50 percent reduction in cell viability to approximately 90 percent. This study implies that Maitake D-fraction may also have a chemosensitizing activity on certain anticancer drugs. By enhancing the efficacy of such chemotherapeutic agents, this can help oncologists to establish the least toxic combination of cancer drugs to be used against difficult-to-treat prostate cancers.

But there's more to this experimental work. The enzyme glyoxalase I is often overexpressed in cancerous prostate tissues. A major function of this enzyme is to detoxify biochemical agents that might be deadly to prostate cancer cells. It may even be said that this enzyme is responsible for the drug-resistant nature of some types of prostate cancer. Yet, when BCNU and Maitake D-fraction are combined, there is extensive inactivation of

Effects of *Grifola* D-Fraction (GD) Combined with Various Agents on PC-3 Cell Viability

	GD (μg/mL) 0	30	60	Differences between groups (t-test)
No addition	100%	100	100	NS[a]
+Vitamin C (200 μM)	95 ± 4.2	8.3 ± 3.5	4.7 ± 1.3	P<0.001
+BCNU (50 μM)	48 ± 4.9	33 ± 6.1	11 ± 2.7	P<0.01
+VBL (100 nM)	50 ± 5.8	49 ± 5.4	50 ± 4.1	NS
+5-FU (5 μg/mL)	53 ± 5.2	51 ± 5.1	52 ± 4.7	NS
+MTX (100 μM)	55 ± 3.6	53 ± 4.4	53 ± 5.0	NS
+VP-16 (100 nM)	100	100	100	NS
+CPL (100 μM)	100	100	94 ± 2.0	NS
+CyP (300 μg/mL)	100	100	95 ± 1.6	NS
+Mit.C (300 nM)	100	100	100	NS

Cell viability data (%) are mean ± standard deviation of three separate experiments.

[a]NS = differences are not statistically significant.

Abbreviations: BCNU= 1,3-bis(2-chloroethyl)-1-nitrosourea (carmustine); VBL = vinblastine; 5-FU = 5-fluorouracil; MTX = methotrexate; VP-16 = etoposide; CPL = cisplatin; Cyp = cyclophosphamide; Mit.C = mitomycin C.

Table adapted from Konno, S. "Maitake D-fraction: Apoptosis inducer and immune enhancer." *Alternative & Complementary Therapies*, April 2001:102-107.

this enzyme. Thus, Maitake D-fraction, used alone, with carmustine or other potential chemotherapeutic agents may have a great potential as an effective, alternative therapeutic modality for hormone-refractory prostate cancer. Now, of course, it is important to discover precisely which chemotherapeutic agents may be sensitized by the addition of Maitake D-fraction, since, as the table below indicates, synergies are not apparent for all such combinations.

These current findings are supported by clinical results from patients with prostate cancer and other cancers. When D-fraction was given with chemotherapy, response rates improved from 12 percent to 28 percent.[102] The clinical status of patients with prostate cancer was improved significantly with D-fraction.

Preliminary data from the ongoing FDA-sanctioned study indicates that Maitake D-fraction use seems to help lower or maintain low prostate-specific antigen (PSA) levels among prostate cancer patients, while helping to maintain healthy functioning of their immune system. The PSA level is important, since PSA is a protein made by the prostate and rising blood levels suggest that the prostate is enlarged or even cancerous. Since chemotherapy often damages the body's immune function, the ability of Maitake D-fraction to help maintain optimal immune cell activity is also important. However, both Drs. Tazaki and Konno caution their clinical results for prostate cancer are preliminary.

Nevertheless, these results, combined with earlier work from other researchers, should offer both reassurance and hope that Maitake D-fraction can safely and beneficially augment mainstream prostate cancer treatment. When we are dealing with patients and a newly introduced drug, surgery, or other intervention, the most important thing we must ask is whether it is safe to use by the patients. That is the most important question. We have 100 percent confidence in the safety of Maitake D-fraction. Based on our and other researchers' current and earlier work, we know that we have a potentially very helpful agent for many types of cancer that will help to prevent metastases and augment immune function. When we are talking about patients for whom current therapies have little efficacy, as in the case of men with hormone-refractory prostate cancer, Maitake D-fraction is definitely worthwhile trying. We already know from other cancers that Maitake D-fraction is beneficial. We even now know some of the mechanisms, including inducing programmed cell death and deactivating certain detoxifying enzymes.

We have here a natural agent that poses no safety risk, yet with a potentially important health dividend for prostate cancer patients. There is enough data to convince us that we are seeing positive outcomes. Not in everyone but often enough to make it definitely worthwhile.

"Maitake D-fraction has all of the biochemical attributes that a pharmaceutical company would desire in a small molecule clinical candidate for prostate cancer," notes Mar J. Neveu, Ph.D., vice-president of medical research, National Foundation of Alternative Medicine, Washington, D.C.

PART THREE

THE GLUCOSE/ INSULIN CONNECTION

DIABETES & SYNDROME X

IN MARCH 2001, TOP OFFICIALS in the Food and Drug Administration received ominous warnings from the FDA's top epidemiological expert that virtually every patient taking the diabetes drug troglitazone (Rezulin) was at high risk for sudden liver failure.[103] Yet, FDA officials decided to allow Rezulin to remain on the market for nearly another year.

Since the March 26 advisory, at least 53 patient deaths have been reported in which Rezulin is thought to be the cause. Clearly, FDA's handling of the safety of diabetes drugs must now be questioned.

Yet, at the same time, there is intense pressure to help people with diabetes get drugs that can help them. The death rate from diabetes and its related complications is mounting and has exploded by 50 percent since 1985.[104]

Between 1993 and 1995, 67,000 diabetes-related amputations were performed with 28,000 cases of end-stage kidney disease reported in 1995 and 24,000 cases of blindness also reported every year. Bottom line: some 193,000 diabetes-related deaths occur annually. Right now, we know that frank diabetes affects more than 16-million people in the United States and some 250-million people worldwide.[105]

There are two tragedies associated with adult onset diabetes today. The first is that by the time a person has been diagnosed with this condition, they've most likely already had it several years or longer. Extensive damage to the nervous and circulatory systems and even their vision may have already occurred.

The second tragedy is that diabetes is striking baby boomers with a vengeance. About six percent of our population presently has diabetes. Many experts believe that percentage will increase significantly as the boomers enter their fifties and sixties. And they say that diet and nutrition will be crucial to

helping persons with diabetes maintain heir health and reduce their risk of complications. The prevalence of diabetes is increasing four to five percent annually with an estimated 40 to 45 percent of people over 65 years of age at most risk.[106]

Indeed, these estimates were recently further confirmed by a study in the November 2001 issue of *Diabetes Care*. The number of Americans with diagnosed diabetes is expected to increase 165 percent over the next 50 years, says the U.S. Centers for disease Control and Prevention. "The study projects the highest increase in prevalence will occur among those age 75 and older," notes *USA Today*.[107] "Among ethnic groups, the biggest jump in prevalence is expected to be among black men (363%), with black women expected to see the second highest increase (217%). The total number of Americans diagnosed is expected to rise from 11 million in 2000 to 29 million in 2050. Lifestyle changes related to increases in obesity, the aging, pop-

FYI:
Poor Circulation One of the Key Symptoms of Diabetes

Adult onset diabetes is a dangerous disease. You should be aware of the risk factors and symptoms. If you tend to eat too much, are obese and over 40 you're at risk for adult diabetes. If you are more than twenty percent above your ideal weight, over 50 and female, your risk for diabetes is even greater. People with a family history of the disorder are also at higher than normal risk. Do you ever feel a heaviness in your lower legs, tingling, or suffer nocturnal cramps? Do your fingers sometimes feel alternately numb or tingly? Is your vision deteriorating? Do you urinate much more than usual, sometimes as often as every hour? Are you often unusually thirsty? And does consuming sweetened beverages increase the amount you urinate and worsen your thirst? Do you often feel extremely tired, weak and apathetic? Is it difficult to get up in the morning? Do you suffer from foot or leg ulcers or varicose veins?

Any of these symptoms, alone or together, means you could be suffering from diabetes. Unfortunately by the time these symptoms appear, it is likely that you've already been suffering from diabetes for several years. That is why it is important *not* to delay seeing your health professional to be sure of the diagnosis or in taking positive steps to improve your overall health. Type II diabetes lends itself beautifully to natural methods of control. Diet, for example, can help a great deal. Such a diet restricts the amount of carbohydrates a person consumes at one meal. Eating smaller portions more frequently during the day is important. Also cutting out sweets such as the concentrated sugars of candy, cake, baked goods, and other snacks is helpful. Cutting calories also means losing weight, and that will help, too.

ulation, and the changing racial composition will fuel the increase."

New drugs such as Avandia from SmithKline Beecham and others from Eli Lilly & Co., Pfizer Inc. and Novartis AG are on the way. Researchers at these and other pharmaceutical companies are studying how to restore the body's sensitivity to insulin, the effects of diet and obesity on diabetes, and other drugs that can help to prevent deadly diabetes-related complications. (Rezulin, a member of family drugs known as thiazolidinediones, has been shown to attach to specific receptors on muscle, fat and liver cells and help the body better utilize insulin.)

In fact, thanks to Rezulin, the U.S. market for diabetes treatments nearly doubled since 1994, hitting $3 billion in 1998. Altogether we're in the midst of "a revolution" in our ability to treat diabetes, enthuses Dr. Mitchell A. Lazar, director of the Diabetes Center at the University of Pennsylvania Medical Center.

But the case of Rezulin raises important questions about the ability of FDA to protect consumers from potentially toxic drug complications—and the ability of the pharmaceutical giants to create anti-diabetes drugs with acceptable efficacy and safety profiles that fully justify their use among an ever-growing populous in need of support for their glucose/insulin problems.

Metformin hydrochloride (Glucophage) is one of the most widely used anti-diabetic drugs and one of the safest but, still, its use is accompanied by a stern warning that complications could include increased risk of overall mortality and heart disease-related deaths. In fact, this warning (listed in the *Physicians' Desk Reference*) is based on a study by the University Group Diabetes Program which found that patients on other oral anti-diabetic drugs (e.g., tolbutamide and phenformin) for five to eight years actually had a total mortality rate and cardiovascular-death rate that was highly increased over persons who were able to adequately control their diabetes with diet or diet plus insulin.[108,109] The PDR further advises doctors inform patients of alternative methods of therapy.

Meanwhile, acarbose (Precose) has shown some evidence of carcinogenicity to the kidneys and testicles.[110]

Unfortunately, the devastating consequences of diabetes plague sufferers so terribly, this often makes use of potentially dangerous medical drugs seem to be absolutely necessary. Yet, rather than thinking "outside the box" and looking at ways to help patients without the toxicity of prescription drugs, medical doctors often become even further entrenched and place patients on an even more extensive drug regime simply because none of the drugs alone is working at all and they hope that greater combinations of drugs will yield better results. Such mixing of various anti-diabetic drugs, however, can bring on extensive complications.

No wonder many doctors find so many of their diabetes patients are dissatisfied with prescription drugs (i.e., allopathic medications). They simply do not bring expected results in lowering blood sugar. Therefore, persons with diabetes are desperately seeking answers in natural products.

Clearly, the underlying theme of current diabetes treatment is that for most adult cases of diabetes, front line therapy should consist of improved diet, weight loss, and exercise and, when additional help is required, nature's pharmacy offers proven herbs and minerals for the control of diabetes and its related complications.

There is no question that patients must work with their doctors, that very often diabetes drugs—for all of their potential complications—are absolutely necessary. But we now also know there is true hope from nature's pharmacy that men and women can reduce their dependency on diabetes drugs and reduce their complications.

BLOOD SUGAR BALANCE BLUES

When all systems for balancing blood sugar are working, people can eat sweet or refined foods which enter the blood stream very quickly and levels of sugar in their blood will stay relatively the same. Not so for everyone, however. Without an optimally functioning, equalizing mechanism, blood sugar levels would fluctuate so much that a person would have difficulty even functioning.

Your blood sugar is a valuable source of readily available energy for your body's cells, including your brain, and therefore also helps to regulate mood and cognitive function. But when sugar isn't absorbed by the body's cells it becomes a blood poison.

Diabetics know this. A lot more of us probably should know more about blood sugar basics than we do. That is because more of us are on the border for blood sugar problems than official clinical numbers show—especially when we consider that about 20 percent of the adult population is already suffering from Syndrome X (see next page).

Sugar is the primary fuel for the body. Anyone who has gone through a bout of three p.m. sugar cravings and found themselves munching a candy bar knows how intimately sugar governs alertness, mood, and all of our mental powers. Every cell of your body needs sugar. Your need for sugar is instinctual and genetic.

Many of us will find that our overall mood and health will benefit by paying more attention to our own personal sugar metabolism, and by learning how to maintain normal sugar balance. It is critical for those who are on the

FYI:
Types of Diabetes

Medical experts recognize two main types of diabetes.

Type I (insulin dependent) usually occurs in childhood. Its onset is often sudden and severe; control of this disorder requires insulin. People with Type I diabetes have reduced numbers of active beta cells in the pancreas. Beta cells are responsible for production and secretion of insulin. That is why people with this type of diabetes must inject insulin and balance the entry of insulin into the blood with food intake to maintain normal sugar balances. Remissions are rare for this condition, which is thought to be autoimmune related. Type I diabetes is thought to be an autoimmune condition where the body's own immune cells' antibodies attack the insulin-producing beta cells.

Type II, or **adult-onset**, diabetes is slow to occur; in the beginning, symptoms are mild, insidious, almost unnoticed. In adult-onset diabetes, people may have reduced beta cells in the pancreas, but they are more likely to have adequate production and secretion of insulin. The cells of the body have become insensitive or "insulin resistant." Adult-onset diabetes accounts for 90 percent of all cases of diabetes. Fortunately, people with adult type diabetes actually can do a great deal to help themselves. The key is nutrition and lifestyle adjustments.

borderline of having high blood sugar or other sugar-related problems to take positive steps to improve their diet, nutrition, and weight, and to take advantage of the proper use of scientifically validated nutritional supplements.

SYNDROME X

Not all of us with glucose/insulin problems suffer from overt diabetes. You may recently have heard in the news about a sinister-sounding condition called Syndrome X. No, this isn't a newly discovered disease, but rather a new term for a cluster of conditions, that, when occurring together, may indicate a predisposition to diabetes, hypertension, heart disease and other common deadly diseases of aging.

The term was first coined by a group of researchers at Stanford University to describe a cluster of disease-causing symptoms, including high blood pressure, high triglycerides, decreased high-density lipoprotein (HDL, the "good" cholesterol) and obesity, which tend to appear together in

some individuals and increase their risk for diabetes and heart disease and, possibly, cancer and many other disease processes.

The term also has been linked with another term—insulin resistance. Insulin is the hormone responsible for getting energy, in the form of glucose, or blood sugar, into our cells. A person who is insulin-resistant has cells that respond sluggishly to the action of insulin. Following a meal, this person will have elevated glucose circulating in the blood, signaling yet more insulin to be released from the pancreas until the glucose is taken up by the cells. Experts suggest that up to 25 percent of the adult population may be resistant to insulin to some degree.

In fact, Type II diabetes and Syndrome X have much in common. Both are very complex diseases where insulin deficiency is not the problem. Rather, the problem is the body's resistance to insulin. The body may be pumping out plenty of insulin but the hormone isn't being metabolized for optimal use. This condition is known as peripheral insulin resistance. It is difficult to treat, even with our best medical drugs.[111]

Dr. Konno, who has studied maitake and blood sugar, notes in the December 2001 issue of *Alternative & Complementary Therapies*:[112]

"In fact, because of insulin resistance, current oral therapy using sulfonylurea derivatives, which primarily stimulate insulin secretion from pancreatic B-cells, often fails to achieve the expected level of efficacy. Thus, more effective treatment of patients with type 2 diabetes relies mainly on *how* to overcome insulin resistance."

Once again, we see that drugs such as troglitazone and metformin are used to enhance peripheral insulin sensitivity with some improved glycemic control.[113,114,115]

But, again, our patients face troubling side effects. Metformin causes lactic acidosis, which presents as an impairment of their kidney function, cardiogenic or septic shock, or even frank liver failure. Indeed, it was due to such liver toxicity (hepatotoxicity) that troglitazone was removed from the market.

"This raises questions," notes Dr. Konno in his article. "Are there alternative means to overcome insulin resistance safely? Or are any safer *natural* agents available? Such agents could be a key to a better treatment for patients with type 2 diabetes."

FAQS: UNDERSTANDING INSULIN RESISTANCE

What is insulin? Insulin is a hormone secreted by the pancreas. It helps the body utilize blood glucose (blood sugar) by binding with receptors on cells like a key

would fit into a lock. Once the key—insulin—has unlocked the door, the glucose can pass from the blood into the cell. Inside the cell, glucose is either used for energy or stored for future use in the form of glycogen in liver or muscle cells.

What is insulin resistance? Insulin resistance occurs when the normal amount of insulin secreted by the pancreas is not able to unlock the door to cells. To maintain a normal blood glucose, the pancreas secretes additional insulin. In some cases (about one-third of the people with insulin resistance), when the body cells resist or do not respond to even high levels of insulin, glucose builds up in the blood resulting in high blood glucose or Type II diabetes. Even people with diabetes who take oral medication or require insulin injections to control their blood glucose levels can have higher than normal blood insulin levels due to insulin resistance.

Why is insulin resistance in the news? More and more people in the United States are becoming obese, physically inactive, or both. Obesity and physical inactivity aggravate insulin resistance. Also, people who are insulin resistant typically have an imbalance in their blood lipids (blood fat). They have an increased level of triglycerides (blood fat) and a decreased level of HDL (good) cholesterol. Imbalances in triglycerides and HDL cholesterol increase the risk for heart disease. These findings have heightened awareness of insulin resistance and its impact on health.

What is Syndrome X? Syndrome X is a cluster of risk factors for heart disease associated with insulin resistance. These risk factors include: hypertriglyceridemia (high blood lipid), low HDL-cholesterol, hyperinsulinemia (high blood insulin), often hyperglycemia (high blood glucose), and hypertension (high blood pressure).

Who has insulin resistance? Almost all individuals with Type II diabetes mellitus (diabetes) and many with hypertension, cardiovascular disease, and obesity are insulin resistant. These diseases and conditions are predominantly found in countries with an improved economic status such as the United States and United Kingdom. And in the industrialized nations, these diseases and conditions are among the leading contributors to morbidity and mortality. Also, about 20 to 25 percent of the healthy population nevertheless may be insulin resistant.

What are the symptoms of insulin resistance? There are no outward physical signs of insulin resistance. A glucose tolerance test, during which insulin and blood glucose are measured, can help determine if someone is insulin resistant. Many people who are insulin resistant produce large enough quantities of insulin to maintain near normal blood glucose levels.

What causes insulin resistance? Some scientists think a defect in specific genes may cause insulin resistance and Type II diabetes. Researchers continue to investigate the cause. What we do know is that insulin resistance is aggravated by obesity and physical inactivity, both of which are increasing in the United States and other industrialized nations. Dietary and lifestyle habits play a major role.

Do all people with insulin resistance develop diabetes? No. Science has not yet determined why some people with insulin resistance eventually develop diabetes and others do not. By maintaining an appropriate weight and a physically active lifestyle many individuals are able to reduce their chances of becoming insulin resistant and developing diabetes.

What is the best diet for people with insulin resistance? Research indicates that low-fat diets may aggravate the effect of insulin resistance on blood lipids. Therefore, for individuals who are insulin resistant, a diet low in trans and saturated fat (less than 10 percent of total calories) and more moderate in total fat content (40 percent of total calories) may be beneficial. This recommendation is different from the low-fat, high-carbohydrate diet that many health organizations have, up to now, recommended to help prevent heart disease.

It is also beneficial to maintain an appropriate body weight because obesity can aggravate insulin resistance. To maintain an appropriate weight, regulate caloric intake and maintain a physically active lifestyle. A certified nutrition specialist and registered dietitian can assist with developing a proper diet plan for people with insulin resistance, or a family history of Type II diabetes.

What else can people with Syndrome X do to help themselves? Because the individual conditions of Syndrome X occur in a cluster, the steps you take to bring one of the conditions into a healthy range will likely improve the others. For example, if you're overweight, simply losing up to 10 or 15 percent of your current body weight can bring blood pressure down and increase your cells' sensitivity to insulin. Exercise is an important component of weight loss. It also raises HDL blood levels, even without weight loss.

Steps to help bring triglycerides down include a diet moderate in alcohol and low in refined carbohydrates like soda, table sugar and high fructose corn syrup, which is widespread in prepared foods and listed on labels. Contrary to what some think, this is not in conflict with the dietary guidelines recommendation to eat 55 percent of total calories from carbohydrates, primarily complex carbohydrates. The key words here are "complex carbohydrates," such as grains, beans and vegetables, rather than sweets and desserts, and the total number of calories being consumed—just enough to maintain or achieve desirable weight.

FYI:
Syndrome X Symptoms

Increasingly in recent years, scientists have recognized that some symptoms of impending or overt disease cluster together in certain people. These risk factors, part of Syndrome X, include:

- Central obesity (excessive fat tissue in the abdominal region)
- Glucose intolerance (inability to process sugar)
- Hyperlipidemia (primarily high triglycerides and low levels of beneficial high density lipoprotein cholesterol)
- Hypertension (high blood pressure)

THE SIX DEADLY DISEASES OF AGING

People with Syndrome X are at increased risk for the six most deadly diseases of aging:

- Heart disease (including coronary artery disease, hypertension and high cholesterol)
- Stroke
- Cancer
- Diabetes
- Kidney malfunction
- Weakened immune function (creating susceptibility to many infectious maladies)

Indeed, these six conditions account for more than two-thirds of all deaths in the Western world today.

SYNDROME X—THE BODY UNDER ATTACK

Many physicians and scientists today believe strongly that various disturbances common during the aging process—including hypertension, lipid abnormalities, disturbances in glucose/insulin metabolism, obesity, augmented production of free radicals, and tumor formation—are caused or at least potentiated by the dietary and lifestyle habits of modern society. In Japan, where Syndrome X and its cluster of symptoms and disease patterns, have been infrequently seen in the population, this is all changing as more and more people have switched over, at least to some extent, to the so-called Western diet. We all talk about the wonderful lifestyles we live in the West—

and it's true. But in many ways so many of us are suffering from overnutrition—too many calories and too much sugar and trans fats.

Let us explain. Obesity is largely due to "overnutrition," the modern industrialized world's version of malnutrition.[116] It might be said that at the same time Americans are overweight they are paradoxically undernourished. Obesity reflects interrelated factors, particularly diets high in calories, refined carbohydrates and fat and low in soluble in soluble fibers, and lack of adequate exercise. Ounce for ounce, fat contains twice the calories of protein or carbohydrates. Thus, high fat diets are by definition high calorie diets, largely responsible for obesity, but lacking important nutritional factors found in low-fat, nutrient-dense foods such as fruits, vegetables, nuts, grains, and legumes. Refined carbohydrates with their rapid absorption stress the insulin system. The Western diet, high in fatty acids and sugars, is associated with people suffering from insulin resistance and hyperinsulinemia.

Doctors almost always find Syndrome X symptoms among diabetics as well as among hypertensives (those with high blood pressure) and persons who are nondiabetic but insulin-resistant and compensate by secreting large amounts of insulin (a condition known as hyperinsulinemia). A third group is heart attack survivors who often have hyperinsulinemia without having abnormal glucose levels.

It is so important for all of us to recognize that disturbances in glucose/insulin metabolism, principally insulin resistance, *also hasten the overall aging process*.[117] Indeed, it is becoming more accepted that elevations in circulating glucose and insulin levels, even small ones, secondary to insulin resistance may contribute to aging.[118,119]

Thus, patients with Syndrome X—especially insulin resistant patients—are likely to age faster than their normal counterparts. Two clinical situations provide supporting examples: Diabetics and end stage renal disease patients undergoing hemodialysis show marked disturbances in glucose/ insulin metabolism and are considered by some clinicians as examples of "premature aging."[120,121]

How could such disturbances in glucose/insulin metabolism lead to many chronic disorders associated with aging? There are at least three major possibilities: enhanced glycosylation; augmented free radical formation; and lowering of dehydroepiandrosterone (DHEA) levels.

Glycosylation

When people suffer from syndrome X, hyperinsulinemia, diabetes or heart disease, they usually also have too much sugar circulating in their

bloodstream. This excess sugar can attach itself to protein and DNA, leading to various body perturbations.

While this term—glycosylation (**gly·co·syl·a·tion**) may be highly technical, it's easy to see the end result. Glycosylation of proteins causes the formation of harmful brown, fluorescent pigments that occur when proteins are cross linked. Also known as advanced glycosylation end (AGE) products, the brown spots on your hands or aging pigment are the result of glycosylation-related cross-linking and the accumulation of a slimy substance called lipofuscin, which is the pigment left over from the breakdown and digestion of damaged blood cells. Lipofuscin is also found in heart muscle and other smooth muscles.

Glycolsylation causes formation of free radicals, damaging the body's collagen, which comprises the lining of the arteries and our skin; damages nucleic acids (the genetic materials of the cells); initiates formation of cholesterol plaques in the arteries; and increases overall free radical formation. People with too much sugar breakdown products in their bloodstream and in whom AGE products accumulate at a faster than normal rate are more likely to develop kidney disease (diabetic nephropathy).[122] They also experience a higher risk at a younger age for cataracts and atherosclerosis.[123,124] This process occurs speedily in overt diabetics. But, compared to normal, the same process could be hastened perhaps at a slower pace in aging, nondiabetics (persons with Syndrome X) due to the development of gradual insulin resistance and elevations of circulating glucose associated with aging.

Free Radical Formation

In order to stay alive, all cells must have an energy source, and that source is oxygen. But although oxygen enabled life to emerge from the oceans, oxygen also initiates changes that destroy life.

A human breathing pure oxygen could live only two days before his lungs would sustain so much oxygen-related damage that he would die. Fortunately the earth's air supply is composed of only 20 percent oxygen.

The human body uses oxygen combined with food to produce energy but this process also turns out harmful byproducts called free radicals.

When prehistoric man was busy being chased by saber-toothed tigers and other woolly beasts, he wasn't concerned with a life span of 90 years; he would have settled for living beyond the next 90 seconds! It seems that for most of humankind's existence, Mother Nature didn't really intend for us to live much longer than 30 years—the time required to mature, breed and prop-

agate the species. Men and women back then were breeding machines. Once humans procreated and passed on their genetic structure, it was time to die.

At least that's what leading experts on aging today like Dr. Denham Harman believe. Dr. Harman is considered the founder of the *free radical theory on aging* which asserts that oxygen-based compounds within our own bodies are the primary cause of human aging. These oxygen compounds, which we have come to know well in the last few years, are known as *free radicals*.

The free radical theory of aging, based on Dr. Harman's findings beginning in 1954, was one of the most important theories on life extension developed in the Twentieth Century and remains so even today in the new millennium. The University of Nebraska emeritus professor of medicine and biochemistry told reporters recently, "Chances are 99 percent that free radicals are the basis for aging. Aging is the ever increasing accumulation of changes caused or contributed to by free radicals."

Dr. Earl Stadtman, chief of the laboratory of biochemistry of the National Heart, Lung and Blood Institute in Bethesda, Maryland, agrees that the damage caused by free radicals is a very important part of the aging process—much more important than medical science was willing to accept in the past. Human life span, says Dr. Stadtman, is dependent on cellular damage caused by free radicals. The body's cells do resist some oxidation damage but eventually they become so damaged that they can no longer function.

Have you ever seen a piece of metal rusting away? Have you ever cut open an apple, and watched it turn brown after a few minutes? Those are two examples of the process called oxidation, caused by free radicals. The hardened metal and the softened apple both fall victim to oxidation and will eventually wear away. Oil-industry scientists in the 1930s showed that free radicals could produce spectacular chemical transformations such as the rancidification of fats and oils. These discoveries gave birth to the development of the plastics and polymers industry.

Free radicals have been described as "great white sharks in the biochemical sea." They are "cellular renegades: they wreak havoc by damaging DNA, altering biochemical compounds, corroding cell membranes and killing cells outright," says *Time* magazine. Such molecular mayhem, scientists believe, plays a major role in the development of ailments like cancer, heart or lung disease and cataracts. The cumulative effects of free radicals also underlie the gradual deterioration that is the hallmark of aging in all individuals, healthy as well as sick.

Looking more closely at free radicals, we see that they are different from other molecules: their electrons—electrically charged particles found in all atoms and molecules—are unpaired and unbalanced.

Because the free radical is so unstable, it desperately seeks to find a match. But a free radical can only get an electron from another molecule. This process of searching for a second electron creates cellular mayhem.

The unstable molecule knocks frantically against other molecules in an effort to attract away an electron. The process destabilizes additional molecules within other cells.

When formed, certain free radicals have the ability to: 1) attack vital cell components; 2) injure cell membranes; 3) inactivate enzymes; and, 4) damage the genetic material in the cell nucleus.

Free radicals formed from oxidative stress have been implicated in the pathogenesis of the aging process and a variety of chronic human diseases associated with aging, including inflammatory diseases, cataracts, diabetes, cancer and cardiovascular diseases.[125,126,127,128,128,130,131]

Augmented free radical formation and lipid peroxidation are not uncommon in diabetes mellitus.[132]

Says Dr. Roy Walford, M.D., one of the nation's leading anti-aging researchers, "Once generated, [free radicals] grab on to everything in reach. And once triggered, free-radical reactions tend to be unstoppable, uncontrollable, and irreversible, almost explosive. Blam! Like Sodom and Gomorrah! Turn you into a pillar of rancid fat!" Incredibly, considering all the damage that they cause, the life span of an oxygen free radical is only a few thousandths of a second.

Because they are short-lived, detection of free radicals is measured characteristically through analyses of their by-products.[131]

Free radicals released in our bodies also destroy the proteins that are essential constituents of our body and that regulate our hormones and enzymes and compose our nerves, muscles, skin and hair. In other words, those wrinkles that we all fear are also the dirty work of free radicals.

Dr. Walford explains their effects: "Chief sites of attack are against cell membranes, both those inside cells (mitochondrial and nuclear membranes) and those forming the external walls of cells.... The radicals may also damage DNA, the hereditary blueprint for life within each cell. Indeed, many of the substances that cause or promote cancer may do so by stimulating cells to produce free radicals which then damage or alter the blueprint until the cell becomes cancerous."

Dr. Harman notes that studies strongly suggest that free radical reactions play a significant role in the age-related deterioration of the cardiovascular and central nervous systems. Free radical reactions may also be significantly involved in the formation of the neuritic plaques associated with senile dementia of the Alzheimer type.

Over time free radical damage accumulates especially in our cellular genetic materials. Dr. Bruce Ames, director of the National Institute of Environmental Health Sciences at the University of California at Berkeley, estimates that the genetic materials in each cell are hit 10,000 times a day by free radicals. The cells that are damaged ultimately repair themselves. But the repair process is only 99.9 percent perfect. Thus, every time a cell is struck by a free radical, the damage becomes a little more devastating and the repair process a little less perfect; the damage to the cell is said to be *cumulative*. For example, one such free radical, called hydroxyl, damages the DNA in human breasts, and when enough damage accumulates to the genetic materials, cancer may follow, according to research performed by Dr. Donald Malins, a cancer researcher at the Pacific Northwest Research Foundation in Seattle.

Since we know that perturbed glucose/insulin metabolism is associated with augmented formation of free radicals, it is not hard to accept that therapies favorably influencing the glucose/insulin system also will lower free radical formation.[134]

Dehydroepiandrosterone (DHEA)

There has been much recent speculation on the role of dehydroepiandrosterone (DHEA), a steroid hormone, and its sulfated ester, dehydroepiandrosterone sulfate (DHEAS), in the aging process. Circulating concentrations of DHEA, which decline during aging, are related closely to insulin concentrations, and exogenous insulin infusion decreases DHEA concentration over hours. In contrast, lowering insulin levels via metformin and chromium administration elevates DHEA and DHEAS concentrations. Like insulin resistance, low DHEA levels have been associated with cardiovascular diseases, tumor formation, osteoporosis, and diabetes mellitus. Infusion of DHEA was reported to ameliorate insulin resistance in a diabetic patient. Chromium supplementation, known to enhance insulin sensitivity, has been shown to increase bone density while increasing the excretion of urinary DHEA. Thus, effects of insulin metabolism on DHEA and DHEAS may play an important role in aging and chronic disorders associated with it.

CHAPTER EIGHT

MAITAKE SX-FRACTION, DIABETES & SYNDROME X

IT IS OFTEN ONE OF THE GREAT MYSTERIES. No one yet has figured out what makes most medical students go in one direction or another and adopt one field of expertise over another. Sometimes, a family illness or the illness associated with a close friend may be influential. But for most of us, God only knows why we end up where we do. And maybe not even God can figure out the mind of a medical student.

Students enter medical school and don't know what they are going to end up doing. All they know is that everyone is always telling them to specialize. Even if they're going to practice family medicine, they're told to become a specialist—a family medicine specialist.

You see, medicine today moves at such a fast clip that it is impossible to keep up with everything. When you start out as a fledgling physician, you want to know everything about everything when it comes to the field of medicine, but you soon realize the field is changing so rapidly that over weeks or months you may be out of date. The challenge is to maintain your excellence. As a physician, you find that as you specialize people come in from other areas and they start talking about your field and you realize they really are not up to snuff. And, when you talk about stuff in their field, you realize you sound equally uninformed and out of date. You just can't do everything in medicine. You can't know everything. So you break up the discipline into smaller pieces. That's both good and bad. You do become good at one thing but you often end up feeling that while you know the trunk of the elephant, a whole lot more is being missed.

One of us (Dr. Preuss) studied renal physiology for two years at Cornell University and then went onto Georgetown University and worked for two

more years specializing in kidney disease—and, lo and behold, he sudden-
ly became a leading expert in the field of nephrology (kidney disease).

The kidneys are not exactly what one might call the body's glamour
organs. They certainly don't get the big bucks in medical funding like mat-
ters of the heart or brain. We tend to take kidney function for granted.
Nephrologists (the technical name for a kidney specialist) are like linemen
on a football squad. They play a vital role but are not stars.

But it was through nephrology that one of us was led to explore new areas
of applications for natural products like maitake mushroom. For example,
high blood pressure specialists often come from a kidney background. The
kidneys control salt and water balance and the kidneys put out various hor-
mones such as renin and angiotensin, which play a vital role in blood flow.

You see, we already knew that whole maitake mushroom could be most
beneficial in alleviating hypertension—but, in the last decade, we have
also been sensitized to the fact that hypertension is often associated with
insulin resistance and lipid disorders such as high circulating cholesterol
and triglycerides, as well as obesity—the major hallmarks of Syndrome X.
And, interestingly, maitake's fractions seem to have a beneficial impact on
all of these.

Not only have we found that whole maitake is a potent natural agent for
normalizing various bodily functions, it can help Syndrome X patients mod-
ulate many of the symptoms that mark this condition. So, with maitake's
various fractions, we are again reexamining the whole picture. We are not
portraying maitake as a "miracle" remedy, but its various fractions contain-
ing specific beta-glucans and other constituents in a concentrated form offer
doctors and other health professionals a safe and effective method to help
patients live healthier, longer lives. This is similarly true for consumers
involved in self-managed care.

Evidence that whole maitake aids the body's glucose-insulin sensitivity
dates to at least 1994. At that time, the fruit body of maitake was confirmed
to contain substances with anti-diabetic activity.[135] When one gram daily of
powdered fruit body of maitake was given orally to a genetically diabetic
mouse, a marked blood glucose reduction was observed in contrast to the
control group. But we were finding our best results with the crude maitake
powder—at the time not any one specific extract.

This study was actually well done. It was a double-blind, cross-over
study and provided key evidence of just how powerful the benefits from
maitake might be. In this study, the mice were divided into two groups. One

group was fed a crude beta-glucan powder from the maitake and the other group served as the controls, consuming their normal laboratory chow. Eight weeks later, the mice receiving the crude powder had significant improvements in three key parameters associated with diabetes: blood glucose, insulin, and triglycerides. Maitake had literally won a triple crown.

Next, the study was continued but with the former control group now receiving the maitake extract and the former treatment group serving as the control. For another four weeks, the same parameters were followed.

Sure enough, after only one week, it was quite clear that the maitake was responsible for the improved blood parameters.

Since this study suggested that the maitake could be a potentially useful remedy for blood sugar problem, additional studies were performed.

Effects of Maitake on Parameters of Diabetes in Mice: Eighth Week

Parameters	Control mice	Maitake-fed mice
Blood glucose (mg/dL)	400	200[a]
Insulin (µU/mL)	1200	220[a]
Triglyceride (mg/dL)	780	410[a]
Body weight (g)	48	38[a]

Adapted from ref. 11.

[a]Differences are statistically significant.

Changes in Parameters of Diabetes After 1 Week of Feed-Switch in Mice

Parameters	Control > maitake	Maitake > control
Blood glucose (mg/dL)	400 >155[a]	180 > 365[a]
Insulin (µU/mL)	790 > 20[a]	120 > 990[a]
Triglyceride (mg/dL)	560 > 125[a]	230 > 620[a]
Body weight (g)	46 > 41	37 > 7

Adapted from ref. 11.

[a]P<0.01 (Note: No statistical differences in body weight.)

Table adapted from Konno, S. *Alternative & Complementary Therapies*, "Maitake SX-fraction: Possible hypoglycemic effect on diabetes mellitus." December 2001;7:366-370.

In 1996, glucose tolerance tests were conducted on the same type of genetically diabetic mice.[136] The elevated blood glucose levels after 15 minutes and 30 minutes of maitake-fed group were 64 and 76 percent of those of the control group respectively, indicating significant inhibition of blood glucose increases.

Insulin receptor capability of liver cells then was examined using the liver perfusion method. Downward regulation (better insulin utilization) was observed among the maitake-fed group, while a state of tolerance was seen among the control group.

Next, glucose absorption activity along the mucosa of the small intestine was examined. Neither inhibition of glucose at the small intestine nor inhibition of the activation of sucrase (an enzyme necessary for sugar assimilation) was observed when maitake powder was administered. These results suggested that maitake's anti-diabetic activity is not related to the inhibition of glucose absorption but with the process of metabolism of absorbed glucose.

At Georgetown University, a research team (under the direction of co-author Preuss) began experimenting with recovering additional maitake fractions for their effects on the glucose-insulin system.

At a national meeting of nutritionists in October 1998, co-author Preuss had the honor of presenting his research team's work. In this study, he noted, researchers investigated the effects of maitake and its newly discovered beta-glucan-based SX-fraction on Zucker fatty rats (ZFR), which display insulin resistance and spontaneously hypertensive rats (SHR), which show a genetic predisposition to hypertension. In each rat strain, they followed groups of eight rats receiving either a baseline diet; baseline diet with whole maitake; baseline diet with SX-fraction; and baseline diet with another fraction. Different responses were found between the two strains. Over 33 days, they found that SX-fraction decreased blood pressure significantly in the ZFR strains, significantly affected angiotensin II, and lowered creatine levels by 29 percent, which may be related to influences on the angiotensin system. The whole maitake fruit body was also adept at reducing triglyccride levels.

Another study carried out at Georgetown University performed on diabetic mice study showed us some other interesting things about maitake's use for blood sugar control.[137] A single dose of merely 28 milligrams of a water-soluble maitake extract could decrease glucose levels significantly in a time-dependent manner. However, this specific amount of maitake extract was effective up to approximately 16 hours, at which time the glucose levels subsequently returned to their initial levels by 24 hours (see figure). An ether

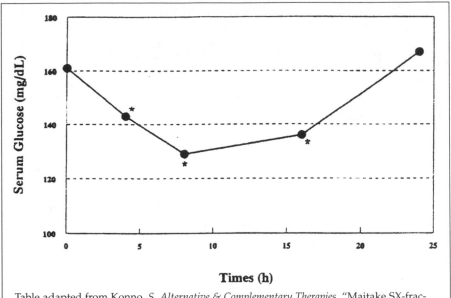

Table adapted from Konno, S. *Alternative & Complementary Therapies*, "Maitake SX-fraction: Possible hypoglycemic effect on diabetes mellitus." December 2001;7:366-370.

soluble fraction, obviously containing factors other than beta-glucans, also lowered systolic blood pressure in hypertensive rats and lowered circulating insulin and glycoslylated hemoglobin concentrations in diabetic rats.

The study also suggested if maitake were given to diabetic mice twice per day, instead of one single dose, this might provide a sustained and prolonged effect of the extract's blood glucose-lowering effect.

In fact, when a higher dose of 70 milligrams of maitake was given to mice twice per day for seven days, the concentrations of both glucose and insulin were significantly lower than those of control on the four and seventh days of the trial (see table, next page).

Overall, the serum glucose levels in maitake-fed mice declined from 241 to 171 mg/dL and the insulin levels also decreased from 5.9 to 2.5 ng/mL. We also used glipizide to see how it would compare. Yet, oral glipizide failed to produce significant reductions in glucose and insulin concentrations (although we saw a nonsignificant trend toward decreased glucose levels). Dr. Preuss's team could only conclude that maitake's beta-glucan extract appeared to perform as well on glucose/insulin metabolism as glipizide in a long-term trial.

**Effects of Maitake and Glipizide
on Serum Glucose and Insulin Concentrations in Mice**

	Days		
	0	4	7
Serum glucose (mg/dL)			
Control	225	232	211
+ Maitake	241	180[a]	171[a]
+ Glipizide	229	200	186
Serum insulin (ng/mL)			
Control	3.8	4.1	4.2
+ Maitake	5.9	3.2[a]	2.5[a]
+ Glipizide	4.1	5.3	2.9

Adapted from ref. 24.
Note: Data are the mean value of 7–9 mice tested per group.
[a]Differences are statistically significant compared to baseline control (P<0.05)

Table adapted from Konno, S. *Alternative & Complementary Therapies*, "Maitake SX-fraction: Possible hypoglycemic effect on diabetes mellitus." December 2001;7:366-370.

In 2001, a Japanese study reconfirmed these findings.[138] The researchers were from the Department of Food Science and Nutrition, Faculty of Home Economics, Nishikyushu University, Saga, Japan. They noted they had previously reported that rats with diabetes, induced by injecting streptozotocin into neonates, showed remarkably lower blood glucose, urine volume, and glucosuria after administration of maitake. In the most recent study, they investigated the effects of maitake on insulin concentration, organ weight, serum composition, and islets of Langerhans in streptozotocin-induced diabetic rats using the same method.

From the age of nine weeks, the rats were given experimental diets for 100 days. The diabetes and control groups were given either diets containing 20 percent maitake or control diets. During administration of the experimental diets, the researchers measured body weight, food intake, amount of feces, and serum insulin concentration at glucose loading. The glucose tolerance test was performed at the tenth week after the start of the experimental diets. The control group had an initial fasting blood glucose of 225+/-49 mg/dL, and a maximum blood glucose of 419+/-55 mg/dL at 60 minutes. In the maitake-fed group, however, the initial fasting blood glucose was 170+/-23 mg/dL, and the maximum blood glucose was only 250+/-41 mg/dL at 15 minutes. Both values were markedly lower than those in the control group.

After the 100-day experimental period, blood samples were collected. The fructosamine level was significantly lower in the maitake-fed group

than in the control group. From these results, the researchers postulated that the bioactive substances present in maitake can ameliorate the symptoms of diabetes.

We don't know for sure how maitake's beta-glucan fraction (SX-fraction) works mechanistically to lower glucose and insulin levels. But what we do know is that SX-fraction enhances peripheral insulin sensitivity and weakens insulin resistance, clearly, in a very powerful and safe manner.

But, obviously, we want to move from lower life forms to human clinical data. Thus, there is so much more to the maitake mushroom story.

CLINICAL EXPERIENCE

So encouraged were these animal studies on the hypoglycemic effect of maitake that Dr. Konno—with his interest in diabetic nephropathy—undertook case studies among volunteers with Type II diabetes at the Department of Urology, New York Medical College. The preliminary results, which show improved glycemic control, were reported on in *Diabetic Medicine*[139] and *Alternative & Complementary Therapies.*[140]

The product used in these case studies was maitake mushroom powder caplets, prepared from the fruit bodies of maitake mushrooms. These caplets contain a nonfractionated whole mushroom powder that also contains four to five percent of the active component with hypoglycemic activity (the SX-fraction).

First Cast Study

The first case study involved a 44-year-old male who was newly diagnosed with Type II diabetes. His initial fasting blood glucose value was 248 mg/dL (the normal range is 55-115 mg/dL) with glycosylated hemoglobin level of 11.5 percent (the normal level range is 5-7.5 percent). No retinopathy or neuropathy or other diabetes-related complications had developed. He was immediately given daily 2.5 mg of oral glyburide therapy and his fasting blood glucose level went down to approximately 180 mg/dL over the next two days. He also started taking a 500 milligram maitake caplet three times per day with glyburide on the third day.

The results were impressive. His fasting blood glucose level declined to 83 mg/dL, followed by a quick rise to approximately 120 mg/dL and then a gradual decrease to approximately 100 mg/dL in 10 days.

After this short "adjustment" period, his fasting blood glucose levels remained 80-90 mg/dL for the next three months and his glycosylated hemoglobin level was also down to 5.2 percent. Glyburide was then reduced to 1.25 mg with two maitake caplets a day and the fasting blood glucose levels still remained at 80 to90 mg /dL for the next two months. Consequently, glyburide was completely withdrawn but he was kept on daily maitake caplets two times per day and his fasting blood glucose levels remained at approximately 90 mg/dL and his glycosylated hemoglobin remained at 5.6 percent over the next six months.

During this "glyburide-free" period, the patient's maitake caplets were also withdrawn for two weeks. During this wash-out interval, the subject's fasting blood glucose rose slight to 120 mg/dL but returned to approximately 80 mg/dL when his daily maitake caplet intake was resumed.

Although it has been nearly two years since this patient's initial diagnosis, he is currently free of any medication, except for two maitake caplets per day. He has remained normoglycemic.

Second Case Study

The second case study involved a 75-year-old woman with Type II diabetes for six years. Her average fasting blood glucose had been approximately 200 mg/dL with a glycosylated hemoglobin level of approximately

Hypoglycemic Effect of Maitake Caplets (MMP) on Newly Diagnosed Type 2 Diabetic Patients		
Diagnosis/Prognosis	(Average) FBG (mg/dL)	HbA_{1c} (%)
Initial Diagnosis	248	11.5
3rd month Prognosis (with 2.5 mg Glyburide and MMP)	80-90	5.2
5th month Prognosis (with 1.25 mg Glyburide and MMP)	80-90	N/D*
9th month (to present) Prognosis (with MMP only)	~90	5.6

*N/D: not determined.

Table adapted from Konno, S. *Alternative & Complementary Therapies*, "Maitake SX-fraction: Possible hypoglycemic effect on diabetes mellitus." December 2001;7:366-370.

9.1 percent while she was taking five milligrams of glyburide per day, but she had no diabetes-related complications. Once she was placed on three maitake caplets day with glyburide, her fasting blood glucose declined to 130 mg/dL in two weeks and remained at 110-130 mg/dL for the next 2.5 months. Her glyburide dose was then reduced to 2.5 milligrams with maitake caplets and her current fasting blood glucose levels is less than 130 mg/dL.

Additional Results

With an additional three cases, all five patients showed over 30 percent (30 to 63 percent) declines in their fasting blood glucose levels under a maitake regimen in two to four weeks. These results are also summarized (see table *below*).

Summary of Hypoglycemic Effects of Maitake on Diabetic Patients					
			Average Fasting Blood Glucose (mg/dl)		*% of Fasting Blood Glucose Decline with Maitake*
Patients	*Age (Yrs)*	*Sex*	*Before Maitake*	*After Maitake*	
1	44	M	~260	90-100	~63
2	75	F	~200	110-130	~40
3	25	F	150-180	110-120	~30
4	67	M	180-200	120-140	~32
5	43	M	~220	100-110	~52

THE DOCTORS' PRESCRIPTION

These reports suggest that patients with Type II diabetes with persistent hyperglycemic conditions even when treated with oral medications may gain improved glycemic control when their medications are supplemented with the Maitake SX-fraction. We believe that they will experience improved peripheral insulin sensitization.[141] But, because of the lack of serum insulin measurements in these case reports, a possible insulin-sensitizing effect cannot be properly assessed at this time. More volunteer patients are being recruited at this time to participate in controlled trials with maitake mushroom to obtain the needed additional serum insulin data. Nevertheless, one may safely say, that maitake mushroom and its SX-fraction appear to have hypoglycemic potential for patients with Type II diabetes and who need better glycemic control.

The following protocol is currently being used in a clinical trial with patients who have Type II diabetes and are taking oral medication, but the dosages of maitake caplets (500 mg) used should be considered as only the "recommended" (not as established) dosages.

After assessing the severity of a patient's hyperglycemic condition, he or she might initially take one to two maitake caplets, three times per day, after each main meal with at least one glass of water.

Optional recommendations also include 500 to 2,000 mg of vitamin C and 400 to 800 IU of vitamin E, which may help to protect peripheral tissues from harmful oxidative stress caused partially by high serum glucose levels. Patients concerned with stomach upset from the acidity of vitamin C should use a buffered form or a form with rose hips. We also urge patients to use a natural vitamin E, which is more potent with regard to antioxidant status.

Patients should drink water often and do moderate exercise. Once there is a good response, patients may be advised to reduce the dosage of medication. Patients must remember that it is critical to consult the physician responsible for prescribing their medications before making any cuts in dosages.

*CHAPTER NINE**

MAITAKE & HYPERTENSION (HIGH BLOOD PRESSURE)

WHAT IS THE EVIDENCE THAT HIGH BLOOD PRESSURE is associated, at least in part, with perturbations in the glucose/insulin system? Diabetics have premature aging of the cardiovascular system due, in part, to a high incidence of hypertension and other cardiovascular disease (CVD) risk factors. Predictably, measures to enhance insulin sensitivity and ameliorate hyperglycemia and hyperinsulinemia, such as exercise and dosing with somatostatin, metformin, and troglitazone, also lower blood pressure and ameliorate other coronary vascular disease risk factors. In the Framingham Study, an association between systolic hypertension and diabetes was noted. Systolic blood pressure was found to correlate with glycemic control, as indicated by glycosylated hemoglobin, especially in women. Black men and women, known to have severe problems with hypertension, also have higher fasting insulin levels than their white counterparts.

While the relationship between diabetes and coronary vascular disease is generally accepted, less certain is whether milder perturbations in glucose/insulin metabolism, like those seen with aging, can in time play a major role in the eventual development of coronary vascular disease. Probably so. Most clinicians know that obesity and hypertension are often found concomitantly in the same individual. Further, obesity is frequently linked to glucose/insulin disturbances; therefore, it is not surprising that loss of muscle mass with accumulation of fat is commonly seen in aging along with the development of insulin resistance.

* *Authors' note: Hypertension (i.e., high blood pressure), hyperlipidemia (i.e., elevated cholesterol) and obesity are significantly related to both diabetes and Syndrome X. Thus, in the following three chapters, we explore scientific studies that support use of maitake mushroom by patients for these conditions.*

AGE-RELATED HYPERTENSION AND INSULIN RESISTANCE

Another consequence of a perturbed glucose/insulin system is alterations in membrane electrolyte transport. Basically, if you remember any of your lessons from high school physiology, you might recall that blood pressure is intimately related to the passage of various minerals, including sodium, calcium and potassium, in and out of cellular tissues. The proximal tubule is the major site of renal sodium reabsorption and malregulation of this reabsorption is thought to cause hypertension.

Bottom line: Perturbations in insulin metabolism are commonly seen in patients with hypertension, while hypertension is more prevalent among diabetics. When researchers have examined the relation of blood pressure to fasting insulin and glycosylated hemoglobin in nondiabetic subjects, they find statistically significant associations of systolic and diastolic blood pressure with insulin levels and glycosylated hemoglobin. We can even measure serum glucose and insulin concentrations in case-matched normotensive and hypertensive subjects. Hypertensives will have higher fasting insulin and plasma norepinephrine concentrations than normotensives. Similar to diabetes mellitus, disturbances in both insulin metabolism and blood pressure are common among obese patients. Although correlations are similar in various races and gender, black men and women have higher fasting insulin, and of course, greater proclivity for and worse forms of hypertension than Caucasians. Dietary indiscretions such as heavy sugar ingestion are associated with insulin resistance, hyperinsulinemia, and hypertension, as well as many perturbations associated with hypertension—obesity, lipid abnormalities, platelet disturbances, and hyperuricemia.

That we know maitake benefits diabetic and Syndrome X patients' insulin/glucose levels may offer some clues to its additional blood pressure-lowering effects. But not completely. Sometimes, natural remedies—especially herbs—can be too highly purified, and we lose some of the synergy that comes with a complete spectrum of phytochemicals present in the natural product. That's why the benefits of maitake mushroom are so far ranging. While we know a little about maitake's various beta-glucans and that they are extremely beneficial for treatment and prevention of cancer, diabetes and Syndrome X, this still only represents but a fraction of the active constituents in maitake mushroom. Many more healthful constituents await our discovery.

FYI:
Diet & Hypertension

What is the evidence that hypertension, more prevalent with aging, is associated with diet? Epidemiology provides many clues concerning the importance of dietary effects on blood pressure. Hypertension is not inevitable in the elderly, because no general rise in blood pressure occurs with advancing age in some nonacculturated societies. This difference may relate to diet. Diets of these nonacculturated societies differ from acculturated societies—containing less sodium, simple sugars, and saturated fats and containing more complex carbohydrates, fibers, and potassium. In addition, nonacculturated populations tend to show less obesity, having smaller increases in body weight with aging than the elderly in modern society. However, hypertension often develops when these groups become more "modernized" or when individuals from these cultures migrate to more acculturated societies, strengthening the concept that environmental considerations, like dietary changes, are important as well as genetic factors. In the industrialized world, vegetarians, who characteristically have a lower blood pressure, generally eat diets containing higher levels of fiber, polyunsaturated fats, potassium, calcium, and lower levels of animal proteins, saturated fats, and monounsaturated fats compared to the general public.

Take, for instance, the beneficial effects of maitake on high blood pressure. This is a case where the crude powder probably works as well as the SX-fractions. (D-fraction does not influence blood pressure.) We just simply don't know yet the specific constituents in the SX-fraction of maitake that account for its blood pressure-lowering effect. We do know, however, that maitake is very helpful for lowering high blood pressure. In fact, maitake appears to have a "superior ability to lower blood pressure," notes Anthony J. Cichoke, M.A., D.C.

EXPERIMENTAL RESULTS

In a 1987 study, researchers from Department of Food Chemistry, Faculty of Agriculture, Tohoku University, Sendai, Japan, studied the effect of maitake on hypertension in spontaneously hypertensive rats (SHR).[142] The rats were fed a diet containing five percent mushroom powder for nine weeks. The dietary mushroom markedly decreased the blood pressure. (Total cholesterol levels also decreased. Most important, the good cholesterol fractions remained stable. Maitake feeding caused a decrease only harmful very low density lipoprotein (VLDL) cholesterol. Plasma LDL-cholesterol was not affected by dietary mushrooms.) In contrast to the control group (*in which the blood pressure increased with aging*), the maitake group experienced a reduction in blood pressure. When the maitake group was returned to its normal feed ration, blood pressure increased. However reduction in blood pressure occurred when the animals were once again placed on the maitake-containing feed. Maitake appears to have a superior ability to lower blood pressure, notes an expert. "The results suggest that dietary Maitake mushroom reduces the blood pressure," note researchers.[143]

Dramatic results were also seen in a 1988 study. Hypertensive rats fed maitake powder experienced a reduction in their blood pressure by 60 mm Hg from 230 mm Hg to 170 mm Hg in only four days. When given a more purified ether-soluble extract, their blood pressure went from 200 mm Hg to 115 mm Hg in only *four hours*.[144]

CLINICAL RESULTS

Maitake mushroom has played an important role in the practice of Abram Ber, M.D., of Scottsdale, Arizona. Dr. Ber, who is a graduate of McGill University, became the first doctor in Arizona to be licensed as a homeopathic physician (a separate board) and has relied on extensive use of environmental medicine and orthomolecular therapy for more than twenty-five years.

During the course of two to three months, he treated more than 30 high blood pressure patients with maitake powder, using three grams of whole dried maitake powder per day for the first week, four grams per day for the second week, and then five grams per day, adjusting the dosage as the patients' blood pressure readings indicated. "When on medication, the

blood pressure is all over the place, but with maitake mushroom there is a gradual decrease in blood pressure toward normalcy," he notes. "Further, there are absolutely no side effects."[145] *

Scott Gerson, M.D., director of the Foundation for Holistic Medical Research, New York City, is another physician with extensive experience using maitake in his practice. Dr. Gerson reports:

"Eleven patients (seven men and four women) between 46 and 48 years old with 'documented essential hypertension' were studied. All 11 subjects were instructed to take three 500 mg caplets of maitake mushroom twice per day in the morning and evening at least 90 minutes away from food. Blood pressure was then measured weekly in the same clinical setting for an average of six weeks....There was a mean decrease in systolic BP of about 14 mm Hg and a mean decrease in diastolic BP of about 8 mm Hg. It is notable that there were no adverse effects reported by any of the subjects. In fact, all of the subjects reported feeling quite well during the study."

Dr. Gerson related to colleagues: "I was left with a strong suspicion that maitake does indeed reduce blood pressure in hypertensive patients."[146]

Michael Williams, M.D., Ph.D., former chief medical officer of the Cancer Treatment Centers of America, has also benefited from maitake's profound blood pressure lowering effects: "I am six-feet tall with a family history of hypertension, with blood pressure ranging from 150/105 to 140/90. Systolic blood pressure before and one hour after one, two or four maitake pills ranged from 136 to 124, from 140 to 128, and from 146 to 134 on different test days. Diastolic blood pressures remained 88-92. The eight to twelve percent decrease in systolic pressure was maintained for up to six hours." But the real benefits, he notes, came with regular, prolonged use of maitake caplets. "I resumed taking 10-12 maitake pills in divided doses throughout the day," he says. "Blood pressure has remained at or below 120/80 for over two months without Vasotec [a prescription drug for high blood pressure]."[147]

* By the way, as we mentioned in our Introduction, Dr. Ber also used maitake mushroom to successfully treat patients suffering from uterine fibroids. Although a plausible explantion is not yet available, recent research has shown that that herbal-based Traditional Chinese Medicine can be extremely beneficial for women with uterine fibroids and that medicinal fungi such as maitake as well as cordyceps are thought to be "women friendly." Maitake may help by strengthening the immune system and by aiding liver health and therefore promoting detoxification.

THE DOCTORS' PRESCRIPTION

High blood pressure is often associated with glucose/insulin imbalances. Use both the SX-fraction and crude maitake powder together. Persons with high blood pressure problems not associated with glucose/insulin problems may use crude maitake powder caplets. Generally recommended dosages range from 1.5 to 6 grams daily. Your recommended dosage should be discussed with your doctor in relation to any current medications you may be taking and may need to be adjusted up or down, depending on results.

MAITAKE & HYPERLIPIDEMIA (ELEVATED CHOLESTEROL)

HIGH LEVELS OF CHOLESTEROL AND TRIGLYCERIDES are both indicators of increased risk for heart disease and are part and parcel of diabetic- and Syndrome X-related complications. Unfortunately, millions of Americans suffer from high blood levels of each. While medical drugs may help to reduce cholesterol levels, their side effects may make them less desirable than a safe natural medicine.

Health-conscious people recognize that high levels of cholesterol in their blood increase their risk of heart disease. Cholesterol is not a fat but it is closely related to fat. It is a chemical that is an essential component in the structure of cells and is also involved in the formation of important hormones. If your diet contained no cholesterol your liver would still produce all the cholesterol you need.

However, high levels of a particular kind of cholesterol called low density lipoprotein (LDL or "bad" cholesterol) can contribute to coronary artery disease in which the blood vessels are narrowed by deposits of a fatty tissue called atheromas, which are made up largely of cholesterol. Narrowing of the heart's coronary arteries by patches of atheroma can cause angina. This also increases the risk of an artery becoming blocked by a blood clot.

On the other hand, your body also produces high density lipoproteins (HDLs, "good" cholesterol) which are quickly transported from the bloodstream and do not form atheroma deposits in the arteries.

What many people don't realize, however, is that triglycerides, a type of fat, are also now thought to be associated with increased risk for heart disease.

QUICK TRIGLYCERIDE PRIMER

Traditionally, people with less than 200 milligrams of triglycerides per deciliter (mg/dL) of blood are considered to have normal triglyceride levels. Between 200 and 400 mg/dL is borderline high; between 400 and 1,000 mg/dL is a high triglyceride level; and greater than 1,000 mg/dL is considered very high triglycerides. However, the normal range may require revision.

Previously major changeable risk factors for heart attack included smoking, high blood cholesterol, high blood pressure and physical inactivity. However, high blood levels of the fat triglyceride may need to be added to the list. Elevated triglycerides may be a consequence of other diseases, such as diabetes. Like cholesterol, triglyceride levels can be detected with a blood test.

Researchers say that in middle-aged and older white men, a high level of triglycerides—the chemical form in which most fat exists in food as well as in the body—may mean a higher risk for heart attack. Therefore, the scientists say, high blood levels of triglycerides should be considered an independent risk factor for heart attack.

"The growing attention to high levels of triglycerides and increased coronary heart disease risk is encouraging to veterans of the 'triglyceride wars,'" says former American Heart Association President Antonio Gotto, M.D., dean of the Cornell University Medical School, New York City. "It's also in agreement with another trend in heart attack risk management, namely, the concept of global risk assessment."

Triglycerides are the form in which fat exists in meats, cheese, fish, nuts, vegetable oils, and the greasy layer on the surface of soup stocks or in a pan in which bacon has been fried. In a healthy person, triglycerides and other fatty substances are normally moved into the liver and into storage cells to provide energy for later use.

High levels of triglycerides can influence the size, density distribution and composition of LDL (low-density lipoprotein) cholesterol—the "bad" cholesterol—leading to smaller, denser LDL particles, which are more likely to promote the obstructions in the blood vessels that trigger heart attack. An excess amount of triglycerides in blood is called hypertriglyceridemia.

PRESCRIPTION DRUGS FOR HIGH CHOLESTEROL

The pharmaceutical industry has developed many powerful medical drugs to help people lower cholesterol and triglyceride levels. But there are two areas of concern. First, while we know that these drugs do lower cholesterol, the jury is out whether they still extend the life span of people with high cholesterol levels. Most studies have shown that people taking cholesterol-lowering drugs are at slightly higher risk of death than people not taking any cholesterol-lowering drugs. That is probably because these drugs tend to bind or inhibit the production of other essential nutrients necessary for heart health, or they have an adverse effect on brain neurotransmitters. More recently, encouraging results have been seen from clinical trials, and we are gaining greater faith in these drugs' ability to extend human life span. In life-threatening situations, medical drugs obviously have important uses. Still, in the area of preventive medicine, natural cholesterol-lowering agents are probably a wiser choice.

Cholesterol-lowering Drug Complications

Maitake mushroom's beta-glucans are completely nontoxic and without any drug or nutrient interactions whatsoever. We wish we could say the same was true for medically prescribed cholesterol-lowering agents.

An industry-funded study of pravastatin (Pravachol) reported a rate of breast cancer twelve times higher than among women not using the drug.[148] Bristol-Myers Squibb, the drug's manufacturer, claimed this to be a "statistical fluke."[149] This finding is of particular importance in view of the growing numbers of patients being placed on this drug, one of four similar ones on the market. Moreover, a recent report in the *Journal of the American Medical Association* concluded that commonly used cholesterol-lowering drugs, fibrates and statins, cause breast besides other cancers in rodents and that their use "should be avoided."[151]

CHOLESTEROL-LOWERING BENEFITS OF BETA-GLUCANS

Thanks to Quaker Oats, consumers are starting to associate beta-glucans with another important health benefit: reducing cholesterol. Over the past three decades, at least 37 separate studies of people have demonstrated that oat meal and oat bran could reduce serum cholesterol, a major risk factor in heart disease, notes *Sciences News Online*. "These reductions have been seen

not only in people with heart disease but also in healthy individuals—even those already consuming a low-fat, low-cholesterol diet."

In 1997, an FDA ruling issued in the *Federal Register* allowed manufacturers to say that soluble fiber from whole oats, oat bran, or oat flour "as part of a low-saturated-fat, low-cholesterol diet, may reduce the risk of heart disease."

Over time, chemists have isolated the active ingredient in these products: beta-glucan is the key factor for the cholesterol-lowering effect of oat bran. As with other soluble-fiber components, the binding of cholesterol (and bile acids) by beta-glucan and the resulting elimination of these molecules in the feces is very helpful for reducing blood cholesterol. To be sure, beta-glucans found in oats and from yeasts and fungi such as maitake mushroom are not identical. In their natural state, yeast and mushrooms contain a mixture of beta-1,3-glucan and beta-1,6-glucan. Oats and barley contain a mixture of beta-1,3-glucan and beta-1,4-glucan. Yet, both have a beneficial effect on serum lipid levels.[152] Oat beta-glucans are found in various breakfast cereals and snacks. Usually, several servings of these products are required to meet the FDA's claim of reducing the risk of heart disease. The yeast- or fungi-derived fiber is a more concentrated source of beta-glucan than the oat product. It is also currently being tested in a wide variety of food products for its cholesterol-lowering effects. Thus far, results have been encouraging.

Heart disease is the leading cause of death in the U.S. But one way to reduce the risk of developing the disease is to lower serum cholesterol levels by making dietary changes. In addition to reducing intake of total fat, saturated fat, trans fats, and dietary cholesterol, serum cholesterol can be further reduced by adding maitake beta-glucans to the diet.

EXPERIMENTAL RESULTS

It has been known for some time that, in animal experiments, a high polysaccharide diet reduces both the blood level of cholesterol and glucose.

In 1996, researchers from Department of Microbial Chemistry, Kobe Pharmaceutical University, Japan, determined the efficacy of maitake mushrooms in inhibiting the elevation of liver and serum lipids in rats.[153] Using Sprague-Dawley rats with hyperlipidemia and who were being fed a diet that would intentionally increase their cholesterol levels, these researchers measured and compared the values of cholesterol, phospholipids, and triglycerides between cholesterol-fed rats and rats whose diets were fortified with 20-percent maitake mushroom dried powder.

The values in maitake-fed rats were consistently less than those in the basic cholesterol-fed rats. Indeed, at the end of only 12 days, the effect was quite clear, as the total cholesterol level of the rats fed the maitake was only 57 percent that of the rats on the same high-cholesterol diet. The value of high-density lipoprotein cholesterol, which usually is decreased by consuming high-cholesterol food, maintained the level that it had at the beginning of the experiment, whereas among the control rats, their HDLs decreased markedly. On the other hand, dangerous triglyceride levels and total and free-cholesterol levels were significantly decreased.

When studied on day 24, it was clear that body weight, liver weight, body fat and serum phospholipid levels were significantly lower in the rats receiving maitake. Weights of liver and fat pad samples were significantly less than those in the basic feed group. The researchers concluded: "Our data suggest that maitake mushrooms have the ability to alter lipid metabolism by inhibiting both the accumulation of liver lipids and the elevation of serum lipids. Further studies are needed to elucidate the mechanism of activity of maitake mushrooms and to establish whether their action in humans is similar to that in the animal model tested here."

In 1997, in another study, the same researchers used a 20-percent maitake-feed as part of the high-cholesterol diet fed to normal rats.[154] They found that fat metabolism was highly improved and that cholesterol excretion improved among rats fed the maitake diet when compared to the control rats. Among other important findings, liver lipids were also measured and it was noted that lower liver weight, lower liver triglyceride levels, lower liver free- and total-cholesterol levels were exhibited by the maitake-fed rats, "suggesting maitake has an anti-liver lipid activity." Indeed, when biopsied, the control rats' livers were inflamed and exhibited signs of fatty liver, an indication of pathological disease. In addition, while HDLs remained stabilized in maitake-fed rats, they fell among control rats. Serum cholesterol and triglyceride levels were significantly lower in maitake-fed rats.

Furthermore, measurement of the amount of total cholesterol and bile acid in feces showed that the ratio of cholesterol-excretion had increased 1.8 times and bile acid-excretion threefold by maitake treatment. From these results, it is believed that maitake helps to improve the lipid metabolism as it inhibits both liver lipid and serum lipid which are increased by the ingestion of high-fat feed.

There was more: maitake's unheralded, yet apparently profound, weight-loss benefits were observed. Starting on day five and going

through day twenty-five, the control rats gained considerable weight, but the maitake-fed rats weighed 24.9 percent less than the control rats. Similar weight-loss results were first observed as early as 1987 when it was shown that maitake's inhibition of weight gain was much greater than that of shiitake.[155]

More recently, researchers from the Department of Bioresource Science, Obihiro University of Agriculture and Veterinary Medicine, Obihiro, Hokkaido, Japan, studied the effect of maitake fibers on serum cholesterol and hepatic low-density lipoprotein (LDL) receptor mRNA in rats.[156] Rats were fed a cholesterol-free diet with 50 grams per kilogram body weight (g/kg) cellulose powder (CP), 50 g/kg maitake (*Grifola frondosa*) fiber (MAF), 50 g/kg shiitake (*Lentinus edodes*) fiber (SF), or 50 g/kg enokitake (*Flammulina velutipes*) fiber (EF) for four weeks.

No significant differences were found in body weight, food intake, liver weight, cecum weight, and cecum pH among the groups. Cecal acetic acid, butyric acid, and total short-chain fatty acid (SCFA) concentrations in the SF and EF groups were significantly higher than those in the other groups.

The serum total cholesterol concentration in the cellulose powder group was significantly higher than that in the maitake group. Fractions of "bad" cholesterol, including very low-density lipoprotein (VLDL), intermediate-density lipoprotein (IDL) and low-density lipoprotein (LDL) cholesterol concentration, were significantly higher than that in the maitake, shiitake, or enokidake groups. High density lipoprotein remained high in the maitake and shiitake groups, but not in the enokidake group. Fecal cholesterol excretion in the maitake group was also was significantly higher than that in the cellulose powder group. "The results of this study demonstrate that [maitake]... lowered the serum total cholesterol level by enhancement of fecal cholesterol excretion..." report the researchers.

In another study, researchers examined the effect of fungi-derived beta-glucans on serum and liver lipids in female rats with hereditary enhanced sensitivity to cholesterol.[157] They found that the consumption of the fungi beta-glucans in the diet prevented serum cholesterol increases by the end of the fourth week of the experiment. At the end of the seventh week, cholesterol levels were lowered by almost 40 percent, compared with control animals kept on the same diet but without the beta-glucans. The decrease in serum cholesterol levels was a consequence of the decreased cholesterol concentrations of very-low-density lipoproteins and of low-density lipoproteins.

CLINICAL RESULTS

Although we must await clinical trials on maitake's beta-glucans and cholesterol lowering, clinical trials on similar beta-glucans show promise.

In a clinical study by the Research Institute of the Ministry of Health of the Slovak Republic, researchers studied a group of 57 middle-aged women and men, (approximately 1:1 ratio) with primary combined hyperlipidemia. For one month they took 10 grams of a beta-glucan-rich fungi with their regular diet. Results were statistically very promising with a 12.6 percent decrease of cholesterol in the serum and 27.2 percent decrease in triglycerols. Consumption of beta-glucan had also antioxidant effects which has been defined by decrease of peroxidation products in the red blood cells.

At the Center for Cardiovascular Disease Control, University of Massachusetts-Lowell, researchers evaluated the effect on serum lipids of a yeast-derived beta-glucan fiber in 15 free-living, obese, hypercholesterolemic men.[158] After a three-week period in which the men ate their usual diet, 15 grams of fiber daily were added to the diet for eight weeks, then stopped for four weeks.

Plasma lipids were measured weekly during baseline and at weeks seven and eight of fiber consumption, and again at week twelve. Compared with baseline, beta-glucan-rich fiber consumption significantly reduced plasma total cholesterol (by eight percent at week seven and another six percent at week eight). "The yeast-derived beta-glucan fiber significantly lowered total cholesterol concentrations and was well tolerated; HDL-cholesterol concentrations rose, but only four weeks after the fiber was stopped."

THE DOCTORS' PRESCRIPTION

Results from a number of double-blind trials demonstrate typical cholesterol reductions, after at least four weeks of use, of approximately 10 percent for total cholesterol and eight percent for LDLs ("bad") cholesterol, with elevations in HDL ("good") cholesterol up to 16 percent.

The usual dosage should be approximately three to six grams daily of the crude maitake powder caplets.

CHAPTER ELEVEN

MAITAKE & WEIGHT CONTROL

DIFFERENT LIFE STYLES AND DIETS can affect the health and the development of diseases. Metabolic syndromes like obesity and increased insulin resistance, which are often interlinked, are becoming more and more common in the industrialized nations.

From a public health perspective it is therefore important to find regimens that improve lipid and glucose metabolism. One strategy is to recommend an increased use of food products having a high nutritional value and a cholesterol- and glucose lowering effect.

Maitake's beta-glucans or other not yet known factors present in the mushroom may be a useful nutritional tool to control metabolic disorders. What's more, maitake powder, when given at high (completely nontoxic) doses, is high in dietary fiber, which is another important component of a healthful diet. Fiber helps to prevent constipation by holding moisture in the bowel and increasing peristaltic action.

In a 1992 study, it was shown that water content of stools was much higher among animals fed maitake powder.[159] After 18 weeks, those fed maitake powder lost weight, whereas controls gained weight.

At the Koseikai Clinic in Tokyo, Dr. Masanori Yokota, M.D., gave thirty obese patients twenty 500 mg caplets of maitake powder daily for a period of two months with no change in their regular diets. This amount was the equivalent of 200 grams of fresh maitake daily. All of the patients lost weight (between 7 to 26 pounds) with an average loss of 11 to 13 pounds.

Indeed, Kenneth Jones, writing in the December 1998 issue of *Alternative & Complementary Therapies*, notes:

"Dr. Yokota believes that he got better results with this regimen than with any other one he had ever tried. His patients all lost weight and got nearly halfway to their optimal weights. Amounts range from as little as 5 kg to as much as 12 kg (26.4 pounds). On average, the patients lost 5-6 kg. For example, a 34-year-old woman just over 5 feet tall, who weight 58 kg 8 weeks before going on the supplement, weight 53 kg after. Because her optimal weight was calculated to be 52.2 kg and she was over by 5.8 kg, the loss represented 86 percent of the weight she had to lose. Dr. Yokota mentioned that one patient lost only 13 percent while another patient lost 67 percent of the weight needed to reach optimal weight. Adding that obviously one's regular diet will still play a significant role, he concluded that if further studies show similar results, the advantage of maitake could be the convenience of not having to make major adjustments to one's diet in order to lose weight."[161]

THE DOCTORS' PRESCRIPTION

Maitake, when used as a crude powder in caplet form, appears to be a highly effective weight-loss nutrient. However, it must be taken at relatively high dosages of about five to ten grams daily (up to 500 mg caplets). Even at these dosages, maitake is completely nontoxic.

PART FOUR

WHY MAITAKE?

CHAPTER TWELVE

WHY MAITAKE?

WITH SO MANY IMMUNOMODULATING NATURAL AGENTS, why maitake? Indeed, it is a question we believe must be answered satisfactorily for the reader, to have confidence in our message about the healing powers of maitake's beta-glucans.

The fact is, most of the medicinal mushrooms such as reishi, shiitake, cordyceps and maitake show a common property of enhancing immune function by stimulating cell-mediated immunity. Furthermore, isolated beta-glucans are also available to the consumer. While some of these products are less than stellar, some are quite good and have been scientifically validated.

Quite simply, all such mushrooms and many other natural agents, including other forms of beta-glucan, turn on the body's immune cells to various degrees.

Based on our review of the published studies and what we have learnt from our own experimental and clinical studies, we think that maitake holds many healthy benefits—that it should be part and parcel of a comprehensive natural healing program. In some cases, as with immune support, cancer, diabetes and Syndrome X, maitake may well be a *key* supplement.

Let's pit maitake against other mushrooms. Maitake is substantially different from many other mushroom-based medicines in that maitake retains its efficacy when administered orally. Lentinan, for example, which is derived from shiitake, must be administered intravenously to be most effective. Further, it has been shown that of all mushrooms studied, maitake has the strongest antitumor activity in tumor growth inhibition both administered orally and intraperitoneally. Given orally, maitake has strongly outperformed all other mushrooms.

As for other purified beta-glucan products, sometimes a natural supplement can be too purified. The β-glucans obtained from maitake mushrooms have unique, complex and varied chemical structures. A three dimensional model of maitake's β-1,3-D glucan shows it to be a helix with its 1,6 main chain having a greater degree of 1,3 branches. Scientists believe that the greater degree of branches provides its beta-glucans more of a chance to reach each immune cell for activation, and thus gives it greater potency. In addition, many more beta-glucans are present in this natural medicine. This is important. In studies on structure-activity relationships of glucan-mediated immunopharmacological activity, it was found that some of the activities tested are influenced by the diversity of the glucans.[162] The Maitake D-fraction activates macrophages, natural killer cells, and other T cells to attack the tumor cells. It also potentiates the activity of various mediators, mainly lymphokines and interleukin-1 and interleukin-2, all of which activate the cell-mediated response. But other glucan fractions obtained from maitake have completely different activities.

Keep in mind that we advise readers to combine crude maitake powder caplets with specific D- or SX-fractions. That's because, truthfully, there's more to the beta-glucan story than we presently understand. Many types of beta-glucans exist in nature. Each has a different function. Maitake seems to be a treasure trove of a wide range of beta-glucans. So while we know that D-fraction is a potent anticancer and immune-augmenting isolate and that SX-fraction is important to diabetes and persons with Syndrome X or insulin resistance, many other beta-glucans contribute additional benefits. Purified beta-glucan is well documented to provide anticancer and immune-augmentation properties, making it important for such conditions. But purified beta-glucan is not a tonic herb, nor an adaptogen. It is not a whole food concentrate. Maitake is. This is important. We in no way wish to denigrate some of the extremely fine beta-glucan products derived from yeast or other fungi. But we do want you to understand the important role that maitake plays in health and in supporting the body's healing response. It provides more phytochemical power than we are currently capable of analyzing. The sum is greater than the known parts. This is important. Many such instances occur in natural phytotherapy where too great a degree of extraction actually weakens the healing power of the whole herb. In this sense, maitake, as a whole food concentrate, offers a greater range of health benefits than highly purified beta-glucan products. At the same time, its isolated fractions are able to approximate the same benefits as purified beta-glucans. You get the

best of both worlds. Also, many consumers or doctors may not realize how well studied maitake is for its anticancer effects. In a Medline search alone which is by no means exhaustive of all sources, some 20 reports were located on maitake's anticancer effects (see Appendix). Additional researchers from China and elsewhere, whose studies are not listed on Medline, have also investigated the antitumor potential of maitake.

What about maitake in relation to medical drugs? Let's take cancer, as a basis for a comparison. We strongly consider maitake—especially its D-fraction—to be the fourth therapy in cancer treatment—after chemotherapy, radiation, and surgery. Immune therapy, the fourth therapy, complements each of these modalities. Maitake may complement such therapies or provide healing support and lead to remission when these other modalities fail. It is also known to have little or no side effects, and the cost is far less than conventional treatments.

Although billions of dollars are spent on cancer research every year, the previous three therapies have not appreciably slowed down the continuous increase in both incidence and death rate from many types of cancer. Chances are that one out of two people will die from cancer by the year 2005. We think that more attention should be paid to immune therapy. The results of clinical and animal studies demonstrate its quite significant protective and preventive potential for cancer. Thus, maitake succeeds in prevention where few medical drugs do—especially in light of its absence of short- or long-term side effects or complications.

In addition to maitake's extraordinary health benefits associated with disease, it has been renowned throughout oriental history to aid in the preservation of vitality and well-being. Maitake is known in Japan as "the dancing mushroom." It is said to have gotten that name because in feudal Japan when someone came across maitake in the wild, they would dance for joy for they knew that the mushroom was so prized it was literally worth its weight in silver.

Maitake is also considered an adaptogen, which means that it helps the body adapt to stress and normalize body functions. In far eastern herbal medicine, maitake has been used as a tonic to strengthen the body and improve overall health.

One expert notes that in traditional Asian medicine, maitake is said to be the most cleansing of the medicinal mushrooms, targeting the liver and the lungs. Most health professionals agree that if liver function can be improved, overall health will benefit because the liver performs innumer-

able functions, including detoxification of internally and externally produced poisons.

Maitake mushroom has the capability to beneficially influence many of the most common and deadly diseases of aging. Our own studies at Georgetown University and the New York Medical College have corroborated the great potential for maitake and certain of its newly isolated beta-glucan fractions to significantly affect diabetes and ameliorate symptoms associated with Syndrome X. Other studies suggest that maitake can play a role in immune augmentation, cancer therapy, lowering cholesterol and blood pressure, and aiding weight loss.

Thus, we see maitake as an important contributor to overall health and well-being, whether used along or as part of an overall program, utilizing the best that both complementary and mainstream health and medicine offer.

Safety

As for safety, maitake mushroom is completely safe. It simply has no toxicity—though it may enable users to lower prescription medication dosages in cases of diabetes. Some people, though very few, react with upset stomach especially when taken in empty stomach. It is also true that some people are allergic to some or most edible mushrooms, including maitake. As for D-fraction, however, we have not seen any side effects since its introduction, even from people who are allergic to mushrooms. Yet, as always, pregnant or nursing women or persons using medical or over-the-counter drugs should consult with a health care provider before taking maitake (or any other supplements).

Maitake D-fraction (liquid form) and maitake tablets (whole crude powder) were tested on mice to assess potential toxicity. Based on a pilot study indicating the optimal dose of one mg/kg of D-fraction for antitumor activity, a ten-times-higher dosage was given to mice for thirty days. On the thirty-first day, the mice were killed and their organs and blood were thoroughly examined. No abnormal symptoms or signs were observed.

Similar tests were repeated using maitake tablets and essentially the same results as D-fraction tests were obtained with no toxic or adverse effects. The researchers of these studies concluded that both Maitake D-fraction and crude powder tablets are safe with no toxicity. These findings are further corroborated by the fact that the FDA has exempted Maitake D-fraction from a phase I study of toxicology.[164]

CHAPTER THIRTEEN

How to Select
a Quality
Maitake Product

MAITAKE SUPPLEMENTS CAN BE FOUND at many health food stores
and are available from health professionals and pharmacies. However, sev-
eral types of mushrooms belong to the maitake family. While Tonbi-maitake
(*Grifola gigantean*), Shiro-maitake (*Grifola albicans*) and Chorei-maitake
(*Grifola umbellate*) are all edible, these present limited health benefits. But the
maitake that has been studied and is desirable for obtaining the power of
the beta-glucan fractions is *Grifola frondosa*, which is rich in D- and SX-frac-
tions. It is also said to be the best tasting.

It is also important to keep in mind that the nutritional composition of
maitake mushroom products will differ from company to company due to
the strain used and cultivation methods. Some maitake products are
thought to contain little D- or SX-fractions. A recent article from the
Department of Plant Pathology, Pennsylvania State University, found that
the effects of various combinations of wheat bran, rye and millet on crop
cycle time, biological efficiency and mushroom quality were all critical to
cultivation of high potency maitake.[165]

Maitake may be consumed both as a whole food and as a whole food con-
centrate. Maitake supplements as capsules, caplets or liquid extracts are
usually more convenient to take and provide the most reliable results.
Supplements consist of a concentrated, dried powder of the whole mush-
room and are recommended for routine use as a tonic or adaptogen.

We recommend three to seven grams of maitake daily. Because the body
of the fruit contains more polysaccharides than the leafy sections, the body
is recommended as a supplement. The usual recommendation is one to
three grams daily for preventive purposes and more when used therapeuti-

cally. The whole mushroom is generally used in combination with either the D- or SX-fractions for specific disease states, including immune deficiency, cancer, diabetes, Syndrome X and related complications (hypertension, hyperlipidemia and obesity).

Because of the emerging interest in maitake, it is now available in a number of products. However, the product that has been studied and approved by the FDA for clinical cancer trials is from Maitake Products, Inc., of Ridgefield Park, New Jersey.

Founded in 1991, Maitake Products, Inc. truly has pioneered the introduction and study of maitake mushroom. Today, the company is a leader in research and product development of maitake mushroom. Maitake Products, Inc. has been involved in and supported a number of laboratory and clinical studies, including those of the National Cancer Institute, Georgetown University, Cancer Treatment Centers of America, New York Medical College and other prominent research institutes. The company has received IND (Investigational New Drug Status) approval from the FDA on its Grifron®-Pro D-fraction® for Phase II trials for advanced breast and prostate cancer patients. For this reason, its products are preferred by health professionals, since they have been scientifically and continue to be clinically validated. Maitake D-fraction, the optimum extract of beta-glucan, is thought to be the most potent and active form of maitake for therapeutic oral administration (capsules and tincture). Maitake D-fraction is now the basis of all research in the area of immune-related chronic diseases both in Japan and the United States. At the time of completion of this book, we also expect the SX-fraction, which will address diabetic and Syndrome X concerns, to be available. Contact Maitake Products, Inc., for information on the SX-fraction (see Resources).

APPENDIXES

MEDLINE SEARCH ON
ANTITUMOR ACTIVITY
OF MAITAKE MUSHROOM

MANY MORE STUDIES THAN THESE HAVE BEEN PERFORMED to study maitake's anticancer potential. These listings found in a Medline internet data search, although not by any means a comprehensive list of citations, indicate that maitake has been relatively well studied for its anti-cancer potential.

1 Ohno, N., et al. "Antitumor activity and structural characterization of glucans extracted from cultured fruit bodies of *Grifola frondosa*." *Chem Pharm Bull* (Tokyo) (1984 Mar) 32(3):1142-51.

2 Adachi, Y., et al. "Physiochemical properties and antitumor activities of chemically modified derivatives of antitumor glucan 'grifolan LE' from *Grifola frondosa*." *Chem Pharm Bull* (Tokyo) (1989 Jul) 37(7):1838-43.

3 Suzuki, I., et al. "Antitumor and immunomodulating activities of a beta-glucan obtained from liquid-cultured *Grifola frondosa*." *Chem Pharm Bull* (Tokyo) (1989 Feb) 37(2):410-3.

4 Ohno, N., et al. "Effect of grifolan on the ascites form of Sarcoma 180." *Chem Pharm Bull* (Tokyo) (1987 Jun) 35(6):2576-80.

5 Adachi, K., et al. "Potentiation of host-mediated antitumor activity in mice by beta-glucan obtained from *Grifola frondosa* (maitake)." *Chem Pharm Bull* (Tokyo) (1987 Jan) 35(1):262-70.

6 Ohno, N., et al. "Effect of activation or blockade of the phagocytic system on the antitumor activity of grifolan." *Chem Pharm Bull* (Tokyo) (1986 Oct) 34(10):4377-81.

7 Ohno, N., et al. "Effect of glucans on the antitumor activity of grifolan." *Chem Pharm Bull* (Tokyo) (1986 May) 34(5):2149-54.

8 Ohno, N. "Characterization of the antitumor glucan obtained from liquid-cultured *Grifola frondosa*." *Chem Pharm Bull* (Tokyo) (1986 Apr) 34(4):1709-15.

9 Iino, K., et al. "Structure-function relationship of antitumor beta-1,3-glucan obtained from matted mycelium of cultured *Grifola frondosa*." *Chem Pharm Bull* (Tokyo) (1985 Nov) 33(11):4950-6.

10 Ohno, N., et al. "Structural characterization and antitumor activity of the extracts from matted mycelium of cultured *Grifola frondosa*." *Chem Pharm Bull* (Tokyo) (1985 Aug) 33(8):3395-401.

11 Ohno, N., et al. "Neutral and acidic antitumor polysaccharides extracted from cultured fruit bodies of *Grifola frondosa*." *Chem Pharm Bull* (Tokyo) (1985 Mar) 33(3):1181-6.

12 Adachi, Y., et al. "Enhancement of cytokine production by macrophages stimulated with (1Æ3)-beta-D-glucan, grifolan (GRN), isolated from *Grifola frondosa*." *Biol Pharm Bull* (1994 Dec) 17(12):1554-60.

13 Suzuki, I., et al. "Antitumor activity of a polysaccharide fraction extracted from cultured fruiting bodies of *Grifola frondosa*." J Pharmacobiodyn (1984 Jul) 7(7):492-500.

14 Takeyama, T., et al. "Distribution of grifolan NMF-5N (I/B), a chemically modified antitumor beta-glucan in mice." *J Pharmacobiodyn* (1988 Jun) 11(6):381-5.

15 Takeyama, T., et al. "Host-mediated antitumor effect of grifolan NMF-5N, a polysaccharide obtained from *Grifola frondosa*." *J Pharmacobiodyn* (1987 Nov) 10(11):644-51.

16 Suzuki, I., et al. "Antitumor effect of polysaccharide grifolan NMF-5N on syngeneic tumor in mice." *J Pharmacobiodyn* (1987 Feb) 10(2):72-7.

17 Ohno, N., et al. "Antitumor activity of a beta-1,3-glucan obtained from liquid cultured mycelium of *Grifola frondosa*." *J Pharmacobiodyn* (1986 Oct) 9(10):861-4.

18 Suzuki, I., et al. "Effect of a polysaccharide fraction from *Grifola frondosa* on immune response in mice." *J Pharmacobiodyn* (1985 Mar) 8(3):217-26.

19 Nono, I., et al. "Modification of immunostimulating activities of grifolan by the treatment with (1→3)-beta-D-glucanase." *J Pharmacobiodyn* (1989 Nov) 12(11):671-80.

20 Nono, I., et al. "Modulation of antitumor activity of grifolan by subsequent administration of (1→3)-beta-D-glucanase *in vivo*." *J Pharmacobiodyn* (1989 Oct) 12(10):581-8.

A Glossary to Understanding the Immune System

Acquired immunodeficiency syndrome (AIDS): A life-threatening disease caused by a virus and characterized by breakdown of the body's immune defenses.

Active immunity: Immunity produced by the body in response to stimulation by a disease-causing organism or a vaccine.

Agammaglobulinemia: An almost total lack of immunoglobulins, or antibodies.

Allergen: Any substance that causes an allergy.

Allergy: An inappropriate and harmful response of the immune system to normally harmless substances.

Anaphylactic shock: A life-threatening allergic reaction characterized by a swelling of body tissues including the throat, difficulty in breathing, and a sudden fall in blood pressure.

Anergy: A state of unresponsiveness, induced when the T cell's antigen receptor is stimulated, that effectively freezes T cell responses pending a "second signal" from the antigen-presenting cell.

Antibody: A soluble protein molecule produced and secreted by B cells in response to an antigen, which is capable of binding to that specific antigen.

Antibody-dependent cell-mediated cytotoxicity (ADCC): An immune response in which antibody, by coating target cells, makes them vulnerable to attack by immune cells.

Antigen: Any substance that, when introduced into the body, is recognized by the immune system.

Antigen-presenting cells: B cells, cells of the monocyte lineage (including macrophages as well as dendritic cells), and various other body cells that "present" antigen in a form that T cells can recognize.

Antinuclear antibody (ANA): An autoantibody directed against a substance in the cell's nucleus.

Antiserum: Serum that contains antibodies.

Antitoxins: Antibodies that interlock with and inactivate toxins produced by certain bacteria.

Appendix: Lymphoid organ in the intestine.

Attenuated: Weakened; no longer infectious.

Autoantibody: An antibody that reacts against a person's own tissue.

Autoimmune disease: A disease that results when the immune system mistakenly attacks the body's own tissues. Rheumatoid arthritis and systemic lupus erythematosus are autoimmune diseases.

Bacterium: A microscopic organism composed of a single cell. Many but no all bacteria cause disease.

Basophil: A white blood cell that contributes to inflammatory reactions. Along with mast cells, basophils are responsible for the symptoms of allergy.

B cells: Small white blood cells crucial to the immune defenses. Also known as B lymphocytes, they are derived from bone marrow and develop into plasma cells that are the source of antibodies.

Biological response modifiers: Substances, either natural or synthesized, that boost, direct, or restore normal immune defenses. BRMs include interferons, interleukins, thymus hormones, and monoclonal antibodies.

Biotechnology: The use of living organisms or their products to make or modify a substance. Biotechnology includes recombinant DNA techniques (genetic engineering) and hybridoma technology.

Bone marrow: Soft tissue located in the cavities of the bones. The bone marrow is the source of all blood cells.

Cellular immunity: Immune protection provided by the direct action of immune cells (as distinct from soluble molecules such as antibodies).

Chromosomes: Physical structures in the cell's nucleus that house the genes. Each human cell has 23 pairs of chromosomes.

Clone: (n.)A group of genetically identical cells or organisms descended from a single common ancestor; (v.) to reproduce multiple identical copies.

Complement: A complex series of blood proteins whose action "complements" the work of antibodies. Complement destroys bacteria, produces inflammation, and regulates immune reactions.

Complement cascade: A precise sequence of events usually triggered by an antigen-antibody complex, in which each component of the complement system is activated in turn.

Constant region: That part of an antibody's structure that is characteristic for each antibody class.

Co-Stimulation: The delivery of a second signal from an antigen-presenting cell to a T cell. The second signal rescues the activated T cell from anergy, allowing it to produce the lymphokines necessary for the growth of additional T cells.

Cytokines: Powerful chemical substances secreted by cells. Cytokines include lymphokines produced by lymphocytes and monokines produced by monocytes and macrophages.

Cytotoxic T cells: A subset of T lymphocytes that can kill body cells infected by viruses or transformed by cancer.

Dendritic cells: White blood cells found in the spleen and other lymphoid organs. Dendritic cells typically use threadlike tentacles to enmesh antigen, which they present to T cells.

DNA (deoxyribonucleic acid): Nucleic acid that is found in the cell nucleus and that is the carrier of genetic information.

Enzyme: A protein, produced by living cells, that promotes the chemical processes of life without itself being altered.

Eosinophil: A white blood cell that contains granules filled with chemicals damaging to parasites, and enzymes that damp down inflammatory reactions.

Epitope: A unique shape or marker carried on an antigen's surface, which triggers a corresponding antibody response.

Fungus: Member of a class of relatively primitive vegetable organism. Fungi include mushrooms, yeasts, rusts, molds, and smuts.

Gene: A unit of genetic material (DNA) that carries the directions a cell uses to perform a specific function, such as making a given protein.

Graft-versus-host disease (GVHD): A life-threatening reaction in which transplanted immunocompetent cells attack the tissues of the recipient.

Granulocytes: White blood cells filled with granules containing potent chemicals that allow the cells to digest microorganisms, or to produce inflammatory reactions. Neutrophils, eosinophils, and basophils are examples of granulocytes.

Helper T cells: A subset of T cells that typically carry the T4 marker and are essential for turning on antibody production, activating cytotoxic T cells, and initiating many other immune responses.

Hematopoiesis: The formation and development of blood cells, usually takes place in the bone marrow.

Histocompatibility testing: A method of matching the self antigens (HLA) on the tissues of a transplant donor with those of the recipient. The closer the match, the better the chance that the transplant will take.

HIV (human immunodeficiency virus): The virus thought to cause AIDS.

Human leukocyte antigens (HLA): Protein in markers of self used in histocompatibility testing. Some HLA types also correlate with certain autoimmune diseases.

Humoral immunity: Immune protection provided by soluble factors such as antibodies, which circulate in the body's fluids or "humors," primarily serum and lymph.

Hybridoma: A hybrid cell created by fusing a B lymphocyte with a long-lived neoplastic plasma cell, or a T lymphocyte with a lymphoma cell. A B-cell hybridoma secretes a single specific antibody.

Hypogammaglobulinemia: Abnormally low levels of immunoglobulins.

Idiotypes: The unique and characteristic parts of an antibody's variable region, which can themselves serve as antigens.

Immune complex: A cluster of interlocking antigens and antibodies.

Immune response: The reactions of the immune system to foreign substances.

Immunoassay: A test using antibodies to identify and quantify substances. Often the antibody is linked to a marker such as a fluorescent molecule, a radioactive molecule, or an enzyme.

Immunocompetent: Capable of developing an immune response.

Immunoglobulins: A family of large protein molecules, also known as antibodies.

Immunosuppression: Reduction of the immune responses, for instance by giving drugs to prevent transplant rejection.

Immunotoxin: A monoclonal antibody linked to a natural toxin, a toxic drug, or a radioactive substance.

Inflammatory response: Redness, warmth, swelling, pain, and loss of function produced in response to infection, as the result of increased flood flow and an influx of immune cells and secretions.

Interleukins: A major group of lymphokines and monokines.

Kupffer cells: Specialized macrophages in the liver.

LAK cells: Lymphocytes transformed in the laboratory into lymphokine-activated killer cells, which attack tumor cells.

Langerhans cells: Dendritic cells in the skin that pick up antigen and transport it to lymph nodes.

Leukocytes: All white blood cells.

Lymph: A transparent, slightly yellow fluid that carries lymphocytes, bathes the body tissues, and drains into the lymphatic vessels.

Lymphatic vessels: A bodywide network of channels, similar to the blood vessels, which transport lymph to the immune organs and into the bloodstream.

Lymph nodes: Small bean-shaped organs of the immune system, distributed widely throughout the body and linked by lymphatic vessels. Lymph nodes are garrisons of B, T, and other immune cells.

Lymphocytes: Small white blood cells produced in the lymphoid organs and paramount in the immune defenses.

Lymphoid organs: The organs of the immune system, where lymphocytes develop and congregate. They include the bone marrow, thymus, lymph nodes, spleen, and various other clusters of lymphoid tissue. The blood vessels and lymphatic vessels can also be considered lymphoid organs.

Lymphokines: Powerful chemical substances secreted by lymphocytes. These soluble molecules help direct and regulate the immune responses.

Macrophage: A large and versatile immune cell that acts as a microbe-devouring phagocyte, an antigen-presenting cell, and an important source of immune secretions.

Major histocompatibility complex (MHC): A group of genes that controls several aspects of the immune response. MHC genes code for self markers on all body cells.

Mast cell: A granule-containing cell found in tissue. The contents of mast cells, along with those of basophils, are responsible for the symptoms of allergy.

Microbes: Minute living organisms, including bacteria, viruses, fungi and protozoa.

Microorganisms: Microscopic plants or animals.

Molecule: The smallest amount of a specific chemical substance that can exist alone. (The break a molecule down into its constituent atoms is to change its character. A molecule of water, for instance, reverts to oxygen and hydrogen.)

Monoclonal antibodies: Antibodies produced by a single cell or its identical progeny, specific for a given antigen. As a tool for binding to specific protein molecules, monoclonal antibodies are invaluable in research, medicine, and industry.

Monocyte: A large phagocytic white blood cell which, when it enters tissue, develops into a macrophage.

Monokines: Powerful chemical substances secreted by monocytes and macrophages. These soluble molecules help direct and regulate the immune responses.

Natural killer (NK) cells: Large granule-filled lymphocytes that take on tumor cells and infected body cells. They are known as "natural" killers because they attack without first having to recognize specific antigens.

Neutrophil: A white blood cell that is an abundant and important phagocyte.

Nucleic acids: Large, naturally occurring molecules composed of chemical building blocks known as nucleotides. There are two kinds of nucleic acids, DNA and RNA.

OKT3: A monoclonal antibody that targets mature T cells.

Opportunistic infection: An infection in an immunosuppressed person caused by an organism that does not usually trouble people with healthy immune systems.

Opsonize: To coat an organism with antibodies or a complement protein so as to make it palatable to phagocytes.

Organism: An individual living thing.

Parasite: A plant or animal that lives, grows and feeds on or within another living organism.

Passive immunity: Immunity resulting from the transfer of antibodies or antiserum produced by another individual.

Peyer's patches: A collection of lymphoid tissues in the intestinal tract.

Phagocytes: Large white blood cells that contribute to the immune defenses by ingesting microbes or other cells and foreign particles.

Plasma cells: Large antibody-producing cells that develop from B cells.

Platelets: Granule-containing cellular fragments critical for blood clotting and sealing off wounds. Platelets also contribute to the immune response.

Polymorphs: Short for polymorphonuclear leukocytes or granulocytes.

Proteins: Organic compounds made up of amino acids. Proteins are one of the major constituents of plant and animal cells.

Protozoa: A group of one-celled animals, a few of which cause human disease (including malaria and sleeping sickness).

Rheumatoid factor: An autoantibody found in the serum of most persons with rheumatoid arthritis.

RNA (ribonucleic acid): A nucleic acid that is found in the cytoplasm and also in the nucleus of some cells. One function of RNA is to direct the synthesis of proteins.

Scavenger cells: Any of a diverse group of cells that have the capacity to engulf and destroy foreign material, dead tissues, or other cells.

SCID mouse: A laboratory animal that, lacking an enzyme necessary to fashion an immune system of its own, can be turned into a model of the human immune system when injected with human cells or tissues.

Serum: The clear liquid that separates from the blood when it is allowed to clot. This fluid retains any antibodies that were present in the whole blood.

Severe combined immunodeficiency disease (SCID): A life-threatening condition in which infants are born lacking all major immune defenses.

Spleen: A lymphoid organ in the abdominal cavity that is an important center for immune system activities.

Stem cells: Cells from which all blood cells derive. The bone marrow is rich in stem cells.

Subunit vaccine: A vaccine that uses merely one component of an infectious agent, rather than the whole, to stimulate an immune response.

Superantigens: A class of antigens, including certain bacterial toxins, that unleash a massive and damaging immune response.

Suppressor T cells: A subset of T cells that turn off antibody production and other immune responses.

T cells: Small white blood cells that orchestrate and/or directly participate in the immune defenses. Also known as T lymphocytes, they are processed in the thymus and secrete lymphokines.

Thymus: A primary lymphoid organ, high in the chest, where T lymphocytes proliferate and mature.

TIL: Tumor-infiltrating lymphocytes. These immune cells are extracted from the tumor tissue, treated in laboratory, and reinjected into the cancer patient.

Tissue typing: See histocompatibility testing.

Tolerance: A state of nonresponsiveness to a particular antigen or group of antigens.

Tonsils and adenoids: Prominent oval masses of lymphoid tissues on either side of the throat.

Toxins: Agents produced by plants and bacteria, normally very damaging to mammalian cells, that can be delivered directly to target cells by linking them to monoclonal antibodies or lymphokines.

Vaccine: A substance that contains antigenic components from an infectious organism. By stimulating an immune response (but not disease), it protects against subsequent infection by that organism.

Variable region: That part of an antibody's structure that differs from one antibody to another.

Virus: Submicroscopic microbe that causes infectious disease. Viruses can reproduce only in living cells.

Resources

THE FOLLOWING COMPANIES utilize the original maitake raw materials used and currently being used in experimental and clinical studies.

Maitake Products
222 Bergen Turnpike, Ridgefield Park, NJ 07660
(201) 229-0101
via facsimile: (201) 229-0585
toll-free (800) 747-7418
website: www.maitake.com
The manufacturer and source for the maitake products used in experimental and clinical trials, including D-fraction and SX-fraction.

Enzymatic Therapy
825 Challenger Drive, Green Bay, WI 54311
Toll-free (800) 783-2286;
website: www.enzy.com
Look for their Healthy Cells™ Breast and Healthy Cells™ Prostate formulas at health food stores and natural health centers.

PhytoPharmica
825 Challenger Drive, Green Bay, WI 54311
Toll-free (800) 553-2370
Website: www.phytopharmica.com
Look for their Healthy Cells™ Breast and Healthy Cells™ Prostate formulas at pharmacies and from health professionals.

NEWAYS, Inc.
150 E. 400. N., Salem, Utah 84653
Toll-free (800) 729-1445
Website: www.neways.com
Look for their Vitacell™ formula.

Body Wise® International, Inc.
2802 Dow Avenue
Tustin, CA 92780-7212
Toll-free (800) 830-9596
Website: www.bodywise.com
Look for their AG-Immune™ formula.

Puritan's Pride®
1233 Montauk Highway
P.O. Box 9001
Oakdale, NY 11769-1030
Toll-free (800) 645-1030
Website: www.puritan.com
Look for their Maitake D-Fraction formula.

Advocare
website: www.advocare.com
Look for their Immunoguard formula.

Vitamin Research Products
3579 Highway 50 East
Carson City, NV 89701
Toll-free (800) 877-3292
International (775) 884-1331
website: www.vrp.com
Look for their anticancer formulas utilizing Maitake D-fraction as a key ingredient and authorized by nutritional expert, Dr. Shari Lieberman.

REFERENCES

[1]Manohar, V., et al. "Effects of a water-soluble extract of maitake mushroom on circulating glucose-/insulin concentrations in KK mice." *Diabetes, Obesity and Metabolism*, 2002;4(1):43-48.

[2]Harada, Y. In: Sasaki, J. (ed.), *Biology in Mushrooms and Molds* [in Japanese; English translation]. Tokyo: Chuo-Koron Sha, 1993.

[3]Jones, K. "Maitake. A potent medicinal food." *Alternative & Complementary Therapies*, December 1998:420-429.

[4] Mizuno, T. & Zhuang, C. "Maitake, *Grifola frondosa*: Pharmacological effects." *Food Rev Int*, 1995;11(1):135-149.

[5]Konno, S. "Maitake D-fraction: Apoptosis inducer and immune enhancer." *Alternative & Complementary Therapies*, April 2001:102-107.

[6]Chang R. "Functional properties of edible mushrooms." *Nutr Rev*, 1996; 54(11 Pt 2):S91-93.

[7]Mayell, M. "Maitake extracts and their therapeutic potential." *Altern Med Rev*, 2001;6(1):48-60.

[8]Fullerton, S.A., et al. "Induction of apoptosis in human prostatic cancer cells with β-glucan (maitake mushroom polysaccharide)." *Molecular Urology*, 2000; 4(1): 7-13.

[9]Mestel, R. "Global warning." *Los Angeles Times*, March 1, 1999: S1, S6.

[10]Ohno, N., et al. "Enhancement of LPS triggered TNF-α (tumor necrosis factor-a production by 1→3)-b-D-glucans in mice." *Biol Pharm Bull*, 1995;18(1):126-133.

[11]Brown, G.D. & Gordon, S. "Immune recognition. A new receptor for beta-glucans." *Nature*, 20016;413(6851):36-37.

[12]Di Luzio, N.F. "Immunopharmacology of glucan, a broad spectrum enhancer of host defense mechanisms." *Trends in Pharmacological Sciences*, 1983;4:344-347.

References

[13]Czop, J.K. & Austen K.F. "A B-glucan inhibitable receptor on human monocytes, its identity with the phagocytic receptor for particulate activators of the alternative complement pathway." *J. Immuno*, 1985;134:2588-2593.

[14]Czop, J.K., et al. "Phagocytosis of particulate activators of the human alternative complement pathway through monocyte beta-glucan receptors." *Prog Clin Biol Res*, 1989;297:287-296.

[15]Wyde, P., et al. "Beta-1,3-glucan activity in mice: intraperitoneal and oral applications." Baylor College of Medicine. *Research Summary*, 1989.

[16]Kim, B.K., et al. "The anti-HIV activities of *Ganoderma lucidum*." Reported at the Fifth International Mycological Congress on August 16, 1994, in Vancouver, British Columbia, Canada.

[17]Developmental Therapeutics Program, National Cancer Institute. *In-vitro* and anti-HIV drug screening results. NSC: F195001, January, 1992.

[18]Lieberman, S. & Babal, K. *Maitake: King of Mushrooms*. New Canaan, CT: Keats Publishing, 1997, pp. 27-30.

[19]Williams, D.L. & Di Luzio, N.R. "Glucan-induced modification of murine viral hepatitis." *Science*, 1980;208:67-69.

[20]Wu, S., et al. "Therapeutic effect of *Grifola* polysaccharides in chronic hepatitis B [abstract P-18]." In: *International Programme and Abstracts: International Symposium on Production and Products of Lentinus Mushroom, Quingyan, Zhejiang, China*, November 1-3, 1994. Qingyuan, Zhejiang Province, China: International Society for Mushroom Science, Committee on Science, Asian Region, Qingyuan County Government, Zheijiang Province, China, 1994.

[21]Jones, K., Op cit.

[22]Kenyon, A.J. "Delayed wound healing in mice associated with viral alteration of macrophages." *Am J Vet Res*, 1983;44:652-656.

[23]Di Luzio, N.R. & Williams, D.L. "Protective effect of glucan against systemic *Staphylococcus aureus* septicemia in normal and leukemic mice." *Infect Immun*, 1978;20:804-810.

[24]Williams, D.L. & Di Luzio, N.R. "Glucan induced modification of experimental *Staphylococcus aureus* infection in normal, leukemic and immunosuppressed mice." *Adv Exp Med Biol*, 1979;121:291-306.

[25]Tzianabos, A.O., et al. "Protection against experimental intra-abdominal sepsis by two polysaccharide immunomodulators." *J Infect Dis*, 1998;178(1)200-206.

[26]Liang, J., et al. "Enhanced clearance of a multiple antibiotic resistant Staphylococcus aureus in rats treated with PBB-glucan is associated with increased leukocyte counts and increased neutrophil oxidative burst activity." *Int J Immunopharmacol*, 1998;20(11)595-614.

[27]Qadripur, S.A. *Ther. D. Gegenw*, 1976; 115: 1072-1078.

[28]Kanai, K., et al. "Immunpotentiating effect of fungal glucans as revealed by frequency limitation of postchemotherapy relapse in experimental mouse tuberculosis." *Jpn J Med Sci Biol*, 1980;33:283-293.

[29]Lahnborg, G., et al. "Glucan-induced enhancement of host resistance in experimental intraabdominal sepsis." *Eur Surg Res*, 1982;14:401-408.

[30]Kimura, A., et al. "Glucan alteration of pulmonary antibacterial defense." *J. Reticuloendothel Soc*, 1983;34:1-11.

[31]Almdahl, S.M., et al. "The effect of splenectomy on *Escherichia coli* sepsis and its treatment with semisoluble aminated glucan." *Scand J Gastroenterol*, 1987;22:261-267.

[32]Browder, W., et al. "Synergistic effect of nonspecific immunostimulation and antibiotics in experimental peritonitis." *Surgery*, 1987;102:206-214.

[33]Williams, D.L., et al. "Effect of glucan on neutrophil dynamics and immune function in *Escherichia coli* peritonitis." *J Surg Res*, 1988;44:54-61.

[34]Takeda, Y., et al. "Augmentation of host defense against *Listeria monocytogenes* infection by oral administration with polysaccharide RBS (RON)." *Int J Immunopharmacol*, 1990;12:373-383.

[35]Rayyan, W. & Delville, J. "[Effect of beta-1,3 glucan and other immunomodulators of microbial origin on experimental leprosy in mice]." Acta Leprol, 1983;1:93-100.

[36]Wolday, D. "Role of *Leishmania donovani* and its lipophosphoglycan in CD4+ T-cell activation-induced human immunodeficiency virus replication." *Infect Immun*, 1999;67(10):5258-5264.

[37]Lovy, A., et al. "Activity of edible mushrooms against the growth of human T4 leukemic cancer cells, HeLA cervical cancer cells, and *Plasmodium falciparum*." *J Herbs Spices medicinal Plants*, in press, 1998.

[38]Zucker, J.R. "Changing patterns of autochthonous malaria transmission in the United States: A review of recent outbreaks." *Emerg Infect Dis*, 1996;2(1):37-43.

[39]Browder, I.W., et al. "Modification of post-operative C. albicans sepsis by glucan immunostimulation." *Int J Immunopharmacol*, 1984;6:19-26.

[40]Babineau, T.J., et al. "A phase II multiple center, double-blind, randomized, placebo-controlled study of three dosages of an immunomodulator (PGG-glucan) in high risk surgical patients." *Arch Surg*, 1994;129(11):1204-1210.

[41]Kimura, A., Op cit.

[42]Research Summary. "Beta-1,3-glucan activity in mice: intraperitoneal and oral applications." Baylor College of Medicine, 1989.

[43]Lahnborg, G., et al. "The effect of glucan—a host resistance activator and ampicillin on experimental intraabdominal sepsis." *Journal of Reticuloendothelial Society*, 1985;7:923-932.

[44]Ber, L. & Gazella, K.A. *Activate Your Immune System*. Green Bay, WI: Impakt Communications, 1998.

[45]Ohno, N., et al. "Structural characterization and antitumor activity of the extracts from mated mycelium of cultured *Grifola frondosa*." *Chem Pharm Bull*, 1985;33:3395-3401.

[46]Hishida, I., et al. "Antitumor activity exhibited by orally administered extract from fruit body of *Grifola frondosa* (maitake)." *Chem Pharm Bull*, 1988;36:1819-1827.

[47]Ohno, N., 1985, Op cit.

[48]Jones, K. Op cit.

[49]Ibid.

[50]Sakurai, T., et al. "Effect of intraperitoneally administered beta-1,3-D-glucan, SSG, obtained from *Sclerotinia sclerotiorum* IFO 9395 on the functions of murine alveolar macrophages." *Chem Pharm Bull* (Tokyo), 1991;39:214-217.

[51]Okazaki, M., et al. "Structure-activity relationship of (1→3)-β-D-glucans in the induction of cytokine production from macrophages, *in vitro*." *Biol Pharm Bull*, 1995;18(10):1320-1327.

[52]Hishida, I., et al. "Antitumor activity exhibited by orally administered extract from fruit body of *Grifola frondosa* (maitake)." *Chem Pharm Bull*, 1988;36:1819-1827.

[53]Adachi, K., et al. "Potentiation of host-mediated antitumor activity in mice by b-glucan obtained from *Grifola frondosa* (maitake)." *Chem Pharm Bull*, 1987;35:262-270.

[54]Kunimoto, T., et al. "Antitumor polysaccharide-induced tumor-regressing factor in the serum of tumor-bearing mice: purification and characterization." *J Biol Response Mod*, 1986;5:225-235.

[55]Sherwood, E.R., et al. "Glucan stimulates production of antitumor cytolytic/cytostatic factor(s) by macrophages." *J. Biol. Response. Mod.*, 1986;5:504-526.

[56]Fukase, S., et al. "Tumor cytotoxicity of polymorphonuclear leukocytes in beige mice: linkage of high responsiveness to linear beta-1,3-D-glucan with the beige gene." *Cancer Res*, 1987;47:4842-4847.

[57]Konno, S., April 2001, Op cit.

[58]Matsui, K., et al. "Effects of maitake (*Grifola frondosa*) D-Fraction on the carcinoma angiogenesis." *Cancer Lett*, 2001;172(2):193-198.

[59]"Potentiation of host-mediated antitumor activity in mice by À-glucan obtained from *Grifola frondosa* (maitake)." *Chem Pharm Bull*, 1987; 35(1): 262-270,

[60]Jones, K., Op cit.

[61]Jones, K., Op cit.

[62]"Effect of maitake D-fraction on cancer prevention." *Annals of the New York Academy of Science*, 1997;833:204-207.

[63]Konno, S., April 2001, Op cit.

[64]Lovy, A., Op cit.

[65]Kurashige, S., et al. "Effects of *Lentinus edodes*, *Grifola frondosa* and *Pleurotus ostreatus* administration on cancer outbreak, and activities of macrophages and lymphocytes in mice treated with a carcinogen, N-butyl-n-butanolnitrosamine." *Immunopharmacol Immunotoxicol*, 1997;19(2):173-183.

[66]Miura, T., et al. "Failure in antitumor activity by overdose of an immunomodulating beta-glucan preparation, sonifilan." *Biol Pharm Bull*, 2000;23(2):249-253.

[67]Ríhová, B., et al. "Polymeric drugs based on conjugates of synthetic and natural macromolecules. II. Anti-cancer activity of antibody or (Fab')(2)-targeted conjugates and combined therapy with immunomodulators." *J Controlled Release*, 2000;64(1-3):241-261.

[68]Mansell, P.W.A., et al. "Macrophage-mediated destruction of human malignant cell in vivo." *J Nation Cancer Inst*, 1975;54:571-580.

[69]Mansell, P.W.A., et al. "Clinical experiences with the use of glucan immune modulation and control of neoplasia by adjuvant therapy." In: *Immune Modulation and Control of Neoplasia by Adjuvant Therapy*. New York: Raven Press, 1978.

[70]Di Luzio N.R., et al. "Glucan induced inhibition of tumor growth and enhancement of survival in a variety of transplantable and spontaneous murine tumor models." *Adv Exp Med Biol*, 1980;121A:269-290.

[71]Stewart, C.C., et al. "Preliminary observations on the effect of glucan in combination with radiation and chemotherapy in four murine tumors." *Cancer Treat Rep*, 1978;62:1867-1872.

[72]Di Luzio N.R., 1980, Op cit.

[73]Proctor, J.W., et al. "Effect of glucan and other adjuvants on the clearance of radio-labeled tumor cells from mouse lungs." *Cancer Treat Rep*, 1978;62:1873-1880.

[74]Di Luzio N.R., 1980, Op cit.

[75]Sveinbjørnsson, B., et al. "Inhibition of establishment and growth of mouse liver metastases after treatment with interferon gamma and beta-1,3-D-glucan." *Hepatology*, 1998;27(5):1241-1248.

[76]Stewart, C.C., Op cit.

[77]Miyazaki, H., et al. "Protective effect of SPR-901 (RBS) on the crease of peripheral leukocyte number in 5-fluorouracil-treated mice." *Int J Immunopharmacol*, 1992;14:11-17.

[78]Sveinbjørnsson, B., Op cit.

[79]Ibid.

[80]Patchen, M.L., et al. "Effects of pre- and post-irradiation glucan treatment on pluripotent stem cells, granulocyte, macrophage and erythroid progenitor cells, and hemopoietic strom cells." *Experientia*, 1984;40:1240-1244.

[81]Patchen, M.L. & MacVittie, T.J. "Stimulated hemopoiesis and enhanced survival following glucan treatment in sublethally and lethally irradiated mice." *Int J Immunopharmacol* 1985;7:923-932.

[82]Patchen, M.L. "Radioprotective effect of oral administration of beta-1,3-glucan." *Armed Forces Radiobiology Institute*, Bethesda, MD. Research Report, 1989 (Abstract).

[83]Mansell, P.W.A. Personal Communication.

[84]Patchen, M.L. & McVittle, T.J. "Temporal response of murine pluripotent stem cells and myeloid and erythroid progenitor cells to low-dose glucan treatment." *Acta Hemat*, 1983;70:281-288.

[85]Arika, T., et al. "Combination therapy of radiation and Sizofiran (SPG) on the tumor growth and metastasis on squamous-cell carcinoma NR-S1 in syngeneic C3H/He mice." *Biotherapy*, 1992;4(2):165-170.

[86]Konno, S., April 2001, Op cit.

[87]Zhu, Y.P., et al. "Clinical study on antitumor and immunomodulating effects of Baolisheng [abstract O-20]. In: *International Programme and Abstracts: International Symposium on Production and Products of Lentinus Mushroom, Quingyan, Zhejiang, China, November 1-3, 1994*. Qingyuan, Zhejiang Province, China: International Society for Mushroom Science, Committee on Science, Asian Region, Qingyuan County Government, Zhejiang Province, China, 1994.

[88]Konno, S., April 2001, Op cit.

[89]Ibid.

[90]Ibid.

[91]Ibid.

[92]Morishige, F. " The role of vitamin C in tumor therapy(human)."In: Meyskens, F.I., Jr. & Parasad, K.N. (eds). *Vitamins and Cancer: Human Cancer Prevention by Vitamins and Micronutrients*. Clifton, NJ: Humana Press, 1986:399-427.

[93]Fullerton, S.A., Op cit.

[94]Scheinbart, E.A. " Integrating allopathic and alternative therapies in the treatment of a patient with multiple myeloma and vancomycin-resistant Staphylococcus aureus pneumonia."*Alternative Therapies*, 2001;7(3):158-160.

[95]Landis, S.H., et al. "Cancer statistics, 1999."*CA Cancer J Clin*, 1999;49:8-31.

[96]Gorman, C. "Life preserver." *Time*, August 20, 2001: 53-54.

[97]Schwartz, L.M. & Osborne, B.A. " Programmed cell death, apoptosis and killer genes."*Immunol Today*, 1993;14:582-590.

[98]Landis, S.H., Op cit.

[99]Mahler, C. & Denis, L. "Management of relapsing disease in prostate cancer." *Cancer*, 1992; 70: 329-334.

[100]Davies, P. & Eaton, C.L. "Regulation of prostate growth." *J Endocrinol*, 1991; 131: 5-17.

[101]Fullerton, S.A., Op cit.

[102]Konno, S., April 2001, Op cit.

[103]Willman, D. "Deaths climb since FDA got Rezulin warning." *Los Angeles Times*, December 15, 1999: A1, A26-27.

[104]"New weapons to cut diabetes' toll." *Business Week*, March 29, 1999: 58.

[105]Alper, J. "New insights into type 2 diabetes." *Science*, 2000;289:37-39.

[106]Wagman, A.S. & Nuss, J.M. "Current therapies and emerging targets for the treatment of diabetes." *Curr Pharm Des*, 2001;7:417-450.

[107]Healy, M. "Enormous rise predicted in diabetes case." *USA Today*, October 25, 2001:9D.

[108]*Diabetes*, 1970; 19 (Suppl. 2) 747-830.

[109]*Diabetes*, 1975; 24 (Suppl. 1): 65-184.

[110]*Physicians' Desk Reference*. Montvale, NJ: Medical Economics Company, 1995: 606.

[111]Groop, L.C. "Insulin resistance: The fundamental trigger of type 2 diabetes." *Diabetes Obes Metab*, 1999; 19(suppl.): S1-S7.

[112]Konno, S. *Alternative & Complementary Therapies*, "Maitake SX-fraction: Possible hypoglycemic effect on diabetes mellitus." December 2001;7:366-370.

[113]Nolan, J.J., et al. "Improvement in glucose tolerance and insulin resistance in obese subjects treated with troglitazone." *N Eng J Med*, 1994;331:1188-1193.

[114]Bailey, C.J. "Biguanides and NIDDM." *Diabetes Care*; 1992;15755-772.

[115]DeFronzo, R.A., et al. "Efficacy of metformin in patients with non-insulin-dependent diabetes mellitus." *N Eng J Med*, 1995;333:541-549.

[116]Hoffman, F.L. *Cancer and Diet*. Baltimore, MD: Williams & Wilkins, 1937.

[117]Masoro, E.J., et al. "Dietary restriction alters characteristics of glucose fuel use." *J Gerontology*, 1992;47:B202-B208.

[118]Cerami, A., et al. "Glucose and aging." *Scientific American*, 1987;256:90-96.

[119]Reaven, G.M. "Role of insulin resistance in human disease (Banting Lecture 1988)." *Diabetes*, 1988;37:1595-1607.

[120]Makita, Z., et al. "Advanced glycosylation end products in patients with diabetic nephropathy." *N Eng J Med*, 1991;325:836-842.

[121]Parfrey, P.S. & Harnett, J.D. "Long-term cardiac morbidity and mortality during dialysis therapy." *Adv Nephrol*, 1994;23:311-330.

[122]Makita, Z., Op cit.

[123]Reaven, G.M., Op cit.

[124]Reaven, G.M., Op cit.

[125]Harman, D. "Free-radical theory of aging." *Ann NY Acad Sciences*. 1994;717:1-15.

[126]Cutler, R.G. "Antioxidants and aging." *Am J Clin Nutr*, 1991;53:373S-379S1.

[127]Harman, D. "Role of antioxidant nutrients in aging: overview." *Age*, 1995;18:51-62.

[128]Kehrer, J.P. "Free radicals as mediators of tissue injury and disease." *Critical Reviews in Toxicology*, 1993;23:21-48.

[129]Halliwell, B. & Cross, C.E. "Oxygen-derived species: their relation to human disease and environmental stress." *Environmental Health Perspectives*, 1994;102(Suppl 10):5-12.

[130]Aruoma, O.I. "Nutrition and health aspects of free radicals and antioxidants." *Fd Chem Toxic*, 1994;32:671-683.

[131]Stohs, S.J. "The role of free radicals in toxicity and disease." *Free Radicals*, 1995;6:1-24.

[132]Gallagher, D.D., et al. "Diabetes increases excretion of urinary malonaldehyde conjugates in rats." *Lipids*, 1993;28:663-666.

[133]Ibid.

[134]Ibid.

[135]Kubo, K., et al. "Anti-diabetic activity present in the fruit body of *Grifola frondosa* (maitake). I." *Biol Pharm Bull*, 1994;17(8):1106-1110.

[136]"Anti-diabetic mechanism of maitake (*Grifola frondosa*)," Mushroom Biology and Mushroom Products. Royse (ed.) 1996 Penn State Univ. ISBN 1-883956-01-3.

[137]Manohar, V., et al. "Effects of a water soluble extract of maitake mushroom on circulating glucose/insulin concentrations in KK mice." *Diabetes Obes Metab*, 2001 (in press).

[138]Horio, H. & Ohtsuru, M. "Maitake (*Grifola frondosa*) improve glucose tolerance of experimental diabetic rats." *J Nutr Sci Vitaminol* (Tokyo), 2001;47(1):57-63.

[139]Konno, S. "A possible hypoglycaemic effect of maitake mushroom on Type 2 diabetic patients." *Diabetic Medicine*, 2001;18:1-2.

[140]Konno, S. December, 2001.

[141]Kubo, K., et al. "Anti-diabetic mechanism of maitake (*Grifola frondosa*)." In: Royse, D.J. (ed.). *Mushroom biology and Mushroom Products*. University Park: Penn State University, 1996, pp. 215-221.

[142]Kabir, Y. & Kimura, S. "Dietary mushrooms reduce blood pressure in spontaneously hypertensive rats (SHR)." *J Nutr Sci Vitaminol* (Tokyo), 1989;35(1):91-94..

[143]Ibid.

[144]Adachi, K., et al. "Blood pressure-lowering activity present in the fruit body of *Grifola frondosa* (maitake). I." *Chem Pharm Bull* (Tokyo), 1988;36(3):1000-1006.

[145]Lieberman, S. & Babal, K. Op cit., pp. 34-36.

[146]Ibid.

[147]Ibid.

[148]Associated Press. "Wider use seen for drugs to reduce cholesterol of heart patients." *The New York Times*, March 27, 1996: A1.

[149]Ibid.

[150]Ibid.

[151]Newman, T.B. & Hully, S.B. "Carcinogenicity of lipid-lowering drugs." *Journal of the American Medical Association*, 1996; 275(1): 55-60.

[152]Bell, S., et al. "Effect of beta-glucan from oats and yeast on serum lipids." *Crit Rev Food Sci Nutr*, 1999;39(2):189-202.

[153]Kubo, K. "The effect of maitake mushrooms on liver and serum lipids." *Altern Ther Health Med*, 1996;2(5):62-66.

[154]Kubo, K. "Anti-hyperliposis effect of maitake fruit body (*Grifola frondosa*). I." *Biol Pharm Bull*, 1997;20(7):781-785.

[155]Kabir, Y., et al. "Effect of shiitake (*Lentinus edodes*) and maitake (*Grifola frondosa*) mushrooms on blood pressure and plasma lipids of spontaneously hypertensive rats." *J Nutr Sci Vitaminol*, 1987; 33(5):341-346.

[156]Fukushima, M., et al. "Cholesterol-lowering effects of maitake (*Grifola frondosa* fiber, shiitake (*Lentinus edodes*) fiber, and enokitake (*Flammulina velutipes*) fiber in rats." *Exp Biol Med* (Maywood), 2001;226(8):758-765.

[157]Bobek, P., et al. "Effect of oyster mushroom and isolated beta-glucan on lipid peroxidation and on the activities of antioxidative enzyme in rats fed the cholesterol diet." *J. Nutr. Biochem*, 1997;8(8):469-471.

[158]Nicolas, R. "Plasma lipid changes after supplementation with beta-glucan fiber from yeast." *Am J Clin Nutr*, 1999;70(2):208-212.

[159]Ohtsuru, M. "Anti-obesity activity exhibited by orally administered powder of maitake (*Grifola frondosa*)." *Anshin*, July 1992;188-200.

[160]Yokota, M. "Observatory trial of anti-obesity activity of maitake (*Grifola frondosa*)." *Anshin*, July 1992:202-204.

[161]Jones, K. "Maitake. A potent medicinal food." *Alternative & Complementary Therapies*, December 1998:420-429.

[162]Ohno, N., et al. "Enhancement of LPS triggered TNF-α (tumor necrosis factor-α) production by 1→3)-β-D-glucans in mice." *Biol Pharm Bull*, 1995;18(1):126-133.

[163]Konno, S., April 2001, Op cit.

[164]Maitake D-fraction obtained IND for clinical study [corporate publication]. Ridgefield, NJ: Maitake Products, Inc. February, 1998.

[165]Shen, Q. & Royse, D.J. "Effects of nutrient supplements on biological efficiency, quality and crop cycle time of maitake (*Grifola frondosa*)." *Appl Microbiol Biotechnol*, 2001;57(1-2):74-78.

About the Authors

HARRY G. PREUSS, M.D., M.A.C.N., C.N.S. is a professor of physiology, medicine and pathology at the Georgetown University School of Medicine. He has authored over 500 medical articles including more than 170 peer reviewed scientific papers. Dr. Preuss is on the advisory editorial board of seven journals. He has edited four books on aging, nephrology, and/or hypertension and recently authored the best seller, *The Prostate Cure*. Dr. Preuss is the president of the Certification Board for Nutrition Specialists (CBNS), the past president of the American College of Nutrition and recently became the ninth Master of the College (MACN). He has been on three National Institutes of Health advisory councils: Executive Director's, Aging and Alternative Medicine and is a former Established Investigator of the American Heart Association, as well as an emeritus member of the American Society for Clinical Investigations. He wrote the nutrition section in the *Encyclopedia Americana*. His major interests lie in the field of aging and manifestations of aging such as obesity, hypertension, dyslipidemias, insulin resistance, and how dietary interventions and supplements affect these processes.

SENSUKE KONNO, PH.D., is an assistant professor and director of molecular urology research at the Department of Urology, New York Medical College. He is also an associate editor for the journal *Molecular Urology*. His research focuses on various urological malignancies such as prostate cancer, renal cell carcinoma, bladder cancer, and renal disorders/diseases including acute renal injury/dysfunction, diabetic nephropathy, and kidney stones. Specific aims of such studies are to elucidate the underlying

mechanisms of these malignancies/disorders and to establish more effective therapeutic modalities. Particularly, his work on prostate cancer has been well recognized and published in several major urology journals. Recently, he has become interested in alternative and complementary medicine and the potential clinical utility of natural remedies such as medicinal mushrooms and natural antioxidants. Preclinical, clinical and basic science studies using these natural remedies for urological cancers and renal disorders are currently in progress.